VICTORIAN LONDON STREET LIFE

in Historic Photographs

John Thomson

Text by John Thomson and Adolphe Smith

DOVER PUBLICATIONS, INC.
NEW YORK

Bibliographical Note

This Dover edition, first published in 1994, is an unabridged republication of the work originally published by Sampson Low, Marston, Searle & Rivington, London, in 12 monthly parts beginning in February 1877, under the title *Street Life in London*. The frontmatter has been rearranged, a new table of contents added, and a new Publisher's Note written specially for the Dover edition. For reasons of space the illustrations, originally on unnumbered pages, have been integrated into the text with a consequent reordering of page numbers.

Library of Congress Cataloging-in-Publication Data

Thomson, J. (John), 1837–1921.
 [Street life in London]
 Victorian London street life in historic photographs / by John Thomson with text by John Thomson and Adolphe Smith.
 p. cm.
 Originally published: London : S. Low, Marston, Searle & Rivington, 1877.
 ISBN-13: 978-0-486-28121-6 (pbk.)
 ISBN-10: 0-486-28121-3 (pbk.)
 1. London (England)—Social life and customs—19th century—Pictorial works. I. Smith, Adolphe. II. Title.
DA683.T46 1994
942.1′2081—dc20
 94-11755
 CIP

Manufactured in the United States by Courier Corporation
28121308 2013
www.doverpublications.com

PUBLISHER'S NOTE

BORN in Scotland in 1837, John Thomson was a pioneering documentary photographer—one of a breed for whom arduous travel under extremely difficult conditions did little to dampen enthusiasm. Exploring and photographing China for ten years (1862–72), he published his photographs and texts of his journeys in *The Antiquities of Cambodia* (1867), *Illustrations of China and Its People* (1873–74; Dover reprint 0-486-26750-4) and *The Straits of Malacca, Indo China and China* (1877; illustrated by woodcuts).

Returning to London, Thomson turned his attention to the city, his *Street Life in London* (1877), reprinted here, frequently being credited as the first instance in which photographs were used as social documentation. He subsequently developed the art of "at home" portraits, was appointed photographer to Queen Victoria and was photographic adviser to the Royal Geographic Society. He died in 1921.

By the mid-nineteenth century, popular perception of the poor had changed. Previously viewed as morally defective, the poor were now regarded as the object of study and charity. Henry Mayhew's monumental *London Labour and the London Poor,* published in 1851, had been illustrated by woodcuts based on photographs by Richard Beard. While *Street Life in London* is hardly as comprehensive a work as Mayhew's, it has the virtue that its photographic reproductions not only show the subjects as they actually appeared but, by capturing the contemporary streetscape of London, also reveals them in their milieu.

While the book is most famous for these photographs, the text should not be ignored. Thomson wrote some (signed J. T.), but most of it was written by Adolphe Smith (A. S.), a journalist who became an activist concerned with labor and the unions. The text is factual, but it is impossible not to detect the sympathy that both Smith and Thomson feel for their subjects who, more often than not, are threatened by deprivation and hunger. The costumes and backgrounds depicted in the photographs may seem picturesque to us today, but Thomson's subjects are caught in a seemingly unbreakable cycle of poverty that has reappeared in many urban areas to present its desperate challenge.

STREET LIFE

IN

LONDON.

BY J. THOMSON, F.R.G.S., AND ADOLPHE SMITH.

WITH PERMANENT PHOTOGRAPHIC ILLUSTRATIONS

TAKEN FROM LIFE EXPRESSLY FOR THIS PUBLICATION.

London:

SAMPSON LOW, MARSTON, SEARLE, & RIVINGTON,

CROWN BUILDINGS, 188, FLEET STREET, LONDON.

[ORIGINAL TITLE PAGE]

PREFACE.

I N presenting to the public the result of careful observations among the poor of London, we should perhaps proffer a few words of apology for reopening a subject which has already been amply and ably treated. We are fully aware that we are not the first on the field. "London Labour and London Poor" is still remembered by all who are interested in the condition of the humbler classes; but its facts and figures are necessarily ante-dated. In later times Mr. James Greenwood has created considerable sensation by his sketches of low life, but the subject is so vast and undergoes such rapid variations that it can never be exhausted; nor, as our national wealth increases, can we be too frequently reminded of the poverty that nevertheless still exists in our midst.

And now we also have sought to portray these harder phases of life, bringing to bear the precision of photography in illustration of our subject. The unquestionable accuracy of this testimony will enable us to present true types of the London Poor and shield us from the accusation of either underrating or exaggerating individual peculiarities of appearance.

We have selected our material in the highways and the byways, deeming that the familiar aspects of street life would be as welcome as those glimpses caught here and there, at the angle of some dark alley, or in some squalid corner beyond the beat of the ordinary wayfarer. It also often happens that little is known concerning the street characters who are the most frequently seen in our crowded thoroughfares. At the same time, we have visited, armed with note-book and camera, those back streets and courts where the struggle for life is none the less bitter and intense, because less observed. Here what may be termed more original studies have presented themselves, and will help to complete what we trust will prove a vivid account of the various means by which our unfortunate fellow-creatures endeavour to earn, beg, or steal their daily bread.

THE AUTHORS.

CONTENTS

VICTORIAN LONDON
STREET LIFE
in Historic Photographs

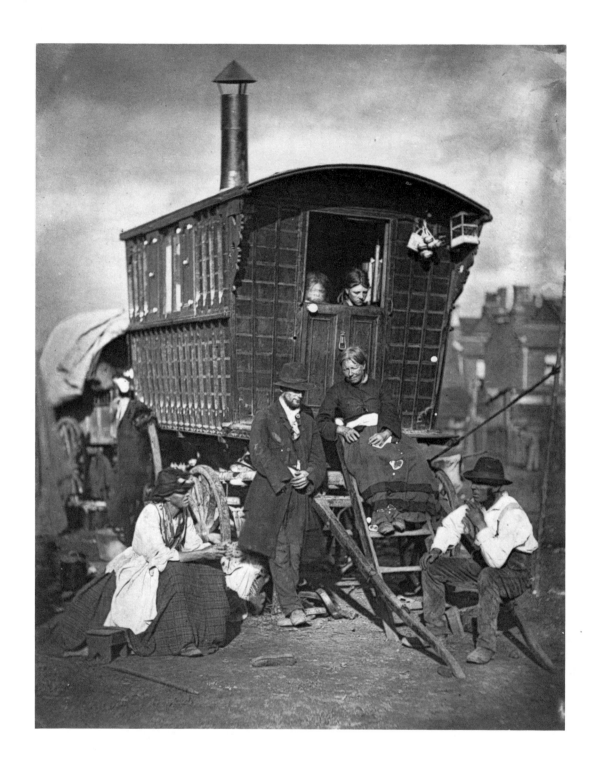

London Nomades

LONDON NOMADES.

I N his savage state, whether inhabiting the marshes of Equatorial Africa, or the mountain ranges of Formosa, man is fain to wander, seeking his sustenance in the fruits of the earth or products of the chase. On the other hand, in the most civilized communities the wanderers become distributors of food and of industrial products to those who spend their days in the ceaseless toil of city life. Hence it is that in London there are a number of what may be termed, owing to their wandering, unsettled habits, nomadic tribes. These people, who neither follow a regular pursuit, nor have a permanent place of abode, form a section of urban and suburban street folks so divided and subdivided, and yet so mingled into one confused whole, as to render abortive any attempt at systematic classification. The wares, also, in which they deal are almost as diverse as the families to which the dealers belong. They are the people who would rather not be trammelled by the usages that regulate settled labour, or by the laws that bind together communities.

The class of Nomades with which I propose to deal makes some show of industry. These people attend fairs, markets, and hawk cheap ornaments or useful wares from door to door. At certain seasons this class "works" regular wards, or sections of the city and suburbs. At other seasons its members migrate to the provinces, to engage in harvesting, hop-picking, or to attend fairs, where they figure as owners of "Puff and Darts," "Spin 'em rounds," and other games. Their movements, however, are so uncertain and erratic, as to render them generally unable to name a day when they will shift their camp to a new neighbourhood. Changes of locality with them, are partly caused by caprice, partly by necessity. At times sickness may drive them to seek change of air, or some trouble comes upon them, or a sentimental longing leads them to the green lanes, and budding hedge-rows of the country. As a rule, they are improvident, and, like most Nomades, unable to follow any intelligent plan of life. To them the future is almost as uncertain, and as far beyond their control, as the changes of wind and weather.

London gipsies proper, are a distinct class, to which, however, many of the Nomades I am now describing, are in some way allied. The traces of kinship may be noted in their appearance as well as in their mode of life, although some of them are as careful to disclaim what they deem a discreditable relationship as are the gipsies to boast of their purity of descent from the old Romany stock.

The accompanying photograph, taken on a piece of vacant land at Battersea, represents a friendly group gathered around the caravan of William Hampton, a man who enjoys the reputation among his fellows, of being "a fair-spoken, honest gentleman." Nor has subsequent intercourse with the gentleman in question led me to suppose that his character has been unduly overrated. He had never enjoyed the privilege of education, but matured in total ignorance of the arts of reading and writing.

This I found to be the condition of many of his associates, and also of other families of hawkers which I have visited.

William Hampton is, for all that, a man of fair intelligence and good natural ability. But the lack of education other than that picked up in the streets and highways, has impressed upon him a stamp that reminded me of the Nomades who wander over the Mongolian steppes, drifting about with their flocks and herds, seeking the purest springs and greenest pastures.

He honestly owned his restless love of a roving life, and his inability to settle in any fixed spot. He also held that the progress of education was one of the most dangerous symptoms of the times, and spoke in a tone of deep regret of the manner in which decent children were forced now-a-days to go to school. " Edication, sir! Why what do I want with edication ? Edication to them what has it makes them wusser. They knows tricks what don't b'long to the nat'ral gent. That's my 'pinion. They knows a sight too much, they do! No offence, sir. There's good gents and kind 'arted scholards, no doubt. But when a man is bad, and God knows most of us aint wery good, it makes him wuss. Any chaps of my acquaintance what knows how to write and count proper aint much to be trusted at a bargain."

Happily this dread of education is not generally characteristic of the London poor, although, at the same time, it is shared by many men of the class of which William Hampton is a fair type.

While admitting that his conclusions were probably justified by his experience, I caused a diversion by presenting him with a photograph, which he gleefully accepted. " Bless ye!" he exclaimed, "that's old Mary Pradd, sitting on the steps of the wan, wot was murdered in the Borough, middle of last month."

This was a revelation so startling, that I at once determined to make myself acquainted with the particulars of the event. The story of the mysterious death of Mary Pradd, however, will hardly bear repeating in detail. She was the widow of a tinker named Lamb, and had latterly taken to travelling the country with two men, one of them is said to have been of gipsy origin and very well known in Kent Street.

The photograph was taken some weeks previous to the event. The deceased was spending an afternoon with her friends at Battersea, when I chanced to meet them and obtained permission to photograph the group. It was on the 18th of November last that the inquest was held concerning this unfortunate woman, at the workhouse, Mint Street. Mary Pradd was fifty-five years old at the time, and her death was reported as involving grave suspicion. A woman named Harriet Lamb gave evidence to the effect that deceased was her mother, the widow of a tinker, and lived with Edward Roland, at 40, Kent Street, Borough. She gave way occasionally to drink, but the witness had seen her alive and well, though not sober, between two and three on the previous day. Mary Pradd was in the habit of travelling through the country with a man named Gamble and with Roland.

Witness had seen her mother strike the latter, but had never seen Roland illtreat her.

Susan Hill, 40, Kent Street, deposed to hearing a noise early in the morning of Thursday, and to being subsequently called up by a woman to the deceased's room, where she found her dressed, lying on her back, dead on the floor, and the two men dressed, and lying asleep on the bed.

Caroline Brewington, with whom Gamble lived, gave evidence that the men had been drinking together during the day, and finding that Gamble did not return, she went to fetch him about midnight, and found the scene as described.

Roland and Gamble, who had been taken into custody on suspicion of having caused the death of the woman, pleaded total ignorance of the whole circumstances.

The medical evidence showed that she had died from hemorrhage, and that there was one external wound on her person.

The jury returned a verdict, " That the deceased died from injuries, but that there was not sufficient evidence to show how such injuries were caused."

The poor woman who met her end in so mysterious a manner had in life the look of being a decent, inoffensive creature. Clean and respectable in her dress, she might in her youth have been even of comely appearance, but now she wore the indelible stamp of a woman who had been dulled and deadened by a hard life. One of her neighbours described her as "a well-conducted, comfortable-looking, old lady. But the life she led latterly sent her sadly to drink. I have often said to her, Mary, you should not give your mind to the drink so."

Mary Pradd was evidently above the common run of these people, and, continued my informant, "She might have done well, for some travelling hawkers make heaps of money, but they never look much above the gutter. I once knew one, Old Mo, they called him ; I used to serve him with his wares, brushes, baskets, mats, and tin things ; for these are the sort of goods I send all over the country to that class of people. Cash first, you know, with them. I would not trust the best of them, not even Mo, though he used to carry £9000 about with him tied up in a sack in his van. He is now settled at Hastings; he has bought property. Never saw a curiouser old man, and as for his father, he was worse than him, a rich old miser. Bought and sold chipped apples because they were cheap. Sat at a corner where he owned houses, and sold halfpenny-worths.

" He had untold ways of making money ; lending it, I think. Mo once bet me he had more old sovereigns, guineas, and half-guineas than any man living, unless a dealer.

" One thing I thought would have killed him. He was once robbed of £1400 in gold and silver, by two men, who sent the boy watching the van off to buy apples. They took as many bags of money out of the sack as the two could carry.

" I have lost the run of him now."

Such is the story of Mo, as it was related to me, and I am further assured that most of these wanderers make money, or have the chance of doing so, their trade expenses being only nominal and their profits frequently large. I myself have been introduced to a man of this class in London, who owns houses and yet lives in his van pursuing his itinerant trade in the suburbs.

The dealer in hawkers' wares in Kent Street, tells me that when in the country the wanderers "live wonderful hard, almost starve, unless food comes cheap. Their women carrying about baskets of cheap and tempting things, get along of the servants at gentry's houses, and come in for wonderful scraps. But most of them, when they get flush of money, have a regular go, and drink for weeks; then after that they are all for saving."

" They have suffered severely lately from colds, small pox, and other diseases, but in spite of bad times, they still continue buying cheap, selling dear, and gambling fiercely."

Declining an invitation to " come and see them at dominoes in a public over the way," I hastened to note down as fast as possible the information received word for word in the original language in which it was delivered, believing that this unvarnished story would at least be more characteristic and true to life.

J. T.

LONDON CABMEN.

THIS old question is assuming a new phase. There is no better abused set of men in existence than the London Cabmen; but recent events and disclosures have helped, at least in part, to remove the blame from their shoulders, and attribute it to those who in this matter are the real enemies of the public interest. Despite the traditional hoarse voice, rough appearance, and quarrelsome tone, cab-drivers are as a rule reliable and honest men, who can boast of having fought the battle of life in an earnest, persevering, and creditable manner. Let me take, for instance, the career, as related by himself, of the cab-driver who furnishes the subject of the accompanying illustration. He began life in the humble capacity of pot-boy in his uncle's public-house, but abandoned this opening in consequence of a dispute, and ultimately obtained an engagement as conductor from the Metropolitan Tramway Company. In this employment the primary education he had enjoyed while young served him to good purpose, and he was soon promoted to the post of time-keeper. After some two years' careful saving he collected sufficient money to buy a horse, hire a cab, and obtain his licence. At first he was greeted with many gibes and jeers from the older and more experienced hands; but fortune soon smiled on him in the person of a bricklayer. This labourer had inherited a sum of £1300. His wife had been a washerwoman, and to quote the cabman's own words, "Nothing was too good for her; but she looked after all only a washerwoman. No more the lady, sir, than a coster's donkey is like the winner of the Derby!"

This couple engaged him day after day, and their drives caused quite a sensation in the neighbourhoods they favoured with their presence. They rattled pence at the windows of the cab, and threw out handfuls of money to the street urchins who followed and cheered in their wake. They hailed their old friends as they passed them in the streets, insisted on giving them a drive to the nearest public-house, where old acquaintance was recklessly drunk from foaming tankards,—knowing that they might always trust the cabman to see them safely home, if unable to guide their own steps. At last the bricklayer's mind became affected by the importance of his fortune. A mania seized him; he could not desist from making his will, and then altering it over and over again. Sometimes he even awoke in the middle of the night, sent for his cab, and insisted on being driven to his lawyer's in Chancery Lane, much to that grave gentleman's annoyance. The matter of the will was, however, soon settled by the money being all spent, and the cabman lost sight of these peculiar customers. But this momentary good fortune, coupled with much hard work, enabled my informant to purchase a cab and another horse. At this point of his career he considered himself at liberty to indulge in the luxury of a wife, of whom he spoke in terms of high respect and affection. His horses were also the subject of his praise, and he sensibly boasted that they had always been serviceable hacks, and "never above their work." "There are among the London cab-horses," he continued, "some

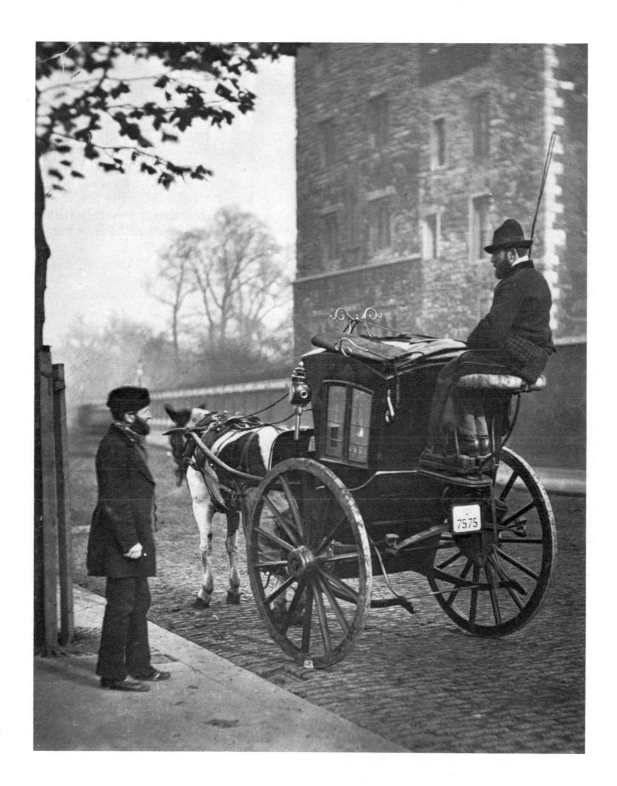

London Cabmen

animals with the bluest blood of the turf in their veins. Horses that have won piles of money for their heartless owners, and when useless as racers they have been sold for an old song. Some of these thoroughbreds are quiet, free, and useful ; others, like broken-down gentlemen, have squandered their strength on the turf."

Altogether there are 4142 Hansom cabs, and 4120 Clarence, or four-wheel cabs, in London. These are managed by 10,474 drivers, and the honesty of these men is best proved by the fact that whereas 1912 articles forgotten in the cabs were given up to the Lost Property Office in 1869 ; this number had increased in 1875 to 15,584. On the other hand, it will be said that if we may hope to recover a forgotten parcel, there is but little chance of escape from overcharge in the matter of the fare. This is undoubtedly true ; but at the same time, the public are generally unaware that the cab-driver is not exclusively responsible for these extortions. In this matter the proprietors are more to blame, for they demand so high a rate of payment for the hire of their cabs, that the drivers could never make a livelihood out of the legal fare. The charge for one Hansom and two horses per day varies from 10s. to 12s. in the dull season ; but there are no less than eight " rises " in the course of the year. The first is in November, when the Law Courts open, and then an extra shilling is charged ; a further rise of a shilling ensues during the Cattle Show week ; then there is a lull till the opening of Parliament, when a third shilling is added to the price. Last Christmas-day the cab-drivers were compelled to pay 4s. extra for the hire of their cabs, but on Boxing-day the proprietors prudently refrain from any such demand. The effects of the season are calculated to influence the drivers, and many would doubtless be glad to profit by any dispute as an opportunity of taking a holiday on Boxing-day. Besides, the occasion is not very advantageous, as the majority of customers are drunken men, who may give much trouble, damage the cab, and from whom no redress is possible.

From the meeting of Parliament up to the Derby-day the price of cabs steadily increases ; and, on the race-day itself, proprietors generally demand £1 15s. to £2 before they allow one of their cabs to go to Epsom. The driver, it is known, generally asks £3 3s. for the trip, and many have been the complaints respecting this apparently exorbitant charge ; but when we remember that the driver is compelled to hand over about two-thirds of the sum to the cab-owner, and has also to spend eight to ten shillings on the road, it will be admitted that his profits are not unreasonable. There is but one cabman known to have kept for several years a detailed account of every fare he has taken. He enters in his book where his customers are found,—whether at a railway station, in the street, or while waiting at a cab-stand,—the amount actually received, and what was the legal fare he should have charged. Armed with these statistics, he is able to prove that, according to his experience, the sums given by the public are every year nearer to the legal fare. At the same time he is also able to prove that his income corresponds almost precisely with what he obtains over and above his fare ; and that, therefore, the sums to which he is legally entitled only suffice to pay for the hire of horse and cab, and would leave him nothing to live upon. The increased astuteness of the public, and their determination not to give much more than the fare, have reduced this cab-driver's income from an average of £2 per week to only thirty shillings.

A cabman's income is subject to numerous fluctuations. The months of October and September are the worst in the whole year ; and, but for the presence of innumerable visitors from the Provinces and from America, many cab-drivers would have to abandon business altogether during this season. Nor are visitors the best of customers : they seem to shrink from employing cabs except on very special occasions. The " young men about town " are infinitely preferred ; and those who

are just one step below what a cab-driver described as "the cream of society." If these gentlemen have no horses of their own, they console themselves by resorting on every possible occasion to the friendly expedient of the Hansom. Then again, fares of this description do not often take the driver far from profitable neighbourhoods. The last and present year have, however, been exceptionally unfavourable, and many small proprietors were compelled to sell their horses and abandon business. Perhaps this accounts for the decrease in the number of fatal accidents; for there were only 87 persons killed in the streets during the year 1875, while the average for the previous six years amounted to 123 violent deaths. On the other hand, there was an increase of 136 more persons maimed and injured than during the previous year, the total being 2704; but it would be unfair to blame the cabmen for this long list of casualties. The light carts, used for the most part by tradesmen, are responsible for the largest proportion of these accidents. Cab-drivers, who depend for their livelihood on their skill in manipulating the ribbons, are naturally more careful, and have more to lose should they injure an unwary pedestrian.

The best season on record was that of the Exhibition of 1851. Notwithstanding the numerous events, the many attractive "sensations" that have occurred since then, cab-drivers have never again been in such urgent request and gathered so good an harvest. Nearly all the present cab proprietors trace their fortunes to this auspicious date. Many of them were mere cab-drivers, or at best but small proprietors, when the first great exhibition was opened; and the money they made at that time enabled them to start on a larger scale. So many people had, however, visited London during the Exhibition, and so much money had been spent, that a reaction naturally ensued, and for the two following years cabmen's fares were scarce and meagre. Those only who were not too elated by the golden receipts of 1851, and were able to weather the storm by dint of economy and work, became the great proprietors of the present day. These are not, it is true, very numerous. It was estimated in 1874 that there were not more than fifty cab proprietors in London who possessed more than twenty cabs each. As a rule, three or four proprietors group together and occupy one mews: each man possessing four or five cabs. The two largest cab proprietors in London are, I believe, Mr. Thomas Gunn, of Doughty Mews, Russell Square, and Mr. Tilling, of Peckham. Westminster is often stated to be the chief haven of London cabmen, though till recently the quarter could only boast of two proprietors who possessed more than twenty cabs each. Two large owners have now, however, moved to this quarter from Islington. In any case, whatever may be the number of cab-owners in this locality, it is to the cab-drivers of Westminster and Chelsea that the honour is due of having initiated a reform movement.

After many private discussions, the Cab-drivers' Society was formed at a meeting held in Pimlico in April, 1874. The Eleusis Club, King's Road, Chelsea, lent its hall to these pioneer organizers, and a most successful public meeting was held, which enabled the drivers to air their grievances for the first time. By the end of the year the Society comprised two branches, 158 members, and boasted of a capital amounting to £48 9s. 5½d. A year later this Society had already become a formidable association. In December, 1875, it numbered thirteen branches, had enrolled 1658 members, and possessed funds amounting to nearly £800. It had been represented and heartily welcomed at the great parliament of labour, the Trades' Union Congress, and is now strong enough to espouse the cause of any cab-driver who is unfairly treated by his employer. In this sense some good has already been achieved by the Society, but I must reserve further details concerning the men engaged in this familiar phase of street labour for a future chapter. A. S.

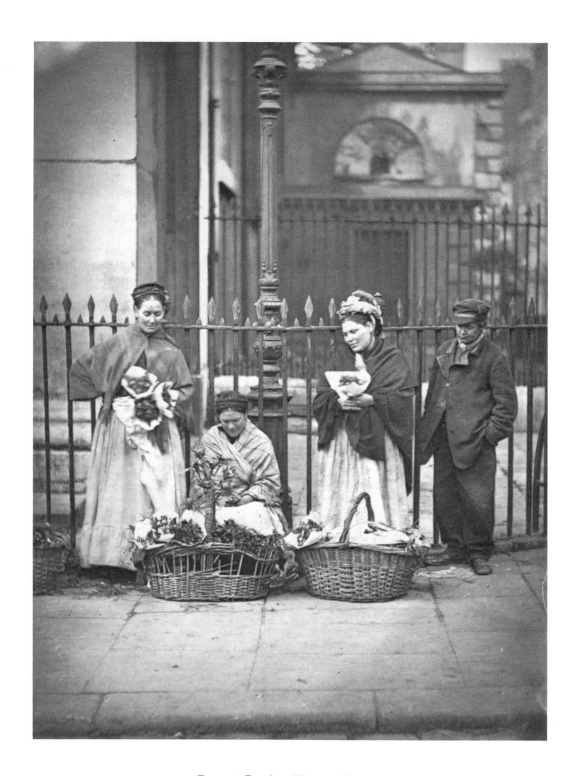

Covent Garden Flower Women

COVENT GARDEN FLOWER WOMEN.

THE metropolis of the vegetable world has class divisions of its own, and a special population depending for their livelihood on the business here transacted. By the side of the wealthy salesmen and wholesale purveyors of fruit, green stuff, and flowers, there are innumerable hangers-on, parasites of the flower world, who seek to pick up the few crumbs that must incidentally fall from the loaded boards and counters where so much is bought and sold.

Where nature, as Charles Kenney puts it, "empties forth her teeming lap filled with the choicest of produce," the poor may well hope to find some small assistance. Indeed, there seems to be something inexpressibly touching in the tendency of the poor to fall back on nature's gifts when reduced to the last extremity. The familiar sight of a poor woman holding a pale child in her arms and offering modest violets to the pedestrian, is pregnant with a poetry which rags and dirt fail to obliterate. In exchange for nature's gifts, she seems to challenge human compassion; and shall the heart of man remain cold where the produce of field and garden are so bounteous and beautiful? Unfortunately, with the spread of civilization, nature seems to lose its hold, and artifice gains on almost every sphere of human endeavour. The fruits, which the earth gives gratuitously, have been converted into the property of a privileged few; and the pauperized street vendor must bargain and haggle before she can obtain the refuse flowers disdained by fashionable dealers. Even such simple flowers as the primrose and violet are now governed by the inexorable and iron laws of supply and demand. They are sold by auction and by contract; the poor, as is customary in trade, paying in proportion a higher price for the worst goods. Nor is this all, the pure and most delicate flowers fade and bow their heads, as if with shame, in the unwholesome atmosphere of ball-room and theatre. To support such an ordeal, they must be drilled and trained, pierced and propped up with cruel wires, and made to look as stiff and unbending as the world of artifice they are called upon to adorn. How different is the Covent Garden of to-day, with its bustle and din, its wealth and pauperism, its artifices, its hot-house flowers and forced fruit, its camelias with wire stems, its exotics from far-off climes, to "the fair-spreading pastures," measuring, according to the old chronicle, some seven acres in extent, where the Abbots of Westminster buried those who died in their convent. In those days vegetables were not only sold here but grew on the spot; and the land, now so valuable, was considered to be worth an annual income of £6 6s. 8d., when given by the Crown to John Russell, Earl of Bedford, in 1552.

Many an interesting story is attached to this celebrated spot, honoured by the daily presence and preference of some of the brightest lights of genius England has ever produced; but it is not my purpose to trace the history of the market. I have to deal rather with the group of women who may be seen daily standing by those ugly Tuscan pillars which Inigo Jones designed to ornament the church of St. Paul. Fire, it is true, destroyed the building in 1795, but the design unfortunately remained,

and it was rebuilt after the old model. The flower-women seem to follow a somewhat similar policy. When death takes one of the group away, a child has generally been reared to follow in her parents' footsteps; and the "beat" in front of the church is not merely the property of its present owners, it has been inherited from previous generations of flower-women. Now and then a stranger makes her appearance, probably during the most profitable season, but as a rule the same women may be seen standing on the spot from year's end to year's end, and the personages of the photograph are well known to nearly all who are connected with the market. By the side of the flower-women may be noted a familiar character, of whom it may truly be said "the tailor makes the man:" for this individual is named not after his family but after his clothes. "Corduroy" generally refused to give his real name, and at last it was conjectured that some mystery overhung his birth. I have, however, only been able to ascertain that he worked for many years in the brickfields; and, on his health giving way, came to the market in search of any little "job" that might bring him a few pence. In the early morning he stood and watched over the costermongers' barrows, while they attended the sales; in the day-time he was assiduous in opening carriage doors, and gallantly held out his arm to prevent ladies' dresses brushing the wheels; while the evening found him loitering about in the vicinity of public-houses, always in quest of a "treat" or of "pence." He is now, however, missing; and, as he suffered severely from asthma, it is supposed that he has sought shelter from the inclement weather in the workhouse infirmary.

His friends and associates, the flower-women, are also greatly dependent on the weather, for it not only influences the price of the flowers, but the wet reduces the number of loiterers who are their best customers. Their income therefore varies considerably according to the season. In the summer months, more than a pound net profits have been cleared in a week; but in bad weather these women have often returned home with less than a shilling as the result of twelve hours exposure to the rain. They arrive at the market before the break of day, and are still faithful to their post late in the afternoon. Those who have children teach them to take their places during the less busy hours, and thus obtain a little relaxation; but at best the life is a hard one, which is the more painful as the women are generally entirely dependent on their own exertion for their existence. The flower vendor, for instance, standing beside "Corduroy," has to provide not only for herself, but for an invalid husband, who, when at his best, can only help her to prepare the nosegays and button flowers. She boasts, however, that in this art he excels all competitors, and certainly we have noticed many customers give preference to her flowers. Her son brings his share of grist to the mill by earning pence as an "independent boot-black;" but how different is the position of this woman to that of Isabelle, the favourite flower-girl of the Paris Jockey Club. Complimented by almost all the crowned heads of Europe, in receipt of £400 a year from the Jockey Club, living in a most luxurious apartment, endowed with a fine collection of diamonds, besporting herself in a neat little brougham, this notorious Parisian flower-girl cannot be compared, morally speaking, with the rough and simple woman whose portrait is before the reader. Notwithstanding her ample income, it is well known that Isabelle refused to give £30 a year to save her mother from starvation; and her meanness caused so great a scandal, that the Jockey Club withdrew its patronage from her, and the popular favourite fell into merited disgrace. The flower-women of Covent Garden are not gifted with the artistic instinct and coquettish charms of Isabelle, but warmer hearts beat beneath their hoddin-grey than ever stirred the black and yellow satin of the Jockey Club.

<div align="right">A. S.</div>

RECRUITING SERGEANTS AT WESTMINSTER.

ITH rumours of war still disturbing the political atmosphere of Europe, and menacing to involve even England in the general conflagration, the question of recruiting troops for our army must of necessity again claim its share of public attention. That the system actually in force is radically wrong, few will attempt to deny; not that there is so much difficulty in obtaining recruits, but how are we to keep them in the ranks when once they have joined? Our soldiers, it appears, run away at the rate of more than twenty-one a day; and there were no less than 7759 deserters last year. Nor is this all; we should add the number discharged as bad characters, which seems to be increasing, for there were 1616 men thus expelled from the army in 1870, and as many as 2025 in 1873; while the average number of men in prison in 1870 amounted to 1288; and this figure rose to 1914 in 1872, and fell to 1554 in 1873. Finally, we should not omit cases of sickness, for we find that in 1872, out of an average strength of 92,218 men, the average number constantly in the hospital was 3628. Altogether, therefore, it will be seen that the recruiting sergeants, notwithstanding the remarkable success that attends their efforts, cannot unaided supply us with a good army. Indeed it must be wounding to whatever sense of honour they may possess, to find that so great a proportion of the recruits they bring to the ranks ultimately regret that they ever yielded to the sergeant's advice. These dissatisfied soldiers might of course have known that the recruiting sergeants were in business bound to present a roseate view of military life, and that the fault to be found with the army would not be disclosed by those who are so eminently interested in enlisting all who are capable of serving in its ranks. At the same time, it is only just to add that the degrading, immoral, and disreputable stratagems which rendered recruiting sergeants obnoxious to our forefathers are now entirely abandoned. Morally speaking, the modern recruiting sergeant would stand on the same level as the ordinary tradesman or business man, who seeks to sell a second-rate or questionable article, by carefully hiding its flaws, and exposing in the very best light whatever small merit it may possess. But the recruit enjoys at least the advantage of ninety-six hours to reflect, and, if he chooses, he can then withdraw from his bargain, on paying a comparatively small sum as " smart money."

Recruiting in London is almost exclusively circumscribed to the district stretching between the St. George's Barracks, Trafalgar Square, and Westminster Abbey. Throughout London it is known that all information concerning service in the army can be obtained in this quarter, and intending recruits troop down to this neighbourhood in shoals, converging, as the culminating point of their peregrinations, towards the celebrated public-house at the corner of King Street and Bridge Street. It is under the inappropriate and pacific sign-board of the " Mitre and Dove " that veteran men of war meet and cajole young aspirants to military honours. Here may be seen every day representatives of our picked regiments. No modest lines-man is allowed

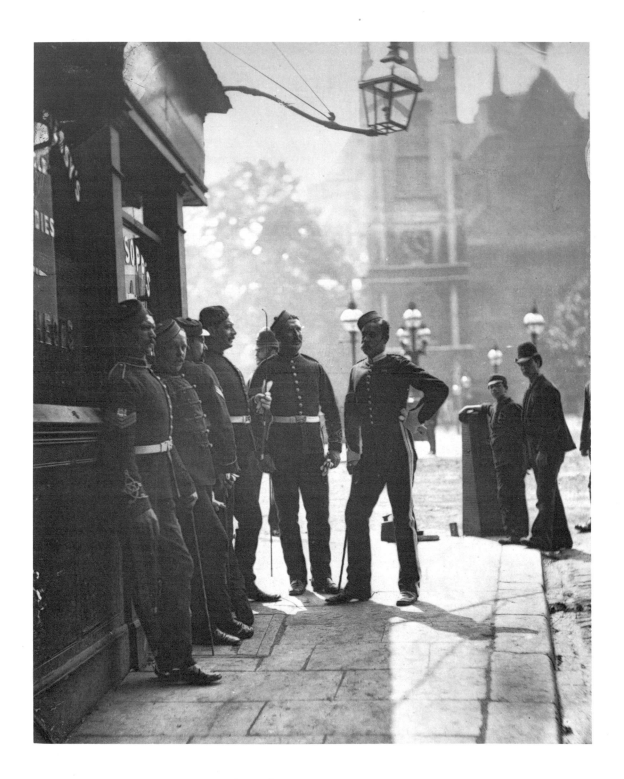

Recruiting Sergeants at Westminster

on this beat; and, though nearly all the recruiting is for the infantry, the sergeants themselves belong to the cavalry—excepting, albeit, a few marines. These men are all well-known characters, and for the most part have been on this spot for many years. For instance, the most prominent figure in the accompanying photograph, standing with his back to the Abbey, and nearest to the kerb stone, is that of Sergeant Ison, who is always looked upon with more than ordinary curiosity as the representative of the 6th Dragoon Guards, or Carbineers—a regiment which of late has been chiefly distinguished for having included in its ranks no less a person than Sir Roger Tichborne himself! To the Carbineer's right we have the representatives of two heavy regiments, Sergeant Titswell, of the 5th Dragoon Guards, and Sergeant Badcock, of the 2nd Dragoons, or Scots Greys; the latter is leaning against the corner of the public-house. Close to him may be recognized the features of Sergeant Bilton, of the Royal Engineers, while Sergeant Minett, of the 14th Hussars, turns his head towards Sergeant McGilney, of the 6th Dragoons, or Enniskillen, whose stalwart frame occupies the foreground. This group would not, however, have been complete without giving a glimpse at Mr. Cox, the policeman, to whose discretion and pacific interference may be attributed the order which is generally preserved even under the most trying circumstances at the "Mitre and Dove." The boot-black is also well known to the neighbourhood, and he has doubtless occasionally helped with brush and blacking to enhance the spruce appearance of Her Majesty's troops.

The amount of work done by the sergeants who loiter about at this corner may best be estimated by the fact that 3605 approved recruits were enlisted from the London district in 1875, and I need scarcely remark that the greater number of these men accepted the fatal shilling at the hospitable bar of the "Mitre and Dove." Henry Cooper, one of the best known and most successful recruiting sergeants, enlisted at this corner during the course of thirteen years upwards of 3000 men; and is generally supposed to have retired with a large fortune. I hear, however, and on good testimony, that this latter detail is altogether erroneous, and that, notwithstanding his prolonged and devoted services, Sergeant Cooper was obliged to resort to the vulgar expedient of a loan on leaving his corps. This last version has at least the advantage of according with the general characteristics of the English army, and harmonizes with that spirit of ungrateful neglect which allows Waterloo heroes to die in the workhouse.

Recruiting sergeants have the credit of making large incomes, but insufficient account is taken of the expenses they are forced to incur. They receive a guinea for every man they enlist, and who, after the doctor's examination, is accepted as fit for service. This sum, however, must cover all expenses, and includes the shilling given to the recruit on his volunteering to join. But it often happens that men accept the shilling and are never heard of again. The sergeants have no right to retain them. The recruit may go immediately to the barracks if he chooses, but he can rejoin his friends if he prefers, and need only appear the next morning for the doctor's examination. Thieves and other dishonest characters consequently profit by this opportunity to obtain a shilling, which, of course, is never refunded to the deluded sergeant. A shilling is also lost every time a man is enlisted, and subsequently condemned by the doctor as unfit for service; it therefore frequently happens that men who possess some constitutional weakness constantly attempt to enlist, with a view to the shilling, relying at the same time on being discharged by the doctor. Hence the traditional shilling is a source of constant trouble and loss to the recruiting sergeants. There are also a number of men who are known as " bringers," because they make it their business to persuade men to enlist, and when in a ripe frame of mind bring them

to the recruiting sergeants. The "bringer" then expects to share the profits, and the sergeant must hand him over 10s. out of his £1 commission. But it may ultimately be discovered that the recruit had already enlisted in another regiment; and the "bringer" having by that time disappeared, the recruiting sergeant loses the ten shillings he had given him, plus the shilling with which he pledged the false recruit, and the money and time expended in drink to celebrate this unfortunate stroke of business.

Sergeant Burgess, of the 1st Royal Dragoons, who has succeeded to the post and popularity of Sergeant Cooper, to whom I have already alluded, related to me an amusing anecdote of this description. A corporal of the Guards once brought him a recruit, and consequently received ten shillings. The recruit, however, deserted, and Sergeant Burgess demanded that his money should be restored ; but the corporal was in difficulties, his wife was ill, and finally his regiment left town before he had been able to refund the ten shillings. On the other hand the deserter was ultimately traced ; he had enlisted again and was with a regiment at Athlone. Thereupon Sergeant Burgess was despatched to Ireland to identify the deserter. This trip cost the government £2 18s. travelling expenses ; and Sergeant Burgess lost fourteen days, during which time he was unable, of course, to recruit a single individual ; and was further out of pocket £5 spent *en route*, and in fraternizing with the Irish garrison.

But misfortunes of this description are not the sole cause of loss and outlay. There is no suitable barrack accommodation for the London recruiting sergeants, and 3s. 6d. "lodger money" is therefore allowed per week. This is supposed to compensate for the room, fuel, and light which should be given in the barracks. It is, however, difficult to get a suitable room in London under seven shillings per week, and three shillings is but a low estimate for coals and light. Besides this outlay, recruiting sergeants have to be better dressed, and wear out their clothes more rapidly than if they were in ordinary service ; yet they have only one pair of boots, and of gloves, and one tunic allowed them per annum, the authorities stretching a point, and giving three pairs of trousers for every two years. As a natural result, the sergeants have to buy the greater part of their clothes, and this at no trifling expense. A good cap, for instance, costs £1 1s., and when exposed day after day without respite to the smoke, dirt, and rain of London, this important appanage to the uniform does not last longer than a year. The recruiting sergeants have, therefore, like every other branch of the service, a formidable list of grievances, and consider themselves far removed from the enjoyment of that good fortune which is generally attributed to them.

Will the day never dawn when some patriotic reformer shall sweep away these grievances, throw the army open to all, render its rewards accessible to sterling merit alone, without regard for wealth, position, or family influence, so that the humblest English recruit may, like the soldiers of the Continent, hope to "carry a marshal's baton in his knapsack." If this could ever be accomplished ; if it were possible to uproot the divisions of caste or class which destroy the harmony of our national defence, and render it as fashionable a distinction to be an officer as it is disreputable to be a common soldier, and if soldiers were not merely allowed on rare occasions to rise from the ranks, but all officers selected exclusively from those who had first served in the lowest grade—then the army would be ennobled from the poorest drummer-boy to the proudest marshal,— thousands of superior, brave, and steady men would throng unbidden to swell its numbers, and we should no longer need recruiting sergeants to cajole simple-minded and ignorant youths amid the intoxicating fumes that are the incense of the "Mitre and Dove."

<div align="right">A. S.</div>

STREET FLOODS IN LAMBETH.

THE sufferings of the poor in Lambeth, and in other quarters of the Metropolis, caused by the annual tidal overflow of the Thames, have been so graphically described as thoroughly to arouse public sympathy. The prompt efforts of the clergy and the relief committees in distributing the funds and supplies placed at their disposal, have done much to allay the misery of the flooded-out districts. Feelings of apprehension and dread again and again rose with the tides, and subsided with the muddy waters as they found their way back into the old channel or sank through the soil. The public have settled down with a sense of relief, and the suffering people returned to rekindle their extinguished fires and clear away the mud and *débris* from their houses; to reconstruct their wrecked furniture, dry their clothes and bedding, and live on as best they may under this new phase of nineteenth century civilization.

Meanwhile the Metropolitan authorities, lulled to a sense of temporary security, have adopted no satisfactory measures to prevent the recurrence of similar disasters. A dangerous experiment is being tried with the health of the community at a time when epidemic disease is only held in check by the most vigilent efforts of modern science. It would be difficult to conceive conditions more favourable to the growth of disease than those at present existing in the low-lying, densely populous quarters of Lambeth, that have been invaded by the floods.

In China, the people get used to floods, simply because they know that river embankments are costly, and not likely to be erected. The Chinese, some of them, construct their houses to meet emergencies. I have heard a Chinaman boast that a mud cabin was the fittest abode for man. In case of flood it settles down over the furniture, keeps it together, and forms a mound upon which the family may sit and fish until the flood abates. When the waters have subsided, the owner, with his own hands, erects his house anew, and calmly awaits the advent of another flood. In Lambeth the conditions—at present at least—are altogether different. There are no mud huts and no wholesome fish in the waters of the Thames. Nor when the waters recede are the conditions so favourable to the maintenance of health. The high tides have left a trail of misery behind, and in thousands of low-lying tenements, a damp, noxious, fever-breeding atmosphere.

A few hours spent among the sufferers in the most exposed neighbourhoods will convince any one that the danger is not yet over; that disease may still play sad havoc among the people. The effects of disasters are still pressing heavily upon a hard-working, under-fed section of the community. Rheumatism, bronchitis, conjestion of the lungs, and fever have paralyzed the energy of many of the bread-winners of the families of the poor. I, myself, have listened to tales of bitter distress from the lips of men and women who shrink from receiving charity.

The localities in Lambeth most affected were Nine Elms, Southampton Street, East and West, Wandsworth Road, Hamilton Street, Portland Street, Fountain

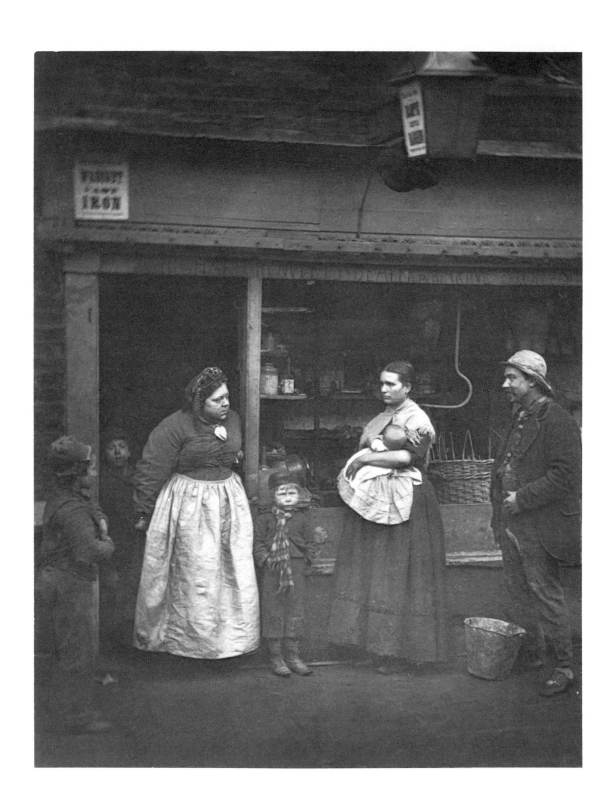

Street Floods in Lambeth

Street, Conro Street, Belmore Street, High Street, Vauxhall; Broad Street, William Street, Belvidere Road, Belvidere Crescent, Vine Street, Bond Street, Duke Street, Prince's Street, Broadwall Street, Stamford Street, Prince's Square, and Nine Elms Lane.

Although the distress was not confined to any particular class, the majority of the sufferers are poor, and their misery was greatly intensified by the loss of furniture and bedding. Heavy losses were also incurred by the higher classes of working men; such, for example, as had invested their savings to purchase their houses through Building Societies. The structural damage done had to be repaired, thus throwing an additional burden of debt upon the prospective owners of small properties.

In such neighbourhoods as Broadwall Street, houses containing four apartments are let at weekly rentals varying from seven shillings and sixpence to ten shillings. These houses are, many of them, let to the men employed in neighbouring works, and to labourers engaged about the wharves and warehouses on the south of the Thames. They are again sublet, so that two or three families frequently shelter under one roof. Each family occupies one or two rooms at a weekly rental ranging from half-a-crown to five shillings.

In one room I found a young married couple and their baby tended by an aged female relative. The husband is a labourer, but the floods had thrown him out of work, and, do what he would, he could only manage to earn about two days' wages during the week. The mother-in-law, a sempstress, had contributed to their support, the rent had fallen into arrear, but the landlady had kindly agreed to receive it in instalments of a shilling, or two shillings, at a time until the husband had secured permanent employment. I was much struck with the bright, cheerful appearance of the comely young wife, and the success of her efforts to maintain a clean, comfortable, and attractive home to cheer her husband on his return after his wanderings in search of work. "If my lad," she said, " could only get something to do, steady-like, we would be happy enough, but this want of work is hard on us, and like to break down a good man!"

In woeful contrast to this interior was another, a few paces further on, occupied by a widow, her son, and daughter. In no land, savage or civilized, have I seen a human abode less attractive and more filthy. The mother, who goes out "charing," had seemingly neither the time nor the opportunity to render her apartment habitable. It was at her own invitation I followed her, as she said she had something to say to me. At a loss to conjecture what her communication might be, I made my way along a dark passage to a small doorway, and stepping over an accumulation of turnip-tops and mingled garbage, entered a room measuring about eight feet by ten feet. The walls were begrimed by smoke, and such portions of the floor as were seen were black and damp. The tidal overflow had registered its rise by partially cleansing the walls to a height of four feet, and by leaving the paper hanging in mouldy bags around. In one corner stood the remains of six sacks of coal and coke, "the gift of the good gentleman." On a dark unwholesome bed lay a heap of ragged coverings, bestrewn with some articles of tawdry finery, and on one corner sat a little girl, whose bright dark eyes shone through a mass of matted hair. A broken chair was propped against the wall, near a chest of drawers warped and wasted by the water. The fire burned with a depressing glimmer, as fitful gusts of foul air found their way through a heap of ashes on the hearth: over the mantelpiece hung a series of small photographs, making up the collection of family portraits of husband and children who had passed away.

"I am sick of it all," said the woman. " I wish I were out of it, done with it, God knows! Look at me, sir. Do you see that bruise on my face? My daughter

struck me down with her fist this morning, because I would not let her sell the clothes off my back. She wont work; she lives upon me. She had been out all night last night, and came home this morning like a mad woman, and I have driven her from my door!" She came home! I involuntarily glanced round the home of this unfortunate outcast, but saving the pictures, and the bits of cheap finery, there was nothing there to woo her back from the streets. The widow went on to say that she had some comfort in her son, who makes good wages in a mason's yard. "I live for my boy and he lives for me, but since the floods he has been troubled by a hacking cough; I don't like to hear it, and it don't leave him, sir. As for myself, I have never felt right since that awful night, when with my little girl I sat above the water on my bed until the tide went down."

The reader will understand why I have brought him face to face with a group of the people who suffered from the Lambeth floods, in preference to photographing a street under water.

It is with the people and their surroundings that I have chosen to deal, in order to show that the floods have inflicted a permanent injury upon them, and that a succession of such disasters may at last affect the health of the metropolis at large.

The group was taken by special permission in front of the rag store of Mr. Rowlett. The Rowletts have occupied the house for twenty-seven years, but it is only in recent times that the water has invaded their premises. The family may be described as prosperous, at least they were prosperous, but the losses caused by the inundations and the failing health of Mr. Rowlett—who is now a confirmed invalid—have narrowed their means. In Mrs. Rowlett's own words, "The water has taken us down a bit, and the last midnight flood was too much for my old man. He has now severe congestion of the lungs. Had it not been for the shop-boy, our losses would have almost been beyond repair. The boy was on the watch, and in time to enable us to save a few things: he appeared below the window, shouting, 'The tide! the tide!!' We knew what that meant and saved all we could. Our heaviest loss was made four years ago. It was so heavy we had to part with our horse and van to keep things going. Our goods, rags, and waste-paper were soaked, and we sold tons for manure. We have never been able to recover our losses. Since the embankment was built, part of our business has gone down the water with the wharves. The 'beach pickers' don't pick up so much old iron and things now. At first I was too proud to take help, but now I am fain to get a little assistance when I can. As they say, the water might be stopped if the Government would only do it. You see the water don't come into the drawing-rooms of fine folks. We would hear more of it if it did. It's never been into the Parliament Houses yet, sir, has it?" I assured the good woman that it had not, but that the question of the floods would be in the House before long, and that something would probably be done.

"We saved our piano you see," continued Mrs. Rowlett, "it's what I prize most, next to my daughter who plays it. I had her taught by times, as I could spare the money. We have nothing to leave our children, but they got a good education, so my girl if she needs to work can teach music. I bought the piano as poor folks buy most things, by paying a few shillings or a few pence at a time to dealers who supply every thing." Our conversation was interrupted by the entrance of a pretty, poorly-clad little girl, who said, "Mrs. Rowlett, mother sent me to pay the twopence for the boots, and I was to ask if you had another tidy pair of stockings for Nell." "No, darling, I have not, but I will keep a look out for a pair." Mrs. Rowlett explained that the girl was one of a large family, and that the twopence was payment for a pair of boots and a pair of stockings she had picked out of a heap of rags and paper.

The woman in the centre of the group with the child in her arms, occupies with her husband and children an adjoining house. They are country folks tempted into the town by the hope of higher wages. The husband is a horse-keeper, whose working hours are from four o'clock in the morning to eight o'clock at night, and on Sundays from six in the morning to six at night, with two or three hours intermission when the horses do not want tending. His wages are twenty-five shillings weekly. Part of their house is sublet to another family. The woman is a skilled lace-maker. She used to work at home with her pillow, pins, and bobbins, but being unable to find a market in the neighbourhood for her fine wares, she has discontinued working. She made very beautiful black silk broad lace at two shillings or half-a-crown a yard. In spite of foul exhalations, mouldy corners, and water-stained walls, the house in which these people lived was clean, comfortable, and attractive. But the family had not escaped colds and rheumatism. The woman complained of a constant cough, and severe pains in her chest and between the shoulders; while one of the children looked sickly and as if it would hardly survive to witness the probable floods of 1878.

On the right of the photograph is a character of an interesting type. A sort of odd-handy man. Jack Smith is well known in the neighbourhood as a local comedian, whose tricks, contortions, and grimaces are the delight of many a pot-house audience. "Yes," said an admirer of Jack, "he's a rum'un, he is; he can do the 'born cripple,' or the man starved to death, or anything a'most, and the jury inquestin' his remains." During his working hours Jack Smith is called a "beach-picker," or "tide-waiter," or a mud-lark. His business takes him wading over the shallows of the Thames, where he picks up fragments of iron, coal, wood, and waste materials. For such miscellaneous wares he receives one shilling or two shillings per cwt. As I have already pointed out, this class of river industry has been partially paralyzed by the erection of the embankment and the removal of the old wharves.

During the recent overflows this "odd man" found many new and comparatively lucrative fields of labour. The water in Prince's Square, after submerging the ground floors of the houses, rose to a height of four feet in the rooms above. All this took place in defiance of the Herculean efforts of a band of men of Jack Smith's class, who were engaged to stop windows and doors with mud, clay, and pulp formed by the paper floated out of extensive printing-works in the neighbourhood. Some of the barricades resisted the pressure of the water, but many more gave way, and the tide rushed in with such force as to break down partition-walls, shatter furniture, and send iron boilers adrift from their brick-work. The "odd man's" hands were full, at one time carrying women and children to places of safety, at another baling out an area with his bucket, or cleansing an interior.

J. T.

PUBLIC DISINFECTORS.

HILE reducing the general death-rate, our recent sanitary legislation has called into existence a class of men who must of necessity be daily exposed to the gravest dangers. To the list of men who, by reason of their avocations, constantly face death to save us from peril, we must add the public disinfectors. These modest heroes are truly typical of our advanced civilization; and, as representing the humble rank and file of the army enrolled in the service of science and humanity, deserve as much credit as the bold archers who won the battle of Agincourt. Their devotion, however, would scarcely inspire the minstrel's song, it gives but little scope to romance, and the details of the work they perform are of the most prosaic description; yet it is an undoubted fact that these men daily risk their lives to save the community at large from epidemics. It would be difficult, it is true, to define the precise nature of this risk; though no one denies the infectious character of zymotic diseases. The germ or virus, whether vegetable or animal, will, it is known, retain all its fatal power, sometimes for months, if proper measures are not taken to destroy these seeds of infection. Fortunately, this could be effectively done if our sanitary laws were enforced in every case. The law stipulates that persons suffering from infectious disease must either be removed to the hospital or isolated in one room, and that the room shall in due time be properly disinfected. Many cases, however, are concealed from the authorities. The expense of disinfecting is thus avoided, but the public health is endangered. It is, therefore, essential to amend the Sanitary Act with a view to render concealment impossible in the future; and this end would be attained if every practitioner was compelled to report all cases of infectious disease coming under his care.

When the inspector of nuisances ascertains that small-pox or a fever has broken out within his district, he calls at the house in question to see that the provisions of the Sanitary Act are properly observed. A certain amount of skill and delicacy are, however, necessary in the execution of this task. This official is not always well received. He is sometimes met with a direct denial; and, as the law does not allow him to force an entrance, he is obliged to leave the house if the person who answers his knock declares there is no case of infectious disease within. When this occurs, the inspector must resort to some stratagem; he must question the neighbours or inveigle some indiscreet servant or child to disclose the truth. Generally the inspectors seek to discover who is the medical attendant at the suspected house, and will call and ascertain from him the real nature of the complaint. If his earlier suspicions are confirmed, and it proves to be some form of zymotic disease, the officer can then obtain a summons from the police magistrate, and the persons who sought to avoid the Sanitary Act are either fined or imprisoned.

Such resistance, however, can only be qualified as criminal folly, and with the spread of education and sanitary knowledge, the visits of the inspector will be courted rather than avoided. Indeed, I am informed that in London, at least, most persons

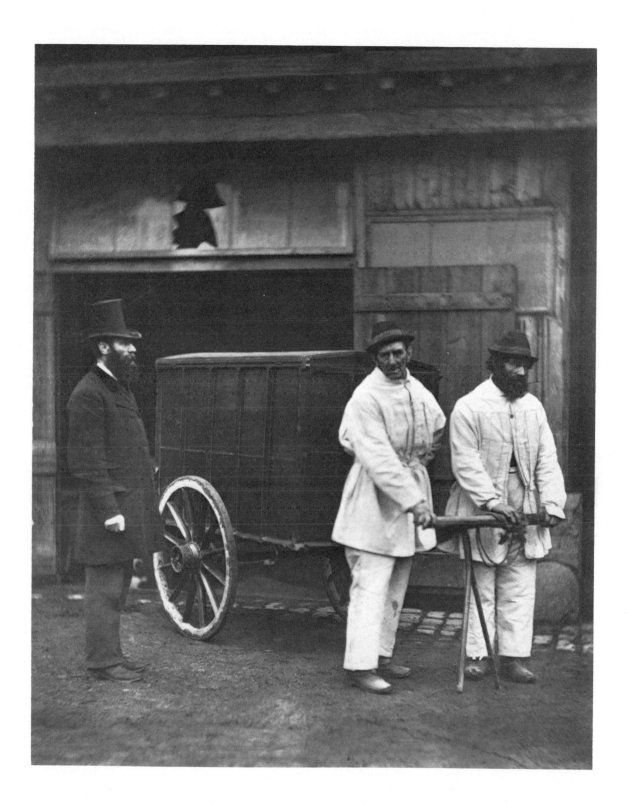

Public Disinfectors

are quite willing that their dwellings should be purified ; and the present prevalence of small-pox occasions much work of this description. Even the poorer and less educated classes are beginning to understand the importance of these sanitary precautions. As a rule, the inspector of nuisances is the first to visit the premises, and boldly entering the patient's room he takes a general survey so as to realize what must be done. If, as is often the case in poor quarters, the room is encumbered with rags and refuse, he will see that what is worthless is destroyed ; but the process of disinfection is only begun after the death or complete recovery of the patient. In either case, the room must be vacated, and the strictest injunctions are given to prevent any one entering. The clothes worn by the patient and his attendants are left in the room ; and then only the disinfectors make their appearance. These men generally wear a blouse and leggings to protect their ordinary clothes from the germs of disease which must of necessity fall upon them. Thus equipped, they proceed to their destination, dragging after them a capacious hand-cart, which is hermetically closed. There is something peculiar, not to say sinister, in the little group thus formed. To the excited imagination of a convalescent their appearance might evoke a sense of horror. The presence of men who are ever engaged clearing out fever dens, and are constantly handling the bed-clothes belonging to persons who have suffered from the most repulsive, contagious, and dangerous complaints, is certainly calculated to produce a painful impression on a debilitated mind ; though, to those whose reason is not impaired by sickness or prejudice, these considerations should, on the contrary, enhance their admiration for the devotion and courage so unhesitatingly displayed. Nor is this the disinfectors' only claim to our sympathy ; they are men whose honesty is frequently exposed to temptation, and against whom I, at least, have never heard the slightest complaint. They alike disinfect the houses of the poor and the rich ; one day destroying the rubbish in a rag merchant's shop, and the next handling the delicate damask and superfine linen which shade and cover the bed in some Belgravian mansion. Once in the sick-room, no prying eyes are allowed to watch the disinfectors at work. They have strict orders to exclude every one from their dangerous presence. Alone and unseen, they remove, one by one, all the clothes, bedding, carpets, curtains, in fact all textile materials they can find in the room, carefully place them in the hand-cart, and drag them off to the disinfecting-oven. This is, of course, a dangerous operation, as the dust it occasions, and which falls on the men, or is inhaled by them, must be loaded with the zymotic particles that engender epidemics. Few persons care to be present on these occasions ; and, but for their own honesty of purpose, the disinfectors might often make away with various objects which in all probability would not at first be missed. The men chosen for this work are therefore carefully selected, and have generally been known for many years to the Vestries by whom they are appointed.

The accompanying photograph has been taken in the yard adjoining the Vestry Hall, close by Ebury Bridge, and the familiar countenance of Mr. Dickson, the Inspector of Nuisances for the Parish or Union of St. George's, Hanover Square, will be readily recognized by all who are well acquainted with this district. The group is gathered in front of the out-house where the disinfecting-oven is situated. This is simply an oblong iron box, which can be heated by a gas apparatus, till the atmosphere within reaches 280 degrees. This intense dry heat cannot spoil the materials placed inside, and has been proved, by innumerable experiments, to be the surest method of killing the germs of zymotic disease. Boiling for about twenty minutes would be equally effective, but we cannot boil furniture. Unless some such method is adopted, the microzymes may live for an indefinite period ; indeed, the germs of scarlet fever can live in woollen materials for several years. Mrs. C. M. Buckton mentions in her

popular Lectures on the Laws of Health a case of a child who died of this fever. Her favourite doll was put away in a woollen dress. Three or four years later, a cousin came to pay a visit at the house, and the mother, to amuse the little girl, brought out the doll, which had not been touched since her own child's death. A week had, however, hardly elapsed since this incident, when the little visitor was in her turn seized with the scarlet fever. The doll evidently should have been disinfected, even at the risk of destroying the symmetry of its waxen features.

When all the bedding, clothes, &c., have been brought to the Vestry yard, they are placed in the disinfecting-oven, the disinfectors taking care to add their own "over-alls," so that they also may benefit by the process. A certain amount of sulphur is burnt within the hand-cart, so that the purified objects may be replaced therein and taken back without danger of being again contaminated. In the meanwhile, the person to whom these objects belong is politely informed that they will not be returned before the inspector has ascertained that the room from which they have been taken has been thoroughly disinfected; and this is done by the parish disinfectors if the person in question cannot afford to pay an ordinary builder to do it for him. The process of disinfection consists of pasting paper over the fireplace, and along the chinks of the doors and windows, so as to render the room air-tight. A large quantity of sulphur is then ignited, and the fumes allowed to permeate the room for some twenty-four hours; but unless these fumes are sufficiently powerful to kill a human being, it is not likely that they will destroy the zymotic germs. When this is terminated, we may venture to enter the room with some sense of security, but the fumigating is not considered sufficient. Every particle of paper must now be ripped from the walls, and burnt; then the whole room is carefully washed with carbolic acid, the walls re-papered, and the ceiling whitewashed; and it is only when all this has been satisfactorily done that the objects taken to the disinfecting-oven are returned. The process, it will be seen, is an elaborate one, but the perfect purification of the patient's room is well worth the trouble; and the efficacy of this system is best proved by the fact that a small-pox hospital was recently disinfected in this manner, and then converted into an asylum for aged or infirm paupers. The disinfection of the hospital, however, had been so effective, that not a single case of small-pox occurred among its new inmates. At the same time I cannot help observing that all who are engaged in this work might be a little more prudent with regard to their own persons. The "over-alls" worn by the men are certainly some protection, but their hair, beards, and caps are well suited to collect and convey the germs of disease to their homes. They should, therefore, be compelled to wash themselves with carbolic acid, or with a solution of potassium permanganate, when their day's work is over, and before they are allowed free intercourse with the public at large. The same ablutions might with equal reason be enforced on the sanitary inspectors, and they also should wear different clothes when off duty.

The disinfectors of St. George's, Hanover Square, were formerly " road men " in the employ of the Vestry, and deem their present work as a considerable improvement. They receive sixpence per hour for disinfecting houses or removing contaminating clothes and furniture, and these are such busy times that they often work twelve hours per day. Thus their income frequently exceeds thirty shillings per week, not to mention little gifts and perquisites which may occasionally fall into their hands. This, but for the personal risk incurred, is far more remunerative than their old avocation of mending the streets. Indeed, such is the irony of our civilization, that the men who labour in the free air to keep our roads in order, look up with envious eyes to their old fellow-workers who have been promoted to the dignity of disinfection. A. S.

STREET DOCTORS.

STREET vendors of pills, potions, and quack nostrums are not quite so numerous as they were in former days. The increasingly large number of free hospitals, where the poor may consult qualified physicians, the aid received at a trifling cost from clubs and friendly societies, and the spread of education, have all tended to sweep this class of street-folks from the thoroughfares of London. Although of late years much has been done by private charities to supplement the system of parochial relief, there is still a vast field open for the extension of medical missions among the lower orders of the community. Far from being in a position to record the extinction of the race of "herbalists" and "doctors for the million" who practise upon the poor, my investigations prove they are still about as numerous as their trade is lucrative.

It would be unjust to say that the itinerant empirics of the metropolis have advanced with the age, as it is part of their "rôle" to adhere to all that is old in the nomenclature and practice of their craft. An intelligent member of the fraternity informed me that as members of the medical profession, they are bound to use what may be called "crocus" Latin. "Our profession is known, sir, as 'crocussing,' and our dodges and decoctions as 'fakes' or rackets. Many other words make up a sort of dead language that protects us and the public from ignorant impostors. It don't do to juggle with drugs, leastwise to them that are ignorant of the business. I was told·by a chum of mine, a university man, that 'crocussing' is nigh as old as Adam, and that some of our best rackets were copied from 'Egypshin' tombs." I ventured to remark possibly they were inscribed on the tombs as a warning from the dead. "Like as not," was the rejoinder, " I expect the dead in this country could tell us summat about poisoning by Act of Parliament. Pardon me, sir, you may be a licensed surgeon yourself. But I would as soon swallow a brass knocker as some of your drugs. A brass knocker is a safe prescription for opening a door, it's poison as a pill. I believe it is just the same with the poisons took out of the bowels of the earth, where they should be left to correct disorders. Herbs are the thing, they were intended for man and they grow at his feet, for meat and medicine. You see, sir, I'm a bit of a philosopher; when I'm not 'pattering'— speaking—I'm thinking. I have been a cough tablet 'crocus' for nine years, only in summer I go for the Sarsaparilla 'fake.' Sometimes this is a regular 'take-down' —swindle. The 'Blood Purifier' is made up of a cheap herb called sassafras, burnt sugar, and water flavoured with a little pine-apple or pear juice. That's what's called sarsaparilla by some 'crocusses.' If it don't lengthen the life of the buyer it lengthens the life of the seller. It's about the same thing in the end. A very shady 'racket' is the India root for destroying all sorts of vermin including rats. It's put among clothes like camphor. Any root will answer if it's scented, but this racket requires sailor's togs; for the 'crocus' must just have come off the ship from foreign parts. It also requires a couple of tame rats to fight shy of the root. The silver paste is a

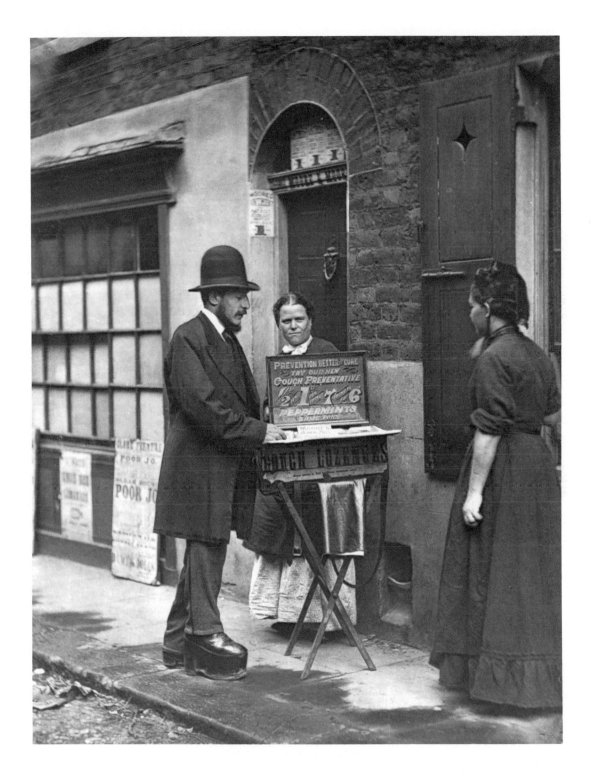

Street Doctors

fatal 'fake.' The paste is made of whiting and red ochre. The 'crocus' has a solution of bichloride of mercury which he mixes with the paste, and rubbing it over a farthing silvers it. He sells it for plating brass candlesticks and such like, but it's the mercury that does the business, he don't sell that. The mercury in time gets into his blood and finishes him. I have known two killed this way.

"There are many different dodges in 'crocussing.' One man I know, togged like a military swell, scares the people into buying his pills. He has half-a-dozen bottles filled with different fluids he works with, turnin' one into t'other. He turns a clear fluid black, and says, 'Ladies and gentlemen, this is what happens to your blood when exposed to the fogs of London. "Without blood there is no life!" You seem bloodless, my friends; look at each other.' They look, and almost believe him. 'Next to no blood is impure blood! This is your condition, I can describe your symptoms; I offer you the only safe, certain, and infallible remedy.' This style of 'patter' makes the pills fly, but it's not every one can come it to perfection.

"As to myself, my 'patter' is on the scholarly tack; reason and persuasion. I uphold the medical profession for most things, and tell all I know, and more so, about Materia Medica, for I don't know much. Once a learned cove, a student, I think, tried to take a rise out of me. Says he, 'What's Materia Medica?' Says I, 'If you've descended from Balaam's ass, you've browsed on it in the fields!' I never saw him again. I am not agoin' to give you my 'patter,' I can't turn it on like steam. You should hear me at my best, it's well worth publishing. On a fair night, in a good 'pitch,' with a crowd round me, my tongue seems aflame. Some of our best 'patterers' lush heavily. One used to say 'Demosthenes when he studied oratory, went to the sea-shore and filled his mouth with pebbles. I know a trick worth two of that, I go to the nearest public and fill my mouth with a glass of the best Scotch whisky.' He went there once too often. The fact is, most of us come to the gutter through boozing, and if a racket is dishonest, you may be certain the 'crocus' drinks hard.

"The corn 'fake' pays with a fellow who can 'patter.' His stock costs next to nothing. It should be sulphur and rosin to drop on the corn red hot. But rosin does alone at a pinch.

"I find a good honest 'racket' pays best in the end, people buy and come again. I have had my regular customers for years, and now I make a tidy living both summer and winter, and I need all I earn, for I have my old mother depending on me."

My informant has the reputation of being an honest, hard-working fellow. His cough tablets, if they do not possess all the virtues he ascribes to them, are certainly pleasant to the taste.

The subject of the accompanying illustration is a vendor of cough lozenges and healing ointment. He was originally a car-driver employed by a firm in the city, but had to leave his situation on account of failing sight. His story, told in his own words, is as follows:—"First of all I had to leave my place on account of bad sight. It was brought on by exposure to the cold. Inflammation set in in the right eye and soon affected the left. The doctors called it 'atrophy.' I went to St. Thomas's Hospital for nine months, to St. George's Hospital, and to Moorfields Opthalmic Hospital. From St. Thomas's Hospital I was sent to the sea-side at the expense of the Merchant Taylors' Company. No good came of it all, and at last I was so blind that I had to be led about like a child. At that time my wife worked with her needle and her hands to keep things going. She used to do charing during the day and sewing at night, shirt-making for the friend of a woman who worked for a

contractor. She got twopence-halfpenny for making a shirt, and by sitting till two or three in the morning could finish three shirts at a stretch. I stood at a street corner in the New Cut selling fish, and had to trust a good deal to the honesty of my customers, as I could not see.

"At this time I fell in with a gentleman selling ointment, he gave me a box, which I used for my eyes. I used the ointment about a month, and found my sight gradually returning. The gentleman who makes the ointment offered to set me up in business with his goods. I had no money, but he gave me everything on trust. It was a good thing for both of us, because I was a sort of standing advertisement for him and for myself.

"I now make a comfortable living and have a good stock. When the maker of the ointment started he carried a tray; now he has three vans, and more than fifty people selling for him.

"I find the most of my customers in the street, but I am now making a private connexion at home of people from all parts of London. The prices for the Arabian Family Ointment, which can be used for chapped hands, lips, inflamed eyes, cuts, scalds, and sores, are from a penny to half-a-crown a box. Medicated cough lozenges a halfpenny and a penny a packet."

On the occasion of my last visit to my informant I had an opportunity of seeing one or two of his patients. One, a blacksmith, who had burned his arm severely, stoutly testified to the wonderful healing properties of the ointment. Another, also a worker in iron, came in to purchase a box : "It has been the saving of my wife," he said ; "she has a bad leg, but this salve keeps the wound open, and this wound do act as a safety-valve to her heart ; were it allowed to close she would die of heart disease. Me and my wife discovered this, and it's worth knowing. It draws off the bad humour, and, bless you, sir, there's a deal of bad humour about my wife ! I'm a temperance son of the Phœnix. My wife ain't. She would not be a Phœnix if she could. She pulls one way, I pull t'other. She was teetotal for five years before me, but when I became a Phœnix she took the bottle. The Phœnix is a benefit and burial society. I pay three pence a week into it, and would be decently buried if I died. It is the interest of the Phœnixes to get us to live long, and for that reason it is a teetotal brotherhood."

This man was subscribing twopence halfpenny weekly to a club which secured for him and his family the attendance of a surgeon in the neighbourhood. For all that, he had sought the aid of this dispenser of quack compounds, and expressed himself perfectly satisfied with the result of his treatment.

I found in the course of my inquiries that the poor, many of them, prefer either resorting to quack remedies or employing their own paid surgeon, to placing themselves in the hands of the parish doctor, or under hospital treatment. This is accounted for in two ways. An honourable feeling of independence deters the poorer orders of the labouring classes from seeking parish relief in any shape. Others, who would gladly avail themselves of free medical advice, cannot find time to obtain a certificate from the relieving officer, and to present the certificate in the proper quarter. When all the forms have been duly complied with, grievous delays frequently occur in obtaining advice, and the necessary prescriptions ; the latter have, in some instances, to be taken to the dispensary at the other end of the parish. Some of the aged, infirm, and friendless poor, who receive regular out-door relief, have under ordinary circumstances to pay a messenger a shilling for collecting their weekly pittance of half-a-crown. In time of sickness, when they cannot crawl from their door, they too are fain to avail themselves of the remedies of itinerant doctors.

STREET ADVERTISING.

RITISH energy in advertising, equalled only by American enterprise, has in any case this advantage, that it gives employment to many destitute individuals who would otherwise become burdens to the parish or swell the list of our criminal classes. In this respect the system of advertising by means of boards, which the men themselves carry on their backs, has proved the most useful, as this is a work which any one can perform, and therefore boardmen, as they are called, are often recruited among the most hopeless of our poor. The men who paste bills on the hoardings, &c., are, however, considered a grade higher in the social scale, though their antecedents are generally more humble and less interesting. The boardmen are often men who have fallen in the world, some have even once enjoyed the title of " gentlemen," boast of an excellent education, but have been reduced to their present pitch of degradation through what they fashionably term dipsomania !

Bill-stickers were described to me as more independent than the boardmen, less subject to insult, but at the same time not so ambitious and more contented. This is due to the fact that many of them have never done anything else, and were, as my informant put it, " born in a paste-can." As a rule, also, when once a man has become proficient in the art of bill-pasting, he rarely abandons this style of work. Nor is it quite so easy as it may seem. There is a certain knack required in pasting a bill on a rough board, so that it shall spread out smoothly, and be easily read by every pedestrian ; but the difficulty is increased fourfold when it is necessary to climb a high ladder, paste-can, bills, and brush in hand. The wind will probably blow the advertisement to pieces before it can be affixed to the wall, unless the bill-sticker is cool, prompt in his action, and steady of foot. Thus the " ladder-men," as they are called, earn much higher wages, and the advertising contractors are generally glad to give them regular employment. The salaries of these men vary from £1 to £1 15s. per week, and they work as a rule from seven in the morning to seven at night. It is, however, difficult to exercise any strict control over the amount of work they do, for as they are constantly travelling about they cannot be easily watched.

Sometimes when there is a stress of business, the contractors are less scrupulous as to the men they employ, and then they are picked out from the common lodging houses, recruited at the Seven Dials, or even disinterred from the workhouses. These men of course earn less; that is to say, 16s. or 18s. per week ; but it is an agreeable change from the stricter discipline and monotony of the workhouse. One large contractor pays his men by the hour, and if it rains will not pay them at all : a system which has proved very economical during this extraordinarily wet winter, but which was most disastrous to the bill-stickers themselves. Altogether the pasting of advertisements on walls and hoardings must give constant employment in the metropolis to about two hundred men, not to mention the foremen and superintendents who ride round to see that the work has been properly done. Fortunately

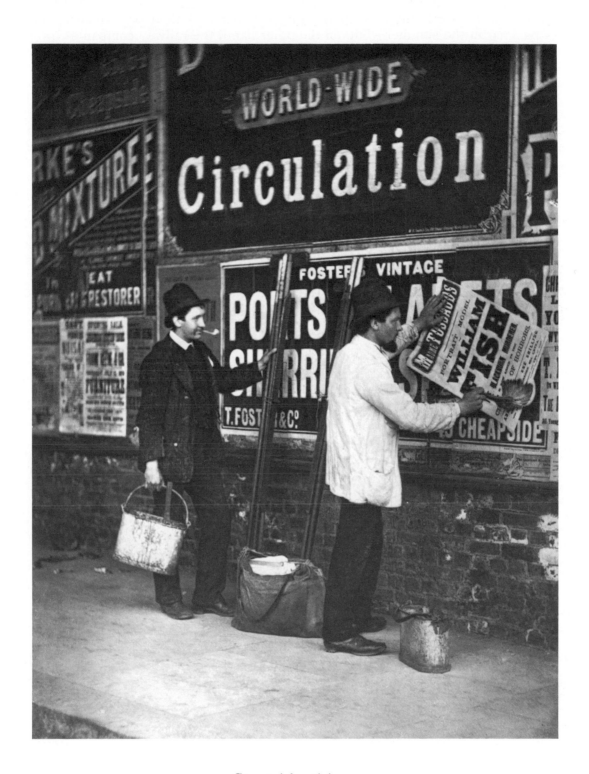

Street Advertising

there is as much advertising in summer as in winter. Towards Christmas the theatres blazon forth the most gaudy announcements of their performance, and are less pushing in the summer; but, on the other hand, the railway companies profit by the fine weather to advertise most extensively their pleasure excursions, &c. Over and above this comparatively regular work there are constantly new enterprises which must be promoted by the most startling publicity.

Apart from the legitimate bill-sticking on hoardings for which rent is paid, there is also another and special branch of work called " fly-pasting," and this is practised principally in the summer. It consists of sending men out to certain distances, either on foot or with a cart and van, to post bills indiscriminately wherever they can find a convenient spot which is not let to, and reserved by a contractor.

The road selected generally leads to a racecourse, or to some other great rendezvous. Now the road to the university boat-race is the scene of extraordinary activity on the part of the bill-stickers. They often start at two in the morning on the day of the race and paste their bills up all along the road. But rival bill-stickers soon make their appearance, and the paste of one bill is hardly dry before another one is daubed over it. Thus the contractors have to send out a fresh batch of men a few hours later to paste each other out. For instance, a firm in Soho assured me that they sent out men on the boat-race day at two in the morning, then at six o'clock, again at eight, and finally at ten, with orders to paste their bills over all other advertisements. The men engaged in this fly-pasting generally make 4s. a day, and during the winter months some of them become boardmen.

The value of advertising space, where it is secured and not subject to obliteration inflicted by some rival "fly-paster," is absolutely fabulous. More than £300 a month was paid a short time ago for some hoardings in Queen Victoria Street; and, altogether, I was assured by a gentleman who has been in the trade for a long time, and enjoys every opportunity of making a fair estimate, that upwards of £60,000 was paid annually for the possession of hoarding and wall space in London to let out to advertisers. Indeed, so much money is made in this way, that there are certain houses standing in conspicuous places by the railway lines, which are not pulled down, though in ruins, because it pays the owners better to let the outside walls for advertising than to let the interior for dwelling purposes.

The largest contractors in London are certainly Messrs. Willing and Co., and Mr. Thomas Smith. The latter gentleman, though not possessing absolutely the oldest business, has been longer in the trade than the head of any other firm, and may be considered as the parent of several of the newest and most ingenious forms of advertising; while, among the more recent men, the young blood of the trade, Mr. Walter Smith seems to have secured important contracts. If I have ventured to record the success of these two latter gentlemen, it is not that they are known merely as prominent business men, but because of the popularity they have acquired among the bill-stickers themselves with regard to the all-important question of the wages. Politically and socially speaking, our chief difficulty is to dispose advantageously of unskilled labour. The contractors for boardmen and bill-posting have, as far as the extent of their business will allow them, offered a solution to this problem; and street advertising has, I may repeat, undoubtedly kept many a person from the workhouse.

<div align="right">A. S.</div>

CLAPHAM COMMON INDUSTRIES.

HOLIDAYS and idle days are golden days to nearly all who earn their bread in open spaces, thoroughfares, or streets. When ordinary business is at a stand-still, when the cares of commerce are laid aside for a few hours, and the great majority of the population seek to enjoy a little rest or recreation, the poor of London make their appearance, invade all places of public resort, and expect to reap a golden harvest from the holiday. Sundays, and especially Good Fridays, are often the busiest days in the year to many who seek to gain a livelihood out of doors. The parks, commons, gardens, in fact all pleasure-grounds, are overrun with eager caterers to the public. They offer for sale objects of the most modest description ; but on such occasions the worst oranges, suspicious sweets, faded flowers, and the dingiest of ornaments, find comparatively speaking a ready sale. Clapham Common is of course one of the most accessible rendezvous for these itinerant vendors ; but certain industries are more particularly successful on this spot. The place is especially attractive to itinerant photographers. During the season they flock to the Common ; though the demand for the class of portrait they produce is of so constant a character, that one photographer at least has found it worth his while to remain in the neighbourhood even during the winter. This faithful frequenter of Clapham Common will be recognized in the accompanying illustration, and he is there represented engaged with the class of subject which generally proves most profitable. Nurses with babies and perambulators are easily lured within the charmed focus of the camera. They are particularly fond of taking home to their mistresses a photograph of the child entrusted to their care ; and the portrait rarely fails to excite the interest of the parents. Nor does the matter rest here. The parents are often so satisfied that the nurse is commissioned to obtain one or more likenesses on her next visit to the common. Thus practically she becomes an advertising medium, and the photographer generally relies on receiving more orders when he has once secured the custom of a nurse-girl. It need scarcely be remarked that at Clapham Common there are not only a large number of nurses and children, but these are generally of a class which can well afford the shilling charged for taking their likeness.

Success depends, however, more on the manners than on the skill of the photographer. Many practised hands, who have highly distinguished themselves in the studio, when the work is brought to them, are altogether unable to earn a living when they take their stand in the open air. They have not the necessary impudence to accost all who pass by, they have no tact or diplomacy, they are unable to modify the style of their language to suit the individual they may happen to meet, and they consequently rarely induce any one to submit to the painful ordeal of having a portrait taken. On the other hand, men who are far less skilled in the art often obtain extensive custom by the sheer force of persuasion. Example, also, is contagious, and if in a throng of people, one person ventures to step forward, others soon follow his

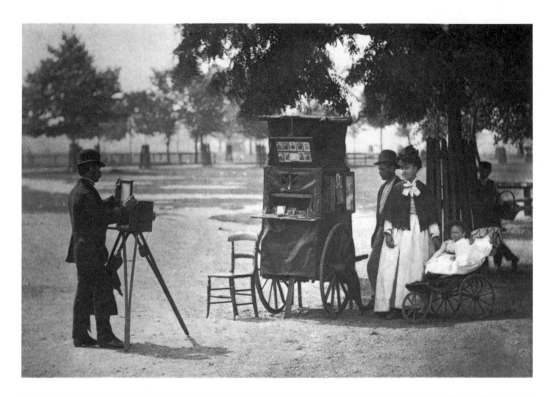

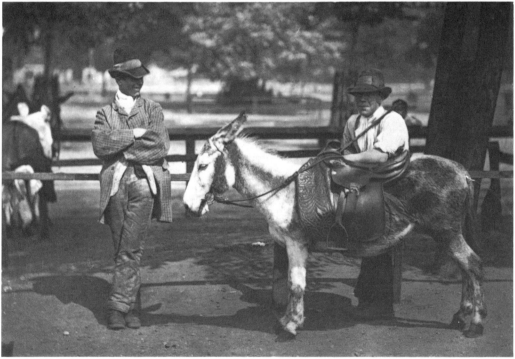

Clapham Common Industries

example, and this renders the large gathering on holidays doubly advantageous. Thus, I know of one photographer, who obtained on Clapham Common no less than thirty-six shillings in the course of one hour. This, however, was altogether an exceptional circumstance, and a receipt of ten shillings a day is considered very fair for the common. Out of this sum about a quarter should be deducted for general expenses; and the work is not always pleasant. The photographer dare not leave his apparatus, for it is impossible to guess when a subject may present himself. He must stand for hours on the damp earth, idling away his time, when perhaps just as his patience is giving way, a tradesman's cart will pull up, and his services are requisitioned to immortalize by his art the waggon which conveys groceries to the prosperous *bourgeoisie* of Clapham.

With the exception of gala days, the photographers on Clapham Common lead a somewhat humdrum life, for men who, in comparison at least, possess superior intelligence. Many, indeed, have held higher positions, have been tradesmen, or owned studios in town; but, after misfortunes in business or reckless dissipations, were reduced to their present less expensive and more humble avocation. When the season which, for the frequenters of the Common, lasts from March to Whitsuntide, is over, the photographers, for the most part, hasten to popular sea-side resorts or follow the vicissitudes of the turf. During the month of March, their receipts on the Common rarely exceed 7s. per day; but, during the warmer months, they often make double and three times as much. Those, however, who have the energy to attend at the races, to get up at five in the morning to catch the cheap train, who do not object to being locked up by the police under the Vagrancy Act if they are unable to procure a lodging, or who can pay 8s. for the privilege of sleeping in a tap-room, may hope to make large sums. The highest patrons of the turf are also the patrons of these itinerant photographers. The Prince of Wales, Lord Vivian, Sir Arthur Chetwynd, the late Marquis of Hastings, the celebrated horse-owner, Mr. Chaplin, and many other equally well known amateurs of horse-racing, have, I was most emphatically assured, all graciously allowed their portraits to be taken by these enterprising photographers. Considering the difficulties of reaching the race-course, the charge is consequently greatly enhanced; the photograph of a break, trap, or coach bearing five persons is generally sold for £1. The Duke of Beaufort, for instance, always paid £1 for one photograph, and 10s. for the second portrait; but the Prince of Wales, it appears, is renowned for his stubborn adherence to a fixed price. One of the photographers in question informed me that his Highness gives £1 for one photograph—"it is his *sovereign* price; and if an attempt is made to take another likeness he only orders the police to send you away." On further inquiry, I found this gossip confirmed by more than one witness. Other sportsmen are particularly generous when it rains; and it seems as if this fashion of patronizing photographers on the race-course is really but charity in disguise. The ordinary glass pictures paid for so liberally are generally given over to the coachman, thrust into the rumble, and never see the light of day again. But the photographs taken on such places as Clapham Common, or at the corner of some quiet suburban street, meet with a more worthy fate. They are cherished in the homes of the poor, and are often found in the nurseries of the wealthy. They serve to recall the past, to revive latent affection for the absent; they never do any harm and sometimes awaken the better and more tender instincts of our nature.

By the side of the photographer, stands the donkey-boy, who also derives special benefit from the close proximity of Clapham Common. He lives in a slum hard by, and belongs to that peculiar and distinct race known under the generic term

of costermongers. There are, I am assured, but two proprietors who let out donkeys for riding on Clapham Common, Mr. Carter and Mr. Laurence. The former has by far the most important business, and as many as twenty or twenty-five of his donkeys may be seen out on the common. The photograph, however, portrays Mr. Laurence's son, leaning affectionately over his dumb companion, and a labourer, temporarily out of work, who has volunteered to assist him in his charge, and is evidently enjoying the sport. As a rule, the donkeys are bought at the beginning of each season, the female being invariably preferred, firstly, because its jolt is not so objectionable, and secondly, because, being generally in foal at the end of the season, it can be sold with a view to providing asses' milk, for a higher price than it cost. Eighteenpence per day is supposed to suffice for the keep of a donkey; but the income derived from the hire varies considerably, amounting on Good Fridays to £1 and even £1 10s., and falling at times as low as 4s. The ideal average is 10s. per day, and the true average probably a little less. It depends, however, who attends to the business, and one man driving two donkeys can make more out of each than what is derived from a greater number entrusted to the care of small boys. These latter generally receive a shilling per day, and are naturally apt to neglect or miss opportunities of obtaining a fare. If, however, the owners would content themselves with sure but smaller profits, they would find many ladies in the neighbourhood ready to pay 5s. or 6s. per day to secure the exclusive use of a donkey for their children, and would also treat it with kindness. One lady even paid 4s. during all the winter months so that her favourite donkey should not be sold, but reserved for her children to ride again at the earliest dawn of spring.

Altogether it will be seen that the commons and open spaces in and about London, are not merely useful in maintaining the health of the population, and as affording some space for recreation ; but they also open out new fields of industry for those who earn their living out of doors. On the great holidays, the itinerant street vendors crowd to the Common, and are able to breathe fresh air while still pursuing their ordinary avocations. Thus many wretched and forlorn individuals are induced by the ordinary interests of their business to occasionally imbibe the purest, most effective, and natural of tonics—a little oxygen ; while those who are always on the Common benefit to a greater extent and boast of exemplary constitutions. Under such circumstances, I cannot help urging in conclusion, that all Londoners owe a deep debt of gratitude to those patriotic citizens who have combined and subscribed to defend the commons against the illegal and selfish encroachments of the neighbouring landowners.

<div style="text-align: right">A. S.</div>

"CANEY" THE CLOWN.

VEN among the street folks of London there are not many who can boast of so varied a career as the hero of this chapter. Caney, whose name, it will be seen, expresses the nature of his work, once enjoyed the exalted position attributed to those who belong to the "pro." Thousands of poor people and pale children remember how he amused and delighted them with his string of sausages and his old familiar and typical salutations, as he made his appearance at the yearly pantomime of the Standard or Britannia Theatre. But Caney has now cut his last caper, though on seeing the accompanying portrait he may be tempted to exclaim once more "Here we are again, sir!"

To begin his story at the very beginning, I should first relate that Caney commenced his career by absorbing such marvellous stories relating to the sea, that, like many other boys, he finally ran away from home. In the same way he in due time found the sea more agreeable in romance than in reality, though it must be confessed he endured more than ordinary hardships. After three trips in the Newcastle collier "Briton," he was so deeply grieved at the loss of a young friend and shipmate, whose life was sacrificed through the carelessness of some drunken sailors, that he left his ship. The boy fell overboard into the Thames in his attempt to clutch at a pier. The sailors themselves were so intoxicated that they failed to make the boat fast to the land, nor could they row with sufficient promptitude and steadiness to save their drowning companion. This incident so horrified Caney that on landing he resolved never to return to sea. He had, it is true, no other occupation and no friends; but he, nevertheless, walked forth boldly into the world, trusting to chance and fortune for bread and employment. This vague saunter brought him to Battersea Fields, and this in the days when that place was the great holiday resort. Here he made acquaintance with Hall, the keeper of the celebrated beershop known as the "Old House at Home;"—a remarkable haunt familiar to all who knew Battersea twenty or thirty years ago. For several years Caney remained in the employ of the eccentric landlord, and helped to keep the pigs, goats, &c., that lived with Hall's family in the one room the house possessed. Indeed, it was so curious an abode that there was once some difficulty in proving that it was a house at all. The beer licence had been refused on the ground that the hovel possessed no chimney; and, to be within the meaning of the Act, the landlord had to build a chimney at the last moment, thus reluctantly complying, in this detail at least, with the exigences of modern domesticity.

Caney's next step in life was the management of a "six-boat up and down," which strange phrase means, I should perhaps explain, the circular swings that render so many people ill, but nevertheless constitute one of the chief attractions of a country fair. The better to watch over this implement of voluntary torture, Caney's new employer bought a second-hand wild-beast van in which the youth was able to sleep at night close to his "six-boat up and down!" It will be seen, therefore, that

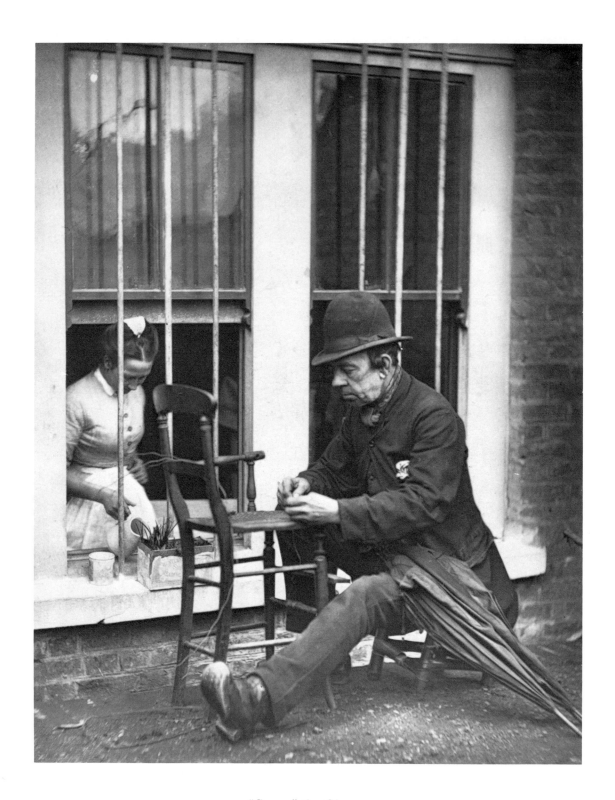

"Caney" the Clown

from his early boyhood, Caney had not been accustomed to gentle treatment ; and if, in after-life, he has occasionally indulged in the British privilege of grumbling, this need not be attributed to exaggerated sensibility on his part.

After attending Stepney Fair for two seasons, he obtained an engagement in Paterson's travelling show, where he impersonated the fool commonly known as " Pinafore Billy," and amused the audiences by submitting to the jokes and kicks liberally bestowed on him by the clowns. Improving with experience Caney was himself ultimately engaged as clown in Richardson's company, where he worked with Paul Herring, who appeared as pantaloon in the pantomime performed a few years ago at Drury Lane Theatre. After playing in many provincial theatres, Caney finally made his *début* in London on the boards of the old Garrick, the Britannia, and the Standard. He rendered good services at these houses in the cause of the people's amusement. No consideration of bone or nerve interfered with his assaults on the pantaloon. He was irrepressible in the matter of bonneting the police ; and he tumbled and danced, and fought, and shouted to the delight of his rough and ready audiences,—and, poor fellow, to his own disadvantage. His exertions to please the people who greeted his first sally with vehement applause, caused the bursting of a varicose vein in his leg, and Caney's successful career was over. There was not enough bodily strength left in him even for a pantaloon. After enduring an operation which was performed at old St Thomas's Hospital, Caney was finally pronounced to be cured, but forbidden to attempt any violent exercise.

Under such circumstances, he was naturally at a loss for some means of subsistence, and soon fell to the last stage of misery and poverty. But among the poor he met with that charity which the poor more than any other class extend one towards the other. A pedlar took compassion on him and initiated Caney into the art and mystery of mending umbrellas, and with a few hints and a little practical assistance from others as poor as himself, he was able to eke out a wretched existence at desultory and humble labour, now mending umbrellas, now making wire work, now dabbling in tinker's work of all descriptions, and thus avoiding while health lasted, both starvation and the workhouse. But of all the work he undertook, that of mending chairs seems to have brought him the most constant employment. In all cases his friends are of this opinion, for they have unanimously dubbed him " Caney," and it is under this soubriquet that he is best known in the purlieus of Drury Lane. At times, however, the old spirit broke loose again, and though he never appeared on the boards of any theatre, he has often graced the streets with some of his clownish antics. At Christmas, and other holiday seasons, he sometimes resorts to the familiar hare's foot and rouge, dons a clown's suit, which is certainly the worse for wear, and follows a band of itinerant street performers, among whom his superior accomplishments and experience insure ready welcome. Such imprudence, however, has more than once nearly cost him his life ; and, but for an exceptionally strong constitution, he would never have survived the loss of blood attendant on the reopening of his varicose veins. Thus, as years crept on, Caney had to observe greater self-control, and constantly curb that frolicsome disposition which formerly suited him to the profession of clown ; till at last his care-worn face fails to reflect his natural joviality, and in him, as in others, we find the indelible stamp denoting a hard life of struggle and adversity.

There are, it is true, many worse employments than that of caning chairs, but nevertheless, the work is precarious, and at best does not bring in much profit. At High Wickham, the centre of the cheap chair manufacture, common beech chairs are made which are actually retailed in the East of London at less than £1 per dozen.

These prove very attractive to newly-married couples, who are thus led to imagine that they can furnish a room or two for a few shillings. But experience soon shows that the wood of these cheap chairs has not been properly dried : they crack, and shrink, part at the joints, and fall to pieces, so that the dearer but sound article proves the cheapest in the long-run. These cheap chairs are generally made in the country, and men of Caney's type would scorn such shoddy wares. At Wickham the children do the caning, the women varnish, the men undertake the French polishing and other rougher work. When by their joint labour a family has produced a certain number of chairs, they entrust them to a van-driver, who takes them up to London and hawks them among the East End furniture-dealers. Having thus introduced into London a constant supply of cane-bottomed chairs, another industry, namely, that of mending the chairs when the cane had worn out, sprang up simultaneously. This was probably first originated by the gipsies ; but others soon followed the example, and now a great variety of persons have learnt the knack. A considerable number of mechanics, formerly employed in heavy work which they have been obliged to abandon through ill-health, find this a light and commodious occupation. But they are terribly undersold by women's labour. The wives of artisans seek to assist their husbands by caning chairs for dealers, and are content to receive 3s. 6d. to 4s. 6d. per dozen and buy their own cane, and the value of the cane for each chair varies from a penny to three halfpence. Nor is this all ; it is necessary to buy tools and apparatus for splitting the cane ; and a married woman may be able to do so if assisted by her husband, but the poor man, the crippled mechanic, who has just left the hospital, is not always in so fortunate a position. Thus, the poorer the person the more likely is he to eschew the comparatively regular work but low pay offered by the dealers. He will prefer wandering through the streets, cane in hand, soliciting from door to door, for a solitary "job." When, however, this is secured, the profit is much greater, for the charge varies from eightpence to a shilling per chair, according to the quality of the cane, the size of the seat, and the probable wealth of the customer. The street chair-mender has generally to buy his cane all ready split and dressed, and this varies, according to quality, from 2s. 6d. to 4s. per pound weight. Nor will this amount cover more than six to eight chairs.

The splitting of cane is so important an industry, that it has been worth while inventing a special machine for the purpose, worked by steam. With this contrivance some twenty pounds of cane can be split up, while a man could only cut about one pound ; and even then would infallibly destroy the centre piece. This latter, it is true, is of very little value ; still some use has already been found for it. The pieces thus saved are converted into little switches or canes, generally died black, and sold on Bank holidays for a penny. Dutch-metal ornaments, which can be bought at 9d. per gross, serve as ornamentation or heads for these canes, and they are quite good enough to delight a child, while affording a large profit on the penny for which they are retailed.

As a rule, the men who cane chairs generally do other work as well, for this style of employment is rarely sufficient in itself. It is, on the other hand, clean and agreeable work ; and, as it is generally done in fine weather and in the open air, it may be considered a thoroughly healthy employment. Further, it has the inestimable advantage of affording a means of subsistence to many persons who have no regular trade, and who would be driven to dangerous extremities, but for opportunities of this description. The biographical sketch I have given of Caney affords a good example of the circumstances which may bring a comparatively prosperous man down to the level where he will gladly avail himself of these easy methods of earning an occasional shilling. A. S

DEALER IN FANCY-WARE.

HE modern " quasi " jewellery sold in the streets is remarkable alike for its variety, its artistic beauty, its marvellous imitations of real gems and ornaments, and its fashionable designs. It is, indeed, necessary now-a-days for the street vendor of jewellery, to exercise tact and judgment in selecting such wares only as are supposed to be in vogue among the upper classes of society. " It is not so much the imitation jewels the women are after," said an old dealer to me, " it's the class of jewels that make the imitation lady. As for the men, they're all there when they got the ring of the aristocrat on their unwashen finger ; fit for Court they be, and fit for courting. The ring goes down uncommon with the girls, 'specially the plain hoop, sir !"

The ornaments which find the readiest market are combs for the back hair, ear-drops, finger-rings, scarf-pins, brooches, and bracelets ; to these are frequently added a miscellaneous array of larger and more costly articles. The best barrows and stalls in Whitechapel, the New Cut, and Tottenham Court Road, display vases and other mantelpiece ware, gilt frames for " carte " photographs, leather and bead purses, and in some instances plated jewellery.

Within the last ten years the fancy-ware trade—popularly termed " swag-selling "—has proved one of the most lucrative branches of out-door industry. The fabulous profits it was supposed to yield, and the small outlay required for stock, tempted so many of the street folks to take to the " swag-board," that the trade has been overdone, the market glutted, and some of the old hands forced to abandon the streets and take to indoor employment. There can be no doubt that the profits on the sale of cheap jewellery are still large, but continued depression of trade, and the number of hands employed in selling have woefully reduced the returns of each individual trader.

I obtained the following account of the present position of the " swags " from a man who had been brought up to the business.

" It is now much harder to make a living in my line than it was ten years ago. Most things is dearer in the feeding way, and the profits ain't nothing like wot they was. They ain't so bad, took as we sell, but we don't sell nigh so much o' the most paying things, and a sight more things that's got next to no 'bounce '—profit—'cause every 'swag' sells 'em. But at the worst o' times I'll back myself again any 'cove' to make a living ; I sell so cheap I've broke the h'arts of every blessed 'swag' in the Cut. I've drove 'em out in the cold, and they hate me as 'pison,' so I've hurd ; but I don't care, it's business not 'pers'nal' feelin'. Wot I does is this. It's my little game always to have a new 'chut'—a novelty—on my barrow. The one I got now is sleeve-links, brooches, studs, and lockets, all at a penny."

I bought several articles at this man's stall at a penny a-piece, all of which I should have appraised at a much higher value. Such ornaments, indeed, had they been offered for sale twenty years ago, would have commanded ready purchasers at a

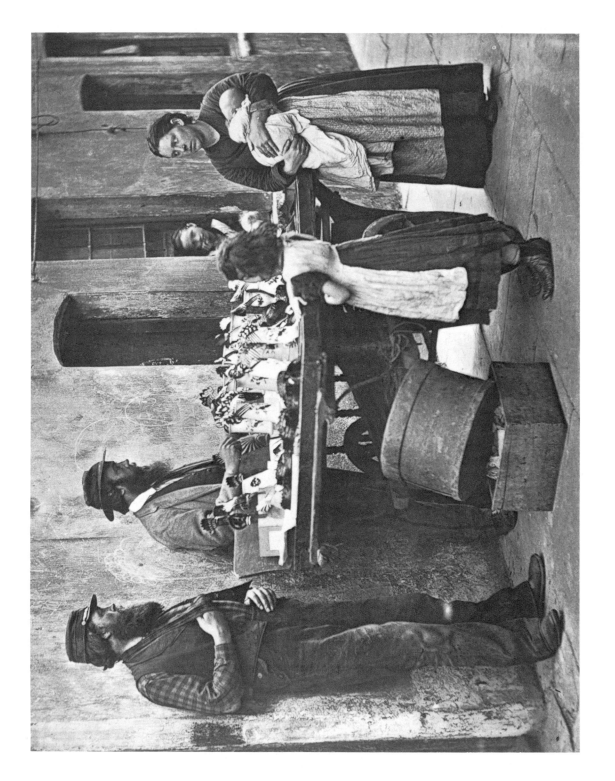

Dealer in Fancy-Ware

shilling a-piece, as astounding examples of the cheap products of skilled labour. Perhaps the most ingenious and attractive pennyworth was a pair of sleeve-links, each containing a dog's head moulded in coloured glass, and protected by a convex glass neatly set in a gilt and burnished rim of metal. Upon expressing my surprise at the trifling cost of the wares, my informant continued,—

"You ain't in my line, I believe, sir? and I don't mind your printin' wot I say in a book, 'cause most swags don't read,—they can't. You won't split on me, so I'll let you up to one or two things. Them goods you see, they fetch a tidy bit o' money. They cost me sevenpence a dozen, that's fivepence a dozen profit. The 'bounce' ain't much, but when a senseless swag would take his barrow home on a wet day, and wait for fair weather, the missus and me we take our baskets and tramp round out o' London and in o' London to places wot want workin'. 'Goin'' from door to door we makes the thing pay, gettin' at times twopence for wot would fetch a penny on the barrow. The extra penny goes for the railway, a drop o' drink, and such like. It's a poor business now, but by workin' twice as hard as before, it's about the same when the week's done. Sunday to most on us is a day for loafin' and liquorin'. I'm workin' a thing now at half 'bounce,' and I've a new 'chut' comin' out, same as the links, only more better got up to my eye. I bought it, as I buy everything else, from the Jews in Houndsditch and such like places. The Jews are fair people at a deal so long as you pay. But they'd never trust a man like me a penny to save my life. At the end o' the year I got sixpence on the pound from some of 'em on my year's buyings. That's their dodge to get me to stick to 'em. In fine weather I make most money by travellin' the country. The gals and green-horns there don't know the 'wally' o' things, and come down with sixpence easy for wot fetches a penny here."

The accompanying photograph represents a street group gathered round a dealer whose barrow is one of the most attractive I have seen during my wanderings about town. The story of its owner was narrated to me in the following words :—" I was brought up in the country as a miller, and earned in good times sixteen shillings a week. Seeing no prospect of advance, I came to London. Ten shillings was all I had in my purse when I left home to make my way in the world. I had heard wonderful tales of London, of its wealth, and the chances of fortune it offered to all. Besides my stock of money I carried more than money's worth in two characters I had from the clergyman and my master. They spoke well of me, but nobody cared to look at them. Only twopence halfpenny remained over of the ten shillings. I had been four days wandering all over the place in search of work. Ten shillings may seem a large sum to spend in four days, but it cost me three and six in the railway to come up here. Just when I was feeling desperate, fit for anything, I got a job at eighteen shillings a-week. I kept this place for two years, a sort of labourer ; at the end of that time I fell in with my wife, and got married. She had a stone-ware shop. We kept the shop running together for about four years, but it run down one morning all along of three other shops that set up in the same street, one at each end, and one in the middle. The competition knocked us over, and we were sold up. Out of the wreck of our business I saved about fifteen pounds and some sticks of furniture. With this I started 'swag' in the streets. The whole of the money was invested in a barrow and stock. Business at that time paid better than it does now, and expenses were not so high. Four years ago I got three shillings for a comb that will only fetch a shilling now. The first cost to me was a trifle more than it is now, but nothing compared to the extra profit. My class of customers, when trade was prime, had more money than they know'd what to do with, in consequence

they used to chuck it about freely and foolishly. There are now too many 'swags,' and most of them ain't the gentlemen they used to be. I should say there are 1500 'swag' dealers about London, counting women, boys, and girls. The average clear profits all round would, I think, be about fourteen shillings each a week. My missus and myself between us, we make clear over thirty shillings a week. It takes about thirty shillings to keep us, five shillings a week rent, and the rest for clothes, food, and fuel. Three or four years ago I have drawn as much as two pounds on a Saturday night. Out of that I had about twenty-six shillings profit. Now I have not been drawing more than five shillings a day, except on rare occasions. The profits are much lower at present. Ten shillings out of the sovereign is considered good now. The profit is not so great as it looks, when you think of how long we stand and how many are the folks we supply before we get a pound. It must take about fifty customers to make up a pound of money. Times are bad, and I have left the streets for a regular job. My wife minds the barrow. But bad as times be, it's wonderful how women will have ornaments. I have had them come with their youngsters without shoes or stockings, and spend money on ear-drops, or a fancy comb for the hair. Some women deal with me for wedding-rings. I sell them gilt from a penny to threepence. I have sold two dozen of them in a night, some for a lark, others for weddings, and a lot to wear in place of the genuine wedding-rings pawned for drink, so as not to let the husband know. I have often sold sixpenny rings for weddings. They are uncommon high-class goods, and warranted to fix a pair as surely as the genuine article.

"I can supply a set of real flash jewels for about three shillings—diamonds if you like, brooch, bracelets, black or gold ear-drops, and finger-ring. The finest plated articles, fit for carriage people, fetch more money. A pair of ear-drops of this sort fetch two and six or three shillings. It's only tip-top dealers like myself that keep them.

"I now sell my best fancy combs for a shilling; they fetched three shillings when I bought them for a shilling. I now pay eightpence a-piece for them, and sell them for a shilling. I have them for the hair as low as twopence-halfpenny. They are in great demand among young women, who would go a'most naked, and feel comfortable, if only their hair was done up in the latest fashion, and decked with one of my combs. I have known them 'swop' their underclothing for a comb when their toes was sticking through their boots. Girls on the street are my best customers. They think nothing of money and give it wings when they get it.

"Saturday and Monday nights are our best times; when the people are looking through a glass of gin our things look wonderful tempting, and their little bare-footed youngsters look clothed and warm. I wish I was a better judge of human nature; some gentlemen in my line can tell when a man or a woman has money, and tempt them to the barrow, where they're sure to leave some of their 'tin.' I can't do it, I have always been unfortunate. I have never had a run of luck. There's something about me like a stone round a drowning man's neck, keeps me from rising. I had a bit of education, and am fit for better work, but it seems never to be my lot to get fairly clear of the streets. Some drink hard and get on, I don't lush and I don't get on. I got a situation the other day only for a short time. The work is done and I am discharged."

I must here take leave of this dealer, joining him heartily in the hope that better days are in store for him, that his industry may yet be rewarded with the modest degree of success to which he aspires.

THE TEMPERANCE SWEEP.

MAY-DAY festivities are still commemorated by, at least, one class of the community; and the presence of "Jack-in-the-green" naturally suggests a few words on sweeps as a seasonable subject. The story of Lady Mary Montagu's lost child is, however, too old to bear repetition; and I will content myself by recording that the London sweeps are highly dissatisfied with the abolition of the grand yearly May feast she was the first to institute. They, however, still maintain the representation of Jack-in-the-green, which is supposed to be for the benefit of the sweeping fraternity. A master sweep often employs persons to parade and dance in the streets, pays all the costs, and receives all the benefits. As chief clown on these occasions, Caney, whose biography will be found in another chapter, often officiated. The green which he accompanied was made of large cooper's hoops, joined together by eight poles or standards, as they are called. Glazed calico, garlands of leaves, and rosettes, covered this rough framework. But to dance inside so cumbersome a contrivance is no easy matter. Coal-heavers, or persons accustomed to heavy work, are generally employed; they are stripped of nearly all their clothes, receive unlimited libations of beer, and 3s. 6d. per day. The dresses for the clown, the pantaloon, Black Sal, and Dusty Bob, are generally bought in Petticoat Lane, and cost in all about £5; and it therefore requires capital to start a Jack-in-the-green. On the other hand, ample receipts are made, though it is in the East End and poorer quarters that these street performers meet with the greatest success. Of course, as there is money to be made in this manner, other persons besides sweeps have sent out Jacks-in-the-green; but such a venture is not altogether safe, for, if found out, the performers run the risk of being mobbed and the green destroyed by those who really belong to the trade.

Unfortunately, the apparently innocent and somewhat child-like capers of the Jack-in-the-green and his jovial troop, engender and increase the vice of drinking. At each halt, more refreshments are produced, and sobriety is not a distinctive quality of the poor in general, or of chimney-sweeps in particular. The past experiences of John Day will illustrate this fact; and, as a temperance sweep is certainly a *rara avis*, his biography may prove of interest.

Born in Lambeth, the son of a road-mender, John Day was sent out to work when scarcely more than ten years old. His father was decidedly addicted to drink, and was in the habit of taking his son on Sunday to public-houses, where drink was sold in defiance of the Licensing Act. So long as the child had a few halfpence for beer, he was in the parental eyes a good boy; but when his meagre earnings had been thus uselessly spent, his father came to the conclusion that he could not afford to keep him, and that it was high time the boy should fight his own way in the world. He was therefore turned out of his home, and had to resort to the friendly, if cheerless shelter of railway arches; or at times he would sleep on a barge, and profited by the opportunity to wash his solitary shirt in the canal, and hang it up on the rigging of

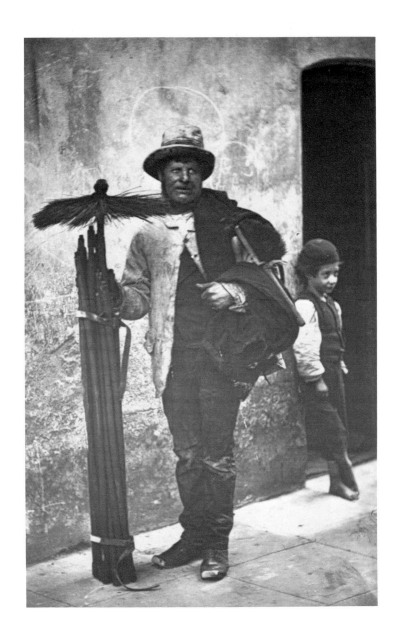

The Temperance Sweep

his temporary home, while he disported himself amidst the tarpaulin till it dried. At times when there was nothing to be done at the flour-mill, he obtained a little work as assistant to a neighbouring chimney-sweep; but in either employ he rarely made more than 3*s*. per week.

At last Day's parents, stirred to a sense of the protection they owed to their son, determined to find him some more satisfactory employment; and they arranged that he should follow an itinerant fish-hawker in his travels, and for this he was to receive a fair remuneration. Accordingly, the hawker and boy started and tramped to Farnham, in Kent, but here the man left his young charge with twopence, and orders to join him at Kingston. Alone with a coster-barrow to drag along, the poor boy started on his journey, barefooted, till he met a farmer, who gave him a pair of old boots twice too big for his slender feet. On reaching Kingston, he found that his employer had failed to keep the appointment. Hungry, pennyless, and drenched with the rain, Day had to sleep on his barrow in the open air, and covered with one or two wet sacks! On the morrow, however, fortune dawned upon him; some compassionate cabmen subscribed a penny each to procure breakfast for the boy; and a gentleman who happened to be passing gave him eighteenpence to carry his fishing-rod, &c., to a neighbouring stream.

After loitering some time longer at Kingston, Day at last met his employer, and continued in his service for five weeks, but failed to obtain any wages, or clothes, nor even a change of linen! Foot-sore, in rags, and in a state of incomparable filth, Day at last, made up his mind to abandon such unprofitable work, and started for home. At Battersea he passed by a potato-field, where he obtained some small potatoes, which he sold for a penny, and therewith procured himself a slice of pudding. Thus fortified, he once more made his entrance into the great metropolis, but as he neared home, and met some friends, the boy's pride brought tears to his eyes, when he noticed how they stared at the sorry appearance he presented. Even his parents were moved, and his mother actually gave him her own boots to wear.

As Day grew older he inherited his father's propensity for strong liquor, and was often arrested for drunken and disorderly conduct. On these occasions he took special delight in fighting the police, and when finally incarcerated, his clothes had generally been torn to pieces in the previous struggle. The bounty-money offered for volunteers to join the Crimean army, and the prospect of an adventurous career, ultimately inflamed this desperate and reckless character, and he enlisted for the campaign. He was enrolled in the transport corps, served in the trenches before Sebastopol, where he fell ill with fever. The danger of this disease was increased by his intemperate habits. He remembers on one occasion spending together with three other soldiers £2 in drink, and on this they succeeded in attaining that extreme stage of intoxication which rendered medical assistance indispensable, or their lives might have been sacrificed.

On his return from the seat of war, Day's parents seem once more to have shown some feeling; for, to use his own words, " Father began to cry at seeing me, and of course I sent for beer, and that soon stopped the crying." This burst of affection was, however, of short duration; and, when the soldier had spent all his money, he was again turned out of his home, and again resumed his old calling as chimney-sweep. He then happened to meet a man who used to clean the pans and boilers at a candle-factory, but who was generally so intoxicated that he could not do the work, and consequently employed Day in his stead, giving him about a quarter of the money. In time, however, he was forced into the workhouse, and Day succeeded to the post, which is worth about £2 per month. Though Day received so little from his

predecessor, he nevertheless allowed him 3*s*. a week while he remained in the work-house. But he soon died, and this miserable end, together with his previous experience, served as another warning of the evils of intemperance. Day, nevertheless, continued to drink steadily till 1864. When Garibaldi came to Nine Elms, Day celebrated the occasion by getting even more drunk than usual; but on the morrow, while intent on resuming his libations, he chanced to obtain a glimpse of his own countenance reflected in a public-house mirror. His bleared eyes, his distorted features and ignominious, degraded appearance produced so sudden and forcible an impression, that he turned round to his friends, confessed that he had wasted his life, was but a miserable fool, called for a penny glass of beer, and swore that it should be the last. Of course they merely laughed and jeered, and thought he had not yet recovered from the excesses of the previous night. But, to his credit be it said, John Day was true to his word, and from that time he never again touched any intoxicating liquor, or even smoked a pipe of tobacco. The latter he assured me was the most difficult to abandon. To this newly-acquired sobriety monetary prosperity soon ensued. He is now the happy father of a large family, he lives in a house near Lambeth Walk, where he once humbly worked in the capacity of a mere assistant. As a master sweep he has an extensive connexion. The money he earns enables him to subscribe to several benefit societies, and he is entitled to receive from them 10*s*. a week in sickness, while his wife will have £46 given her at his death, or he will receive £18 should she die first. Altogether he is both prosperous and respected throughout the neighbourhood, where he ardently advocates the cause of total abstinence, and is well known as the temperance sweep.

Chimney-sweeps of the present day have lost one important source of income. The soot they so carefully collect, and have to sift from the cinders and ashes taken away from the grate at the same time, has no longer any great marketable value. It was used extensively on meadow and on wheat land, where it was especially beneficent in its effects by destroying slugs and other injurious animals. As much as a shilling a bushel was therefore given for soot; but the recent introduction of new manures has reduced the price of soot to about threepence or fourpence per bushel. As a natural result the sweepers charge more for cleaning chimneys, the price varying from sixpence to two shillings or three shillings, according to the height of the chimney, and the probable wealth of the persons who inhabit the house; while five shillings is generally given for putting out a fire. The assistant or journeymen sweeps receive six shillings a week and board and lodging, or about one pound a week and keep themselves; and there must be altogether upwards of 2000 persons earning their living by sweeping the chimneys of the metropolis.

<div align="right">A. S.</div>

THE DRAMATIC SHOE-BLACK.

ACOBUS PARKER, Dramatic Reader, Shoe-Black, and Peddler, is represented in the accompanying photograph standing at his accustomed "pitch." Although the career of Parker has been clouded, and his life-story is one of struggle and disappointment, yet he has fought the battle bravely, and, as a veteran, is not without his scars. "There is one thing I am proud of," said Parker, one day ; "I am near three-score years and ten, have fought life's battle and won, and will carry with me to the end its chief prizes—a hale heart and a contented mind." "Greed of gain, sir, has never been my motto. It is but a poor object to fill up every nook and cranny of a human heart from boyhood to old age, as it does with many." Again, in his own words, "I have always advocated temperance and detested drunkenness.[1] 'In my youth I never did apply hot and rebellious liquor to my blood, nor did, with unbashful forehead, woo the means of weakness and debility.' Ah, sir, I have seen wine make woeful wrecks of men and women too, recalling the powerful lines, 'Oh! thou invisible spirit of drink, if thou hast no other name to go by, let us call thee Devil.'"

"Rumty," to use the cognomen by which Parker is known to a wide circle of poor friends and patrons, made a fair start in life. His father, he assures me, was a sort of private gentleman having some means at his disposal. One brother served his country in the army, another followed the law as a profession, while our hero was apprenticed to a wholesale stationer in the city, his father paying a premium to his master. Beyond this Parker appears to have received no further pecuniary aid, so that when he completed his term of apprenticeship he had to make his way in the world single-handed. At this point in his career he had a number of business associates, but the ties that bound them together were soon broken, and their paths diverged. Some he lost sight of, others he accounted least likely to succeed carved out their fortunes for themselves while he became a journeyman vellum-binder. In this capacity he obtained work in different parts of England, and at last succeeded in getting a post as vellum-binder in the Stationery Department of the Treasury Office. He held this position under the Government contractor for nearly twenty-two years : but to continue our narrative in his own words :—

"At this time, I may say, I lay in clover. Like all gentlemen who labour under the wings of Government, I enjoyed short hours, and a very fair salary. My hours were from about ten to four. I cannot say I was over provident, otherwise I might have saved a trifle of money. I strove, however blindly, to make the most of the present, by devoting my leisure to the drama. I became acquainted with a distinguished prompter in one of the London theatres, and forthwith entered upon an after-hour dramatic career, while still in the Treasury in 1846. I appeared in 'Green Bushes' and 'St. George and the Dragon' at the Adelphi, as a super, of course ; but I soon rose to be St. Philip of Spain in 'St. George and the Dragon.' I must tell you I had previously appeared in Shakspearian characters at other theatres. But in

[1] The quotations were jotted down as they were uttered.

The Dramatic Shoe-Black

Othello I came totally to grief, and quitted the stage for a term, until, indeed, I made the acquaintance of the prompter. Another painful circumstance occurred. I had risen unaided to perform Hamlet's ghost. It was a packed house, and somehow I made a fatal blunder in pronouncing one word. In place of saying 'The glow-worm shows the *matin* to be near,' I said 'The glow-worm shows the *mating* to be near.' This was my first and last appearance as ghost, and you may be sure I got full credit for this original rendering of Shakspeare. I had my successes, too, I remember; one evening when the 'Mysterious Stranger' was on, the gentleman who had to play the corporal on duty failed to appear. The manager was in a fix, until, at the last moment, I volunteered for his part. I had only a few words to say in addressing the dealer in forged passports, but it was a success. After that I became a dramatic reader, got myself up in Goldsmith's 'Deserted Village,' and, in the costume of the period, personating Oliver himself. This brought me before many literary circles in different parts of London and its suburbs, but the pay was little better than that of a super.

"Suddenly I fell ill, lost the sight of my left eye, and had to leave my regular work at the Treasury. After partial recovery I went to Liverpool, to try my fortune there; but found no demand for my services as a workman or as a reader. Coming again to London I hoped to join my son, who was a bookbinder; this, too, proved a failure, as he, poor fellow, had a wife and young family to support. I felt I was a burden to him, and cleared out. Age, poor health, and feeble sight told on me woefully; there was work for younger and stronger men, and my one-sided experience in the Treasury had done me no good as a workman. At last, sir, from sheer necessity, I drifted into Lambeth workhouse. I have nothing to say against such public asylums; they are a great boon to those who cannot help themselves, and many a poor soul in this city would be in a sad plight but for their aid. It galled my proper pride, however, and it is painful for a man who has had anything like decent training to have to herd with worthless, profligate, and abandoned paupers. When I regained my strength I determined to try to earn a living by reading and reciting, as you will see from this card."

The card in question was inscribed with the name Jacobus Parker, Dramatic Reader, accompanied by a quotation from the *Parochial Critic*, which ran thus :—

"June 6th, 1871.
"An inmate of Lambeth Workhouse, Jacobus Parker, well known to the guardians, has taken his discharge, and is trying to earn a living by reciting portions of Shakspeare's plays. He has an excellent voice, capable of considerable modulation and expression. He is passing under the appellation of Jacobus Parker."

"Although," continued Parker, "I was dubbed by my admirers, 'William Shakspeare,' I did not confine myself to the works alone of the great dramatist, but recited as well portions from Burns, Thomson, Bloomfield, &c. My chief successes were in the 'Carpenters' Arms,' William Street, Kennington, where I have entertained many a gathering of my supporters. I still have what I call my Shakspearian cloak, and can give you, old as I am, a Shakspearian evening whenever you choose.

"Now, I am stationed as a shoe-black, at your service, armed with a peddler's licence. I get along fairly well. My pride, perhaps, stands in my way; and were it not for the unsought kindness of my landlady I would fair badly at times.

"I occupy a little room, a garret, all my own, for which I pay half-a-crown weekly. I suffer some annoyance from the brainless practical jokes of a pack of loafers, who have respect neither for old age nor poverty. To tell you the truth,

when I think of my past and present, I am surprised to find myself so happy and contented. My only care is to earn enough to carry me through to the close of each day. I have no bills to meet—no taxes save my licence—no burdens except old age, and that hangs lightly on my shoulders. I quite endorse the sentiment, 'True hope ne'er tires, but mounts on eagle's wings, kings it makes gods, and meaner creatures kings.' Thank God, mean as I am, I am blessed with that princely inheritance, hope, and with what the wealth of kings cannot secure, contentment.

"I have not told you that I was mainly indebted for my rescue from the Workhouse to the kindness of the Ex-Premier, Mr. Gladstone. I wrote to him, and he replied at once to me, a pauper, in a manner so kind that 'it brought my heart to my mouth.' He also sent his secretary to inquire into my case, and the result was a prompt grant of £10 from the Queen's bounty. This started me in the street, where I have since continued to earn a living.

"A shilling a day is about my average net profit; on Sundays I make a trifle over. Sunday morning brings me sundry boots to shine. But if I could get a half-crown reading once a week, I would gladly cut the Sunday work. I am not above cleaning Christian boots on Sunday, yet I would fain rest from my labours.

"Should any of your readers want a Shakspearian evening, I will get my cloak repaired, and rest on the Lord's Day."

"TICKETS," THE CARD-DEALER.

"TICKETS" comes straight from the " centre of civilization," and is a Parisian *pur sang*. He began life in the capacity of a linen-draper's assistant, in the Rue de la Chaussée d'Antin; but, though working in so fashionable a quarter, he was subjected to the grinding exactions which render the French *bourgeois* so unpopular, and social revolutions of so frequent occurrence. His employer made him work from eight in the morning till ten in the evening, and only allowed him a half-holiday on Sunday afternoons. For all remuneration "Tickets" received questionable board and lodging, and the munificent sum of sixteen shillings per month. It is not surprising that under these circumstances his somewhat adventurous spirit rebelled against so monotonous an existence, and in despair he finally joined the army as a volunteer. Though the French soldier vegetates in a condition of proverbial poverty, "Tickets" might have remained contentedly in the army all his life; but, after eighteen months' service, he was discharged on the ground of ill-health. It therefore became necessary for him to make a third start in life. He then tried his hand at agricultural work, and, as a farm-labourer, contrived at least to recoup his health; but this style of life was as monotonous and scarcely more advantageous than his previous existence behind the counter of the linen-draper's shop. He was, therefore, only too

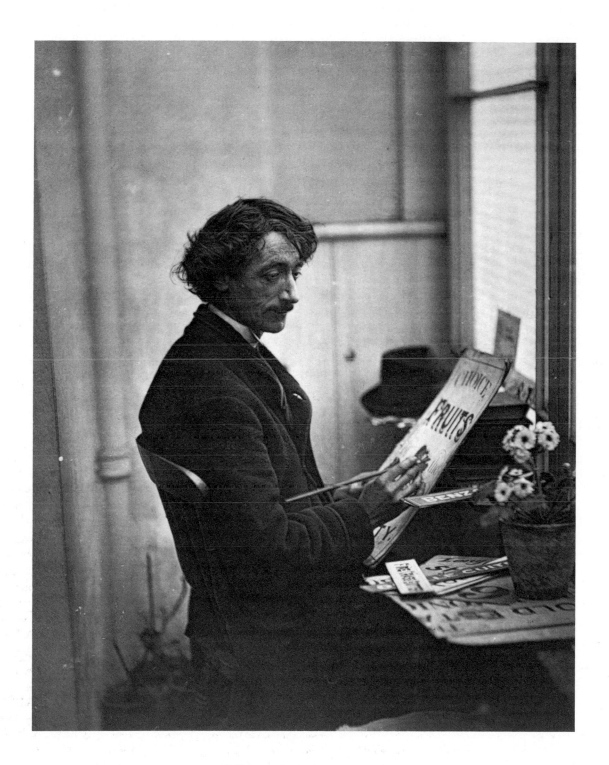

"Tickets," the Card-Dealer

pleased to avail himself of his father's assistance to emigrate. With many blessings, tears, and a few gold pieces, supplied by his parents, "Tickets" embarked at Bordeaux for New York. I need, however, hardly remark that he found it nearly as difficult to obtain employment in the capital of the States as in Europe; and after a month's useless endeavours he proceeded to San Francisco, *viâ* Panama. Here better fortune attended his efforts. After a fortnight's search, just as he was on the point of parting with his last gold coin, he was engaged to wash the dishes at the Miner's Restaurant. Though this was scarcely an exalted calling, he nevertheless earned his board and lodging, and thirty dollars per month. It was a decided improvement on his European experience; but the work was dirty, and otherwise objectionable. Awaiting, however, his opportunity, he profited by the first vacancy to present himself as candidate for the important post of waiter at the same hotel, and during six months he served the Californian miners with the huge portions of green corn, waffles, hominy, and other dishes favoured in the Far West. A better post was now offered to him as courier and interpreter on a San Francisco and Sacramento line of steamships, where his knowledge of English, French, and German proved of good service.

It seemed, however, as if "Tickets" could never settle down to any one distinct line of work, for in nine months' time he was engaged in the new capacity of private night-watchman over a warehouse, for a salary of $40 per month. Then again, a little later, his employer no longer requiring his services, "Tickets" migrated to Chicago, where he was raised to the dignity of Professor of French at a school, and enjoyed the munificent stipend of $50 per month. But he had not yet reached the zenith of his career. Employment, with a salary of $60 per month, was offered him as book-keeper and interpreter in an hotel at New York, and here, at last, the hero of this chapter seemed content with his fate, and remained faithful to his new task for two whole years. Unfortunately, nostalgia, fatal to so many emigrants, is more particularly disastrous in its effects on Frenchmen. New York seemed provokingly near to Europe, and Europe meant Paris and the Boulevards. "Tickets," after some years of prosperity, had saved money, and finally he stepped on board a Cunard steamer, and, long before he had realized his imprudence and appreciated his folly, he was landed at Queenstown. From thence to London was but a matter of a few hours, and here he arrived just in time to meet the great exodus of Frenchmen flying to our shore to escape the poverty and political persecution afflicting the mother country. On all sides "Tickets" was warned not to return to France, where the War and the Communal insurrection had destroyed all chance of obtaining employment. Had he possessed more foresight and a truer knowledge of the difficulties of his situation, he might have attempted to return to the States while he still possessed the means of paying the passage; but he hesitated, and indecision, as usual, proved fatal. His savings were soon spent, and "Tickets" found himself in the most forlorn of all positions, that of a penniless stranger in this huge wilderness called London. Unprotected by friends or recommendations, he was treated with suspicion by every one, and his solicitations for work elicited no response. At last he was compelled to leave his modest lodgings for the still cheaper accommodation of a common lodging-house.

The first money "Tickets" ever contrived to earn in London was obtained from the manager of a theatre where he appeared as a "super" for the ordinary pay of a shilling a night; but, as he had now been reduced to that stage when daily payments are an absolute necessity, he had to give twopence interest on each shilling to the foreman, who paid him every evening instead of once a week. This extortionate interest is frequently imposed by the foremen who manage the "supers" at the various

London theatres. Sometimes he was given prospectuses to distribute in the streets, and received in payment two shillings a day ; but the work was very irregular. On other occasions he attempted to sell maps of London, but he was not well enough dressed. When he entered offices to show the maps he was condemned to a bad reception, by reason of his dilapidated appearance ; and ultimately abandoned this work as hopeless.

About this time " Tickets " made the acquaintance of a Frenchman who possessed considerable skill as a sign-painter ; and the two forthwith entered into partnership. The one paints, the other undertook to travel. " Tickets " is the traveller. From morning till night he wanders about, looking into the windows of small shops, till he discovers a ticket of dingy appearance, stained in colour, dog's-eared, bent, and altogether disreputable. With eagle eye all these defects are discerned, and " Tickets " enters boldly into the shop, to press on the tradesman the advisability of purchasing a new ticket. He undertakes to supply a precise copy of the old and worn announcement on a better piece of cardboard, freshly painted, or, perhaps, more elaborately ornamented. But the tradesmen do not respond readily to these offers. The small linen-drapers are perhaps his best customers, as they constantly want tickets with " Only 1s. 11¾d.," or " Cheap," or, again, " The latest novelty," inscribed thereon, and destined to be affixed to the soiled, dear, old, and waste stock, which must be sold to ignorant and deluded purchasers. These tradesmen must of course be approached with considerable care. On Fridays and Saturdays they are far too busy to listen to such solicitations, and " Tickets " prudently awaits till the beginning of the week, when they are less occupied, selecting in preference the morning. On the other hand, common eating-houses are more assailable in the afternoon, after the dinner-hour. Here there are tickets such as " Try our own dripping at 6d. a lb.," or, " A good dinner for 8 pence," &c. The steam, the grease, the close atmosphere of such establishments soon tarnish these cards, and " Tickets " has enjoyed many opportunities of announcing to the world the price of dripping in clean new letters.

The price charged for an ordinary card is generally a shilling, each letter measuring two or three inches in size. The money is thus divided :—" Tickets " gives his associate 4d. for painting the card ; but he supplies brushes, colours, ink, cardboard, &c., and this he estimates generally at a cost of about 3d. There remains, therefore, a profit of fivepence, to remunerate the trouble and time spent in getting the order. Of course there are many cards that cost more than a shilling, but the division of the benefits is generally maintained in about the same proportion. " Tickets " declares that if his associate had several travellers seeking for orders, and, if he were fully employed from morning till night, he might earn nearly twenty shillings a day at the above rate of remuneration, the chief difficulty being to get the orders. Even while reserving 5d. in the shilling, " Tickets " has never made more than fifteen shillings in a week ; eight to ten shillings is the most usual result of his efforts, and on one occasion he only made four shillings. Sometimes, however, " Tickets " himself takes the brush in hand, and, as it will be seen, even ventures to copy from nature.

Under such circumstances economy is not only a virtue, but a necessity ; and, but for the frugality and sobriety which generally distinguish a Frenchman, " Tickets," as he is familiarly called by the poor among whom he lives, would have come to grief long ago. Indeed, I could not help noticing that he was treated with a certain amount of respect by his neighbours, and I was not surprised to hear that his story elicited the sympathy of a philanthropist whose name should be familiar to the reader. Mr. George Moore happened to call last Christmas at the model lodging-house where " Tickets " and his associate used to live. He was so interested in their little

industry that he determined to give them a better start. The painter had considerable difficulty in accomplishing his somewhat delicate task in the crowded kitchen and common room of the lodging-house; Mr. Moore consequently furnished a private room for him, and paid a month's rent in advance. On the other hand, to facilitate "Tickets" in his efforts to obtain orders, he bought him about thirty shillings' worth of clothes; and since then the associates have been able to work their business with more success. The bad weather has, however, been a great bar to their prosperity. Cards are only required in fine weather, when pedestrians loiter about, and there is a better chance of tempting them by startling announcements affixed to the goods in shop windows. Nevertheless the hero of this chapter is still buoyed by sanguine expectations. He hopes that the number of his customers will gradually increase, and that he will be able to save on his earnings. Then, like a true Frenchman, he will return to France, and purchase the goodwill of some small shop. In the meanwhile he observes the strictest economy. He never drinks. His bed costs him two shillings a week. His breakfast consists of cocoa and bread and butter, the former being more nutritious than tea. For dinner he generally consumes a pennyworth of potatoes, with a herring or a haddock and a cup of tea, while his supper consists of bread and cheese to the value of twopence. It is only on days of exceptional good fortune that he indulges in a little meat. For a man of comparatively speaking good education this is but sorry fare; and I could not help thinking, while listening, as one by one "Tickets" related the various incidents of his career, that his first employer, the linen-draper of the Rue de la Chaussée d'Antin, had perhaps lost a good servant. If this Parisian tradesman could have displayed a little more kindness and consideration, his assistant would not have been tempted to embark on a life of adventure ending in shipwreck amid the slums of London. A. S.

THE OLD CLOTHES OF ST. GILES.

UT few articles change owners more frequently than clothes. They travel downwards from grade to grade in the social scale with remarkable regularity; and then, strange to say, spring up once more with new life, to be worn again by the wealthy. A coat, for instance, after it has been well worn, comes into the hands of an individual known in technical parlance as the "clobberer." This person is a master in the art of patching. He has cunning admixtures of ammonia and other chemicals, which remove the grease stains, he can sew with such skill that the rents and tears are concealed with remarkable success, and thus old garments are made to look quite new. Ultimately, however, a stage is reached when the most skilful manipulation fails to redeem the tattered coat; and it is at this moment that the offices of the "translator" are requisitioned. This gentleman is skilled in the art of amputation. A coat in his hands may be put to many uses. The skirts, being the least worn, are readily converted into waistcoats or

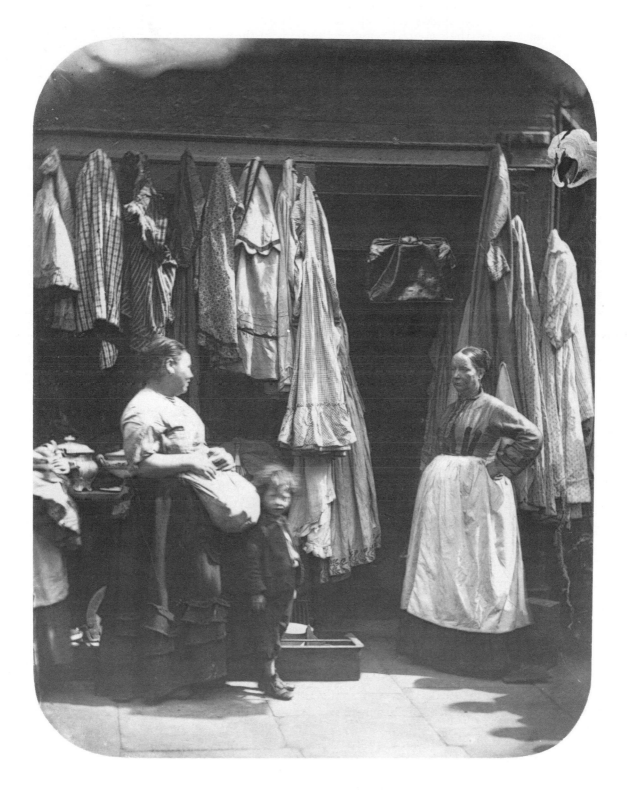

The Old Clothes of St. Giles

small jackets for children. From the other portions of the cloth pieces are selected, turned, and cut to make the caps sold to foreign workmen, and exported in great numbers. Nevertheless, and notwithstanding all these conversions, the original piece of cloth gradually wears out so completely as to become absolutely unfit for use by even the most ragged among the poor of Europe, and then it is that the hour of regeneration is near at hand. Merchant-princes now become the eager purchasers of these disgusting rags. They constitute the "devil's dust" of the Yorkshire woollen manufacturer. The cast-off clothes of all Europe are imported to supply food for the mills of Leeds, Dewsbury, Batley, and other great industrial centres. Here they are torn into shreds by toothed wheels, animated with all the power of steam, till they are reduced to the condition of wool. They may then be mixed with a certain amount of new wool, and finally reappear as new cloth, woven according to the latest pattern, and resplendent in the dye of the most fashionable colours. Thus the cloth of our newest coat is, after all, probably made from the cast-off garment of some street beggar! Sometimes, however, we escape wearing other people's old clothes, but then we drink them instead. That is to say, hops of a certain description flourish best when manured with old woollen rags, and thus are old clothes converted into foaming beer!

The accompanying photograph represents a second-hand clothes shop in a narrow thoroughfare of St. Giles, appropriately called Lumber Court, where several similar tradesmen are grouped together, all dealing in old clothes and furniture of a most varied and dilapidated description. It is here that the poorest inhabitants of a district, renowned for its poverty, both buy and sell their clothes. During the time I was prosecuting my inquiries in the court, I noticed, however, a greater disposition on the part of its frequenters to sell than to buy. First, one woman came to dispose of her husband's tools, than another wanted to sell her children's clothes, and a third sought to raise money on a couple of nickel forks. These offers were for the most part refused by the dealer, who with stolid countenance announced that she was "not buying anything to-day;" thereupon, the articles were proffered at a great reduction, but, being of little value, were generally refused. Sometimes, amid the rubbish accumulated in these shops, some rare articles of virtu may be found; the dealers themselves often ignoring the worth of the treasure which has accidentally fallen into their hands. Connoisseurs are therefore constantly sauntering past for the purpose of discovering objects of this description. As a rule, however, the bulk of the business transacted, relates to the sale of clothes, and it is at such shops that the majority of those individuals who earn a promiscuous livelihood in the streets of London, succeed in clothing themselves for a minimum outlay. Few persons have a better insight into the hard side of life than the dealers in old clothes; for it is to them that are brought the refuse apparel which has been rejected by the pawnbrokers as unsuitable guarantee for even the smallest loan. Indeed, the influx of rubbish to these shops is so considerable, that it has been worth while to organize a regular system for sorting and removing such refuse. Thus, two or three times in a week, a man comes to Lumber Court, and purchases from the shops all the old tin they have been able to collect. Worn-out tin kettles and coal-scuttles are still of use. The best pieces can be cut out, covered with cheap black varnish, and sold to trunk-makers to protect the edges and corners of trunks. If the tin is not strong enough for any mechanical purpose, the chemist can combine it with other substances, and thus form salts that are of great value to the dyer and ink-maker.

There are also men who collect surplus stock of old clothes, which are sold again for manufacturing purposes, as I have already described, or are sometimes taken to

Petticoat Lane. The fact, however, that these objects pass through so many hands, each dealer making his profit on them, suggests that the poor person who is reduced to the necessity of parting with a portion of her clothes, can get but very little for them. Hats are also a favourite article of trade. It is perfectly astounding how the oldest hat may be renovated. The lower and greasy portion is cut off; and a second-hand silk hat may generally be recognized by the shortness of the crown. Then, by dint of ironing, brushing, and combing what remains of the silk, it is made to lay smooth and sleek; while ink, glue, gum, paint, silk, and brown paper, cover, hide or fill up the breaches which time and wear have achieved. Thus, for two or three shillings, a hat is sold which really looks as if it were new. But let the wearer beware of the first shower. His umbrella must be stout, and held with a steady hand, if he would prevent the disclosure of all the deception practised in the renovation of his second-hand hat.

The dealer whose portrait is before the reader cannot boast of a large business. She had been unfortunate in previous speculations, and illness had also crippled her resources, so that her stock is limited, and her purchasing power still more restricted. Under these circumstances she declared that on an average she was unable to make more than thirty shillings a week net profit, which is a very low estimate for persons engaged in this business. I could not help concluding, however, that ignorance was to some extent a bar to greater success. Her knowledge of the value of some old books and some wretched oil paintings was of the vaguest description, and she confessed to having sold a quarto law book, published during the reign of James I., for half-a-crown, which she afterwards discovered could not be bought back for less than two guineas. Such mistakes on the part of dealers are of frequent occurrence; and the opposite extreme may also be noted. It often happens that they ignorantly assume that some ornament is more scarce or has a far higher value than is really the case; and, therefore, it was with some bitterness of feeling that the dealer in question remarked, " There are such a number of persons about who know the value of things." Nevertheless, it would not be fair on my part to conclude this criticism without adding, that if the dealer was ignorant in matters relating to literature and fine arts, she was at least master in the art of keeping her home clean, even under the most difficult circumstances. As a rule, second-hand clothes shops are far from distinguished for their cleanliness, and are often the fruitful medium for the propagation of fever, smallpox, &c. In this case, however, the floor was well washed, the shop carefully dusted, the goods kept in order of merit, and the grate resplendent in all the glory of unstinted black lead. A door at the back admitted a thorough current of air, and the presiding genius of all this adroit organization seemed fully alive to the importance of good ventilation. Perhaps these rare qualities explain the fact that trade is slack with her. Cleanliness is essentially distasteful to, and is even considered " stuck up," by a large section of the population.

<div align="right">A. S.</div>

A CONVICTS' HOME.

I N Drury Lane there is a house which has been celebrated for more than a century. It was a "cook-shop" in Jack Sheppard's time. This notorious criminal often dined there, and it is now still frequented by hungry convicts or ticket-of-leave men, who find kindly welcome and may, if they choose, receive wholesome advice from the owner of this strange establishment, whom I now purpose to introduce to the reader. Mr. Baylis, by no fault of his own, as he himself justly urges, was born under most unfortunate circumstances; though in legal parlance a *filius nullius*, he was in reality the son of a highly-respectable and wealthy magistrate of Oxford. His mother had been a maid-servant in this gentleman's house; and, as the position of the latter improved, he imagined it indispensable to rid himself at once of both mother and son. The former he contrived to marry to some ruffian well known in the slums of Westminster, and who was probably glad to accept the bribe which I presume must have been offered him. As for the boy, he had been for some time at a school at Chipping Norton; his marvellous likeness to his father occasioned, however, so much gossip that he was finally despatched to London, to fight his own way in life, though but nine years old. This occurred in 1839, so that the journey was performed in a coach, and Baylis was met on his arrival by his mother and a strange man whom he was told to call father! The poor boy, however, though scarcely able to understand his position, nevertheless refused to confer on the stranger a name implying a sacred tie he knew did not exist between them. At the very onset he conceived a deep dislike to the man, and subsequent experience proved that he had judged him correctly. His mother's husband was one of those low bullies who are familiar with every vice. He lived in Westminster, and behaved in so brutal a manner, constantly beating his wife, always quarrelling, and often drunk, that the poor boy scarcely dare show himself in this wretched home. The life of a street Arab was a preferable alternative, and Baylis therefore left his mother's lodgings to pick up his fortune in the gutter. He slept anywhere, that is to say, on doorsteps, under bridges, or at times he would have the good fortune to creep unperceived into a cart or cab left in a wheelwright's yard to be repaired. As for money, he occasionally received a few pence for holding horses, or at times he was engaged to blow the bellows at a smithy. The first regular work was obtained in 1840, when he was engaged as errand boy by a doctor, who gave him the munificent salary of eighteen pence per week, but ultimately discharged him for playing at marbles!

During several years Baylis continued leading the life of an Arab, living in a semi-wild state, fighting innumerable battles, enduring the tortures inflicted by the bullies who abound in the streets; often starving, generally underfed, and always in rags. At last, inspired with lofty ambition, the poor boy migrated from Westminster, thinking he would find more gentle treatment and better fortune the other side of the Park. Nor was he disappointed in his anticipations. He made friends in the parish of St. James, and was given something like regular employment at a blacksmith's

A Convicts' Home

forge in Ham Yard. This, however, did not last for long, and young Baylis had to resort to many expedients to keep body and soul together. Nevertheless, during all these trials and struggles, he always proved himself willing to work and thoroughly trustworthy. These qualities attracted the notice of some neighbours, and he was sometimes given work which testified to the confidence of his employers. He was admitted into some good houses ; and it was while engaged cleaning the windows of a fashionable apartment in Jermyn Street, that fortune suddenly smiled upon him through a pane of glass. The door of the back room had unexpectedly opened, and a swarthy gentleman made his appearance in a long robe slashed with gold braiding and a smoking-cap resplendent under the glitter of a gold tassel. Alarmed at the splendid presence of this gentleman, the street Arab hastily snatched up his basin of water, his rags and leather, and attempted to leave the room. But the gentleman in gold called him back, and after ascertaining that Baylis lived alone, had practically speaking no parents, but bore a good character in the neighbourhood, he engaged him as his valet. The boy pathetically pointed to his ragged clothes, and suggested that he was totally inexperienced in the duties of a valet; but these objections only increased the gentleman's desire to secure his service. He gave him several suits of clothes and promised, what seemed fabulous wealth to the poor boy, namely a salary of £1 per week. To the street Arab this sounded as if the gates of El-dorada had been thrown open. He had no fault to find with his new master. He was a foreigner, but evidently extremely wealthy, for he sent Baylis to cash a cheque for £200 every week. Further, he was constantly at the Russian embassy, and once a week Baylis took a letter to be registered at the Post Office, addressed by his master to his Majesty the Emperor of all the Russias! Evidently this distinguished foreigner was a secret emissary of the Russian Government, and he thought it safer to engage a street boy as his valet than some gossiping consequential London flunky, who would have known the servants of many leading families, and spread through them many dangerous rumours concerning the mysterious avocations of his master.

For some years Baylis enjoyed an easy and almost luxurious life. He was even able to save some money, but his master was ultimately called to the continent, and after travelling with him some distance, he received his discharge when at Dresden, together with a handsome present. The Russian gentleman had been compelled to return to his own country, and for some inscrutable reason could not take his servant with him. On returning to London, Baylis sought for another similar situation, but he had only a written reference to show, his former master was too far away to confirm the good character he had given his valet. Gradually, Baylis spent all the money he had saved in advertising and waiting for employment, so that at last he was glad to accept very inferior work at a ginger beer manufacturer's, and was subsequently in the employ of a well-known West End grocer. After some three years spent in these somewhat monotonous and scarcely remunerative occupations, Baylis contrived to learn the art of taking photographs ; and entering into association with a more experienced friend, they took to the road armed with their camera. Their first stage was at a public-house at Uxbridge, and, as photography was quite a novelty in those days, a great number of persons came to have their portraits taken, and at the same time, did not fail to partake of whatever refreshments could be obtained at the bar. Thus the itinerant photographers found ready allies at the public-houses they passed on the road ; and still further to cement the bond, Baylis finally married the daughter of one of these friendly publicans.

With the advent of the dark months, however, photography became more difficult, and Baylis and his bride came to spend the winter in London. As, however, some-

thing had to be done for a living, he joined the police force for four months; but, when summer came round, a child was born, and under these circumstances Baylis was obliged to abandon his hope of resuming the roving life of a photographer. Instead of four months, he remained seven years in the police, and finally only left the service in consequence of ill-health. His experiences as a policeman would in themselves form an interesting chapter. He was one out of a dozen selected to suppress the garrotting so extensively practised some years ago. Dressed in plain clothes, he was commissioned to watch for these footpads, and had the satisfaction of catching one in the very act of garrotting a gentleman. He was also appointed to a beat comprising the Adelphi Arches at the time when public opinion was so strongly moved concerning the scenes enacted under the dark shades of these lugubrious passages. This brought him into personal relation with Charles Dickens and Mr. G. A. Sala, with whom he had many pleasant conversations while guiding them through the intricacies of the Adelphi Arches and explaining all the mysteries of this notorious resort.

Like many other policemen, he had often been able to live rent free by occupying uninhabited houses. He was once asked to take up his quarters in the cook-shop of Drury Lane, while the house underwent some repairs; and when it was re-opened he remained there as a lodger. As time rolled on, he observed how the business was managed; and, being of a mechanical turn of mind, conceived schemes for various improvements which would economize the fuel and utilize the steam used in cooking. Finally he contrived to purchase the goodwill of the house; and, since that day, has been the presiding genius at all banquets the poor here enjoy. For fourteen years he has taken delight in serving the wretched people around him; but, remembering his own past experience, his generosity is unbounded towards the pale faced street Arabs who with hungry eyes frequently throng about his door. His thoughts are constantly occupied with the fate of these children, and he anxiously inquired whether I had any hope that legislature would or could adopt some effective means of protecting the children who had no parents and are left to learn every vice in the streets of London. In the meanwhile, they can, in any case, obtain enormous helps of pudding for a penny, and even for a halfpenny. Nothing is wasted in this establishment. All scraps are used, and those who cannot afford to pay for a fair cut from the joint can obtain, for a penny or twopence, a collection of vegetables and scraps mixed with soup or gravy, that contain a good proportion of the nutritive properties of meat.

This shop is, however, chiefly celebrated as the abode of ticket-of-leave men. Placing himself in connexion with the Royal Society for the Aid of Discharged Prisoners, these latter have been sent to lodge in Mr. Baylis's house. On their arrival from prison he gives them a week's lodging and board on credit, and also exerts himself to the utmost to find them employment. Possessing great experience in the treatment of criminals, he is soon able to detect those whom he may trust from those who are hopelessly lost to all sense of honour and honesty. The latter he is perforce obliged to dismiss, while the former generally obtain employment, and live to thank him for having redeemed them from the abyss into which they had fallen. Indeed there have been even marriages celebrated from this convicts' lodging-house—an ex-convict figuring as the bridegroom, and, in one instance at least, a very respectable tradesman's daughter as the bride. I should add, that one of the released prisoners ultimately married a widow who possessed fifteen houses! In fact experience seems to have confirmed the great faith Mr. Baylis places in convicts who, after a certain time of probation, show themselves really disposed to earn their living honestly. In many cases the good influences brought to bear in this house have certainly

produced the very best effect; and I have had the pleasure of sitting down to Mr. Baylis's table with half-a-dozen of the best behaved and most inoffensive men (who were, I was informed, convicts) that I have met in the course of Street Life study. In their conversation, these men displayed an earnest determination to work, they alluded but charily to the time when they "got into trouble," and did not resort to any hypocritical cant. Indeed, those who assume a pious tone, quote the Bible, and talk about "being saved," and "God's help," and so forth, are generally the least to be trusted.

It is to be regretted that the accompanying photograph does not include one of these released prisoners; but the publication of their portraits might have interfered with their chances of getting employment. Ramo Sammy, therefore, stands at the door of the convicts' home instead. This characteristic old man, familiar to all Londoners as the tam-tam man, lives nearly opposite the cook-shop, and often has his meals there. But the old Indian is getting weak; he does not strike his drum with his wonted energy; and it is to be hoped that Mr. Baylis, who is officiating behind the counter, will find a tit-bit for him from time to time, so as to revive his ebbing vitality.

A. S.

THE "WALL WORKER."

"MY friend Cannon," said Jacobus Parker one day,* "like myself, has had a remarkable career. But he enjoys a fine property in the crossing he sweeps, and in 'wall working.' With the latter I help him as much as I can, as he has fallen into poor health lately. I exact a trifle by way of payment for my aid, quite as much on his account as on my own. It enables him to feel happier and more independent."

One of the most pleasing phases of the life of the poor is found in the sacrifices they make to help each other in times of trouble. In the case under notice, the service offered and gladly accepted by Cannon was all the more grateful as it was not absolutely gratuitous. The recompense rendered for the timely help was in itself so inadequate—sixpence a week— as to leave no doubt that it was the mere subterfuge of a kind-hearted, sympathetic friend.

Cannon, who is pictured seated on the right of the accompanying group, was the son of a boot and shoemaker. He served his apprenticeship to the trade, and afterwards worked for some years as a journeyman, in the days when boots and shoes were solely made by hand. At last, with a capital of ten shillings, he started on his own account. With this amount he bought material sufficient for a dozen pairs of children's shoes. His wife bound the shoes, and he spent his days and nights in finishing them for the market. The energy and perseverance of the young couple was rewarded by an influx of large orders, and by the accommodation secured in opening credit accounts with the dealers in raw material. The smallest pieces cut from the leather of walking shoes were carefully reserved and manufactured into slippers. Twenty-four shillings was the price received per dozen for children's morocco boots—a price which yielded a good return for the labour bestowed. "In those days," said Cannon, "money came freely, and, alas! was spent as freely as it came." Large sums passed through

*See p. 47.

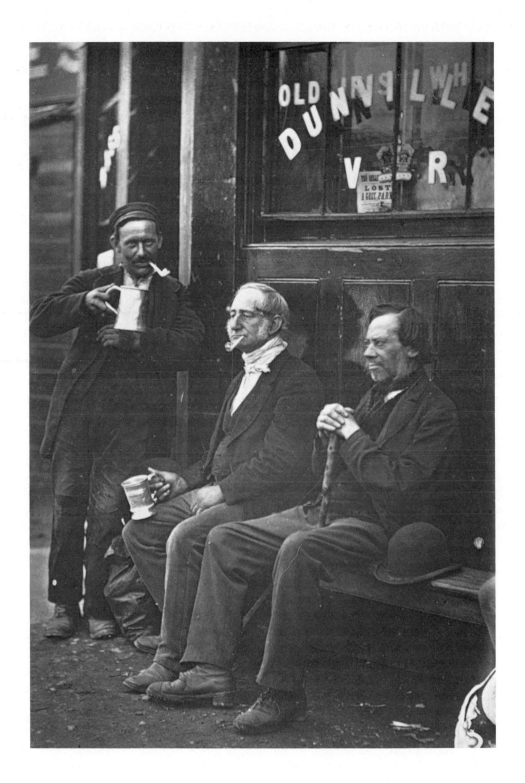

The "Wall Worker"

his hands and always left a satisfactory profit behind, amounting to as much as a shilling per pair on the small morocco boots. Cannon, having borrowed ten pounds from a friend, proceeded to extend his operations by employing labour and devoting his own time to the working of the business. At this stage of his career he experienced no difficulty in obtaining twenty or thirty pounds' worth of material on credit; but a portion of the goods manufactured had to be mortgaged to the merchant who supplied the material. Cannon accounted himself a prosperous man. His business was flourishing, and he had a reserve fund of about fifty pounds to his credit in the bank. But with fatal fatuity, instead of jealously guarding this reserve, it was now and again taxed to meet the cost of a day spent in luxurious, and withal, hardly-earned ease. The hour of reckoning soon came, when all his energy and resources were put to the test. The outbreak of the Crimean War brought many unforeseen troubles upon men who had no active share in the conflict. It fell heavily on Cannon in his peaceful pursuit of boot and shoemaking for children. He had, at the time, about thirty outdoor workers in his employment. Some of his most expert hands, men "who could make a shoe a'most when lookin' at 'em," were seized with the war fever and enlisted. "In fact, sir," said Cannon, "good men were not to be had for love or money; and, worst of all, leather rose awful—out o' my reach. It mounted up as high as a shilling per pound on the old price. I could not get the same article for ten sovereigns that used to fetch five. Men's wages, and duffers they was that demanded them, rose one-half. Fellows no good either for 'sodgerin'' or 'shoemakin'' got more good money than I could spare for bad work. What little I had by me melted off 'like snow in summer.' As the war went on, these even enlisted—one decoyed another away. The advance in the price of the finished article didn't half cover the increased cost in makin'. I was willin' to work, God knows! but it was like sittin' up a straw to stem the tide. It was all too strong for me. I lost my footin' and drifted down. I had no man to lend me a helpin' hand. I was fairly knocked over, and when a man's fairly over, he begins to find out his friends. I found none. When the men returned from the war, they wanted to come back to me, for I had dealt fair with 'em; but I was broke, and could not take 'em on. I gave up everything; was sold up—every stick of furniture went—and, with the odds and ends of my home I had gathered about me, went my heart—my pluck! I sickened, and having no bed—nothin'!—I drifted into the workhouse. I lay there for three months, and feelin' stronger one day, I got up, went out, and was restin' again the rails at Kennington Church. There, sir, a gentleman came to me, and, says he, 'You look very hard up, my friend.' 'You never spoke a truer word,' says I. 'Well,' he went on, 'the man's dead that swept this crossing. If you're not above the job, will you accept a new broom and set to work.' I took the broom, and it put new life in me. The first afternoon I earned three-halfpence. Next day I got sevenpence-halfpenny. My new friend advised me to follow it up. I did so; and after a bit made a shilling, and at times one-and-threepence a day. When I got known, I managed to pick up my food from day to day. I got to be trusted too, with parcels, letters, and such like; but now the trains and 'busses have took that from me, and it's next to nothin' I make that way.

"My health was too bad to allow me to go back to my old trade, and I had no knowledge of the new machinery they was took to usin. My missus had to go out washin' and such like, and used to earn about a shilling a day. I was ill then, but I'm a deal worse now. I thought nothin' of hardships when I could go about; but bronchitis, or asthma, brought me so low at times,—no tongue can tell the misery I suffered. I have to give up the broom, and carpet-beating, so that my only stand-by is the 'wall working.' My old friend Parker gives me a hand to mind the boards."

The "wall working" or fence working, described by Parker as a "fine property," is a system of cheap advertising. Where a portion of a wall or fence, near some public thoroughfare, can be rented or obtained gratuitously, it is covered with an array of boards, which are hung up in the morning and taken in at night. In this instance, the boards covered with thin bills are supplied to Cannon, who hangs them up in the morning and receives about a shilling weekly for each board. But the number of boards afford no clue to the income derived from this mode of advertising, as an indefinite number of dummies are displayed to fill up vacant spaces. The dummies are carefully selected; the advertisements they carry must be as imposing as the names of their owners are respectable. Cannon assured me that it required tact and experience to manage this sort of property. Unfortunately the dummies have been dominant of late, owing to depression in all departments of trade. The result is that the "wall worker's" property produces a return so poor as hardly to repay the pains bestowed on its management.

Cannon and his wife occupy a room, or garret, in the neighbourhood. It is almost devoid of furniture, and their bed covering, even in cold weather, consists of a single sheet and the old coat which the husband wears during the day. This aged couple pay a weekly rental of half-a-crown, while the balance of their joint earnings goes "for a crust of bread."

The figure in the centre of the group is that of an old-clothes man who has followed the same rounds for some half-century. But the trade in cast-off clothes has fallen very low indeed, at least so he assured me in the following prophetic words:—

"Business, sir? don't talk of business! It's going clean away from us." In the "us" were included collectively the merchants of the British Isles, as will appear evident from the following remarks:—"The country is going down-hill; seventy-five per cent. fall in the trousers of an Englishman means no good. Such articles were all honest wool when I took to collecting; but now flash and flimsy is the style. Steam-dressed goods, cotton and dye and shoddy's all the rage. Long ago it was all fleece and no fleecing. When a gentleman tired of an honest coat, he handed it over to me; I put a new face on it, and it was as good as bran new to a poor man. Now, renovating and reselling at a decent profit is out of the question. It comes of the pride of the working classes, trades' unions, strikes, and such like—and fashion, sir, fashion! Fashions used to last a lifetime, and coats were worn till their owners tired of them, and they went down the scale respectable to dress the labouring classes. But labourers now ape their masters and buy at first-hand, because they would be gentlemen on their many holidays, when they've left hod and spade to loaf and lark at leisure. My occupation is therefore nigh gone, since I don't buy of the uppermost swells. It's my solemn opinion that things are fast going to the dogs. We live in a flashy age—nothing solid, nothing substantial—all show and tinsel! That's the world from my point of view; and although I am an old-clothes man, I can draw my conclusions from the signs of the times. I can tell a man from his clothes. There's the gentleman that's cut, and fitted, and padded like a man; and there's the ready-made shopman —trousers ten shillings, and all the rest of it. His clothes would not be worth a bid after a fortnight's wear, and he wouldn't sell them until they are only fit for mashing up or manuring a field. I have, of course, my regular customers, but even they are not a patch on what they used to be for profit."

If space permitted, I might add many more sharp remarks uttered by the "old-clo'" dealer; but, even as it is, I have omitted to give any details concerning the third figure in this group. On some future occasion I may, however, be able to write a brief sketch of this latter character.

COVENT GARDEN LABOURERS.

HE number of persons who obtain out-door or street work at Covent Garden Market is so considerable that it is necessary to devote more than one chapter to the subject. Some account has already been given of the flower-women who frequent the market; and the accompanying photograph represents a group of labourers who are in the service of Mr. Dickson, the well-known florist. Their business is strictly limited to flowers, and they never touch either vegetables or fruits. Nevertheless I am informed that there are five hundred flower stalls at the wholesale flower market, and, at a rough computation, two thousand men are engaged to bring and grow stock for these stalls; while another two thousand men find employment in distributing the flowers to their various purchasers. Only a small proportion of these latter are seen at Covent Garden during the daytime; it is in the early morning that they congregate on this spot, and they are soon scattered again to all parts of the metropolis, laden with plants of every description. The labourers employed by the tradesmen who have shops or stalls at Covent Garden are divided into the job-workers and the regular hands. The former are by far the most numerous; and, but for their improvidence, might be as well-off financially as those who receive regular salaries.

The odd-men, as they are sometimes called, are paid for each commission they execute, for every parcel they deliver. Indeed they are often paid twice over—once by the tradesman who has sold some flowers, and again by the purchaser on the receipt of the same. In busy times, therefore, these men may occasionally make as much as £2 10s. in a week. On the other hand, and during the dull season, they often pass entire days without earning anything at all, and at best scarcely obtain enough to procure the barest necessaries of life. If, however, they were able to strike an average in their earnings, never spend more, and save from the prosperous season to meet the exigencies of the less busy months, they would lead a life of comparative comfort. But such prudence would be altogether foreign to their natures. Resisting the temptation of spending the money actually in hand would be considered a far greater hardship than the privation to be subsequently endured. The greater number of these men are bred and born in the immediate neighbourhood, and not a few are qualified under the generic term of Seven Dials Irish. On the whole, however, they are a reliable body: they are addicted to drink, and occasionally present themselves at the house of a customer in a very disgraceful condition; but disasters of this description happen more or less in all trades where a number of unskilled labourers are engaged to fetch and carry. At the same time, any gross misconduct is not tolerated. The men have to obtain a ticket from the superintendent of the estate, for which they pay eighteen pence. This gives them the privilege to ply for work at the market; but this licence is withdrawn when complaints are made against the bearer.

From this large class of chance labourers a few are selected, for their steadiness, or energy and willingness, and offered regular employment. A position thus acquired

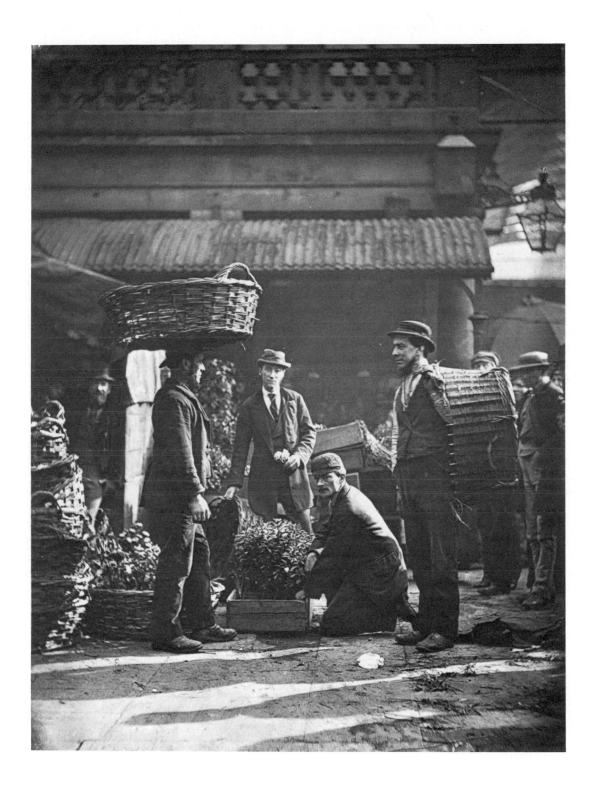

Covent Garden Labourers

is at once more respectable and certain; the men have the disadvantage of working very hard during the busy season for the same rate of wages; but, on the other hand, they are equally well paid when there is nothing to do. Early in the morning, before five o'clock, the men have to be in readiness to carry from the wholesale market the stock bought for the day's business. This has to be arranged all round the shop, with a view to effect; and, as the day approaches, ladies and gentlemen come from all parts of the metropolis to give orders or to select flowers. Hampers are filled and rapidly carried off to the houses of the various purchasers. Then there are ball-rooms or dinner-tables to be decorated. Steady, trustworthy, and experienced men must be engaged for such work. They must also possess some taste, and a certain artistic sense of the fitness of things, or they would be unable to group the flowers in a harmonious manner. It is not surprising, therefore, that men gifted with these qualities should often earn thirty to thirty-five shillings a week. Their wages, it is true, rarely amount to more than £1 per week; the rest is derived from customers who consider themselves bound to give small gratuities.

There are also a few men who through ill-health or lack of muscular strength cannot carry heavy pots of flowers, and these are employed in the bouquet department. They help to gum the flowers, to sort and cut them. It will have been noticed how firmly the leaves of a flower adhere to the stem, though it may be in full bloom and subjected to an unnatural ordeal of travelling and shaking. This result is obtained by dropping a little gum into the centre of the flower. It is quite imperceptible when dry, but it causes the leaves to adhere so firmly that death itself often fails to make them drop off. I had a long conversation with one of the men who devotes the greater part of his time to this work. He is located in a cellar underneath a shop in the central avenue; and justly complains that his employment is most unhealthy. The scent escaping from the mounds of flowers that surround him in so confined a space is very deleterious, and induces chronic headache and much uneasiness. But for an occasional change of air asphyxia would result. Then again his eyesight is seriously affected. If, for instance, he is busy during a whole day gumming nothing but geraniums, the constant and unrelieved glare of the red overbalances and disturbs the power of vision.

In the arranging of flowers for bouquets or button-holes women are preferred. They display more taste, and the button-hole flowers are so gracefully combined, and so rare and exquisite, that they are generally sold for a shilling or eighteen pence—a rather extravagant charge for an ornament that can only last a few hours. It has become the custom to place them in glasses by the plate of each guest at dinner parties; so that, though about the same number of "button-holes" are sold, they are for the most part bought by the hostess, and not, as formerly, by the gentlemen guests. There is also a fashion in the colour of flowers, for they are selected to match the style of dress in vogue. Thus for the present year pink-and-white and yellow-and-white flowers are at a premium, and *de rigueur* in fashionable circles. But as the Court is condemned to mourning, white flowers must for the moment assume the ascendency, to be relieved with the violets in autumn should the mourning continue.

During the winter a second or Christmas season revives the trade in Covent Garden and then the flowers sold are for the most part imported, a great many coming from Nice. In the summer season, the English flowers, reared at a distance of about twenty miles from London, have almost undivided sway over the popular taste. To the labourers, however, the origin of the plants is of little consequence so long as the pots do not weigh too heavy, or if liberal " tips " are forthcoming to reward them for carrying these attractive burdens.

A. S.

HALFPENNY ICES.

ITALIAN ice-men constitute a distinct feature of London life, which, however, is generally ignored by the public at large, so far as its intimate details are concerned. We note in various quarters the ice-barrow surrounded by groups of eager and greedy children, but fail to realize what a vast and elaborate organization is necessary to provide this delicacy in all parts of London. Most persons are aware that there is an Italian colony at Saffron Hill, but it is strange how few visitors ever penetrate this curious quarter. The Italians have certainly succeeded in keeping themselves apart from the rest of the population. Whole courts and alleys are entirely inhabited by these foreigners; there is not a single English person among them, and the tradesmen of the neighbourhood are also for the most part Italians. From this centre the men radiate to all parts of London and the suburbs, many preferring to walk ten and twenty miles per day, to living nearer their "pitch," but further away from their countrymen. It is true they enjoy certain facilities at Saffron Hill, which could not be obtained readily elsewhere. The tradesmen of that locality supply all the paraphernalia necessary to the business of their customers. There also the milk is kept and sold on special terms for the mixing of ices. In little villainous-looking and dirty shops an enormous business is transacted in the sale of milk for the manufacture of halfpenny ices. This trade commences at about four in the morning. The men in varied and extraordinary *déshabille* pour into the streets, throng the milk-shops, drag their barrows out, and begin to mix and freeze the ices. Carlo Gatti has an ice depôt close at hand, which opens at four in the morning, and here a motley crowd congregates with baskets, pieces of cloth, flannel, and various other contrivances for carrying away their daily supply of ice. Gradually the freezing process is terminated, and then the men, after dressing themselves in a comparatively-speaking decent manner, start off, one by one, to their respective destinations. It is a veritable exodus. The quarter, at first so noisy and full of bustle, is soon deserted, a few women only remaining to attend to the domestic affairs and to quarrel with their loquacious neighbours.

Towards evening, about seven o'clock, the ice-men begin to return. From all points of the compass they approach Saffron Hill. At first there are only one or two to be seen, then, as night draws near, the numbers increase, till their barrows jostle together, and they can hardly pass along. The greatest celerity is, however, displayed in unloading and packing these barrows close up one upon the other, against the walls of courts and yards used for this purpose; each man anxiously looking forward to the few hours of recreation which precede bedtime. Groups of loiterers then begin to form, some singing, some engrossed with the game of *mora;* but one and all finding amusement of a sober, though of a noisy description. In this sense the Italian colony sets us an admirable example. Drunkenness is an unknown vice. Yet some of these men are known to be the worst characters that Italy produces. As a rule, they almost invariably style themselves Neapolitans, and in answer to questions will say

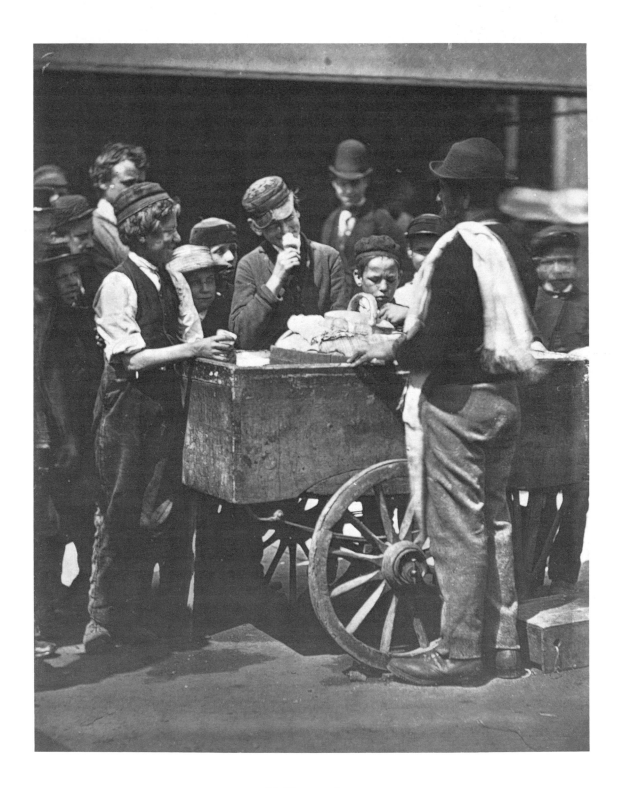

Halfpenny Ices

that they come from Naples itself. The probabilities are, however, that they have never even seen Naples, and a true Neapolitan would energetically repudiate any connexion with the tribe. As a matter of fact, a very large number of the street ice-sellers are Calabrians, and are, therefore, semi-barbarous mountaineers. Some have undoubtedly been brigands in their time, and in that capacity sympathized with King Bomba, and fought for his very Catholic Majesty Francis II., the Bourbon King of Naples. In England, however, they become for the time being, at least, honest. They can make more in selling ices in our thoroughfares than in cutting throats round and about Naples, and this, too, with much greater security to themselves.

Nevertheless, and however questionable his antecedents may be, the Italian ice-man sets an example of steady perseverance, economy, and foresight which is at once the envy and the marvel of the English poor who live around. The latter maintain that the Italian " lives on nothing ;" the fact being that he does not waste his money over extravagant food, and has discovered that he can grow fat and strong on farinaceous substances as well as on meat. Hence a cabbage, a little lard, or the fat of bacon, and some maccaroni as the foundation of his dinner, will suffice to render him strong and happy. By means of this frugality he is able to economize sums of money that appear perfectly fabulous to his English neighbours. I met, and this was a rare exception, an English woman selling ices ; and on my congratulating her for attempting a business which seemed so advantageous, she said it was indeed a pity to see English persons starving, " while foreigners were able to bank the money they picked up in our streets." Effectively the Italians do bank the money they earn, and what is more contrive to save sufficient to indulge in a luxury which but few English middle-class families can afford—they winter in Italy ! Indeed, they not only seek a more propitious sky for the winter months, but they further enjoy sport in which only the wealthy are allowed to participate on this side of the Channel. They spend the winter shooting, and some of the ice-sellers have been known to buy excellent fowling-pieces in England to take back with them to their native villages. Ultimately, they nearly all become landed proprietors. The savings, accumulated during many years, enable them to buy a cottage and a small plot of land, with the right of shooting over the neighbouring woods or mountains, and here they pass a peaceful old age. Sobriety and constant physical out-door exercise endow them with robust constitutions, and they are thus able to look forward with some degree of confidence to a prolonged existence. The idea, therefore, of working and stinting for ten or twenty years does not appal them. Year after year they resume their task, and those who have been less fortunate, and cannot afford to return to Italy for the winter, find some sort of employment in England, many being engaged to lay the asphalte in the streets of London, or of provincial towns.

As such numerous advantages accrue to these men it is natural to inquire what is their income. Of course the ices sold give a large profit, but it is from the coloured and water ices that the largest benefits are derived. The colour, it is true, is an absolute snare and delusion. It generally consists of cochineal, and has no connexion whatever with the raspberries or strawberries which it is supposed to represent. There really is nothing in these ices but sugar, to which the cochineal adds a certain roughness that produces a titillation on the tongue, fondly believed by the street urchins to be due to raspberries. This ice is altogether, therefore, a very questionable article, and the less consumed the better the consumer will find himself. The lemon ices are equally inexpensive, consisting but of sugar and water, flavoured with a lemon, or with some essence of lemon. This is a safer delicacy, and, in fact, if the essence may be relied upon, and the water clean, cannot do any harm, while at the same

time its sale must yield abundant returns. It is of this ice and of the coloured ice that gratuitous mouthfuls are sometimes given to street boys, to excite the appetite of the bystanders and invite custom. The real ice, however, for which there is a universal demand, is that known under the generic term of cream ice. But milk is indispensable to its manufacture, and indeed eggs should also be used. This necessity altogether destroys the golden dreams suggested by the water ices, and great are the efforts made to sell the latter, or at least to mix a goodly proportion with the expensive cream delicacy. Nevertheless, the profits on selling cream ices must amount to nearly a hundred per cent, so that after all the Italians are not so much to be pitied because their customers display inconsiderate pertinacity in their demand for that form of ice which is not only the most agreeable to the palate, but the most wholesome and nutritious. Taking all in all, the ice-sellers must realize a net profit varying from £1 to £2 per week, according to the locality in which the ices are sold, and the state of the temperature. At the same time, no men are more chary of giving any clue as to the money they possess. They generally deem it more prudent to profess extreme poverty, and often carry two purses. The one is secreted in some inner fold or secret pocket, and is only opened in private. This contains gold, which periodically is either deposited in a bank, or sent over to relations in Italy. The other purse rarely holds anything more valuable than penny pieces, and is consequently shown more freely. An ice-seller will not often be seen holding his purse out in his hands; but he may, on the contrary, often be noticed ducking his head under the table, and opening his purse between his knees, so that no one can see what he possesses.

The fear and suspicion thus displayed is one of the symptoms which denote the semi-barbarous nature of these Calabrians. But the crude superstitions which trouble them are the clearest proof of barbarity. They are fanatics of the most ignorant type. They will bow down in abject fear, and tremble before any image or relic, though they know nothing of real religion, and still less of theology, whether Catholic or Protestant, but simply look upon the priest as an awful, mysterious man whom they superstitiously believe capable of inflicting upon them untold tortures. The better educated and skilful Italian artisans, who make chalk statuettes, or looking-glasses, or are engaged in other artistic occupations, express the profoundest contempt for their fellow-countrymen who sell ices in the streets. Some even go so far as to pretend that, ethnologically, they are of a different race, an argument not devoid of foundation. In any case they are bitter against the ignorance which seems to be the worst fault of the class. Despite these objections, I could not help feeling sympathy for men who are, notwithstanding their ignorance, so persevering and sober. That so many of them should succeed in earning a respectable position by becoming peasant pro-prietors, when English workmen, with far greater advantages, so often end their days in the workhouse, is a fact which in itself calls for commendation. The ice-sellers are doubtless stingy, and even mean; they are dirty, and at times objectionably sub-servient; but, nevertheless, the example of their lives is useful in a country where the poorer classes have no notion of economy, are guilty of continuous daily waste, and are ever betraying their interests and selling their substance for the sake of drink. It seems strange that so many hundred foreigners should come over from the far south of Italy to make and sell ices in our streets, when innumerable English men and women are without employment, and could easily practise the same trade; but the pence of the poor which have enriched these Calabrians have not been wasted, if the example given by the latter has spread to some of their English customers, teaching them the value of thrift and sobriety. A. S.

BLACK JACK.

JOHN WALKER, commonly known as "Black Jack," or "Darkie," is one of the army of licensed hawkers who supply the daily wants of the Metropolitan poor. Aided by his wife—an expert needlewoman—it is the proud boast of Black Jack that he has "fetched up the young uns pretty tidy—one's gone soldiering, t'other green-grocering round the corner." In regard to his early career, my informant says, "Well you see, sir, my father was, or would have been, a gentleman if he could. He had no natural inclination for slaving to support a family. He took more kindly to his pipe and his liquor, and his ease, and such like. My mother—bless her!—she kep' things going. She did a roaring trade in washing. The old gentleman, he drove the machine." "What sort of machine?" I inquired. "Well, the mangle, if you must 'ave it. It took the go out of my guv'nor wonderful, and kep' him steady. As a boy I would ha' given a'most anything to turn that machine; but as I got up I found a standing perfession wasn't in my line, so I took to hearth-stone and silver sand in summer, and coke in winter time. I used to go about with a gentleman, a friend of ours, wot was up to every trick and turn in the trade. I was pretty well kicked and cuffed into the mysteries of the business; but let bygones be bygones.

"After a bit me and my missus got together some 'tanners'—shillings—and started a barrow and donkey. Wot we didn't 'ave we borrowed, and 'ad to pay the poor man's price for it. It was a battle to keep things going; because you see, sir, all our goods are cash down, and no mistake, unless a man 'as a friend to lend him a shilling when he's down in luck, or been lushing.

"I am not so well off as I should be, and most like no one's to blame for it more than myself, so my missus says. But Providence and my donkeys have always befriended me. My donkeys took me 'ome many a night when I had a drop o' drink in me." "A skinful o' drink, Jack, is more like the thing," said his wife. "Yes, wot you say is 'korreck so far.'"

"It's all too true, lad. You remember that morning at two o'clock they fetched you all the way from Elton?" "Not all the way, missus; 'old 'ard, I took charge of 'em and the barrow till the publics took me in—and well, no matter." "I never got such a sense in my life," continued the woman. "It was the first time. Mrs. Jones was at her window when the barrow rattled into the court. 'Where's master?' I cried. Says Mrs. Jones, 'there's either Jack or a sack of coke in the bottom of the barrow.' I 'ad to unyoke the beasts, tilt up the barrow." "Well, well, never mind," said Jack; "donkeys 'ave more sense than their masters. I believe, sir," resumed the husband, "I am the only man living that was ever brought afore a magistrate for furious driving of donkeys. I 'ad a bet with a gentleman that 'is donkeys would lick mine hollar on the road. Mine, as fine a pair as ever stepped, was flying like the wind, and it took three 'bobbies' to stop 'em. I appeared in court and was discharged." Black Jack was charged not only with furious driving but with cruelty to his animals, a remarkably fine pair for which he had the most tender regard.

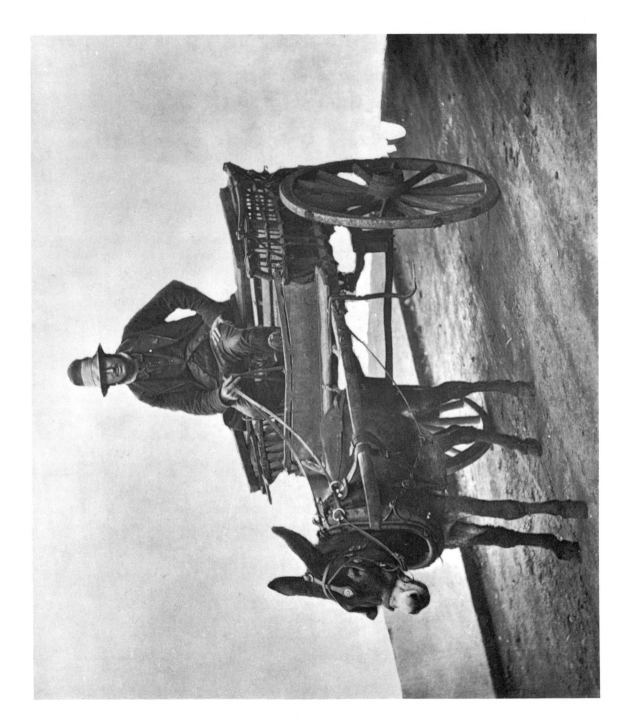

Black Jack

Jack stood charged with cutting and wounding the donkeys with a heavy flail-like instrument. At the request of the magistrate the instrument was put in as evidence. It was produced by the defendant from the depths of a side pocket, and proved to be a switch of about eighteen inches in length. " This is the flail, your honour," said I, "and I own I use it for tickling Tom and Billy, my donkeys. They want no more to make 'em fly." The case was dismissed.

Jack left the court with a clear conscience and an unblemished name among costers; for, although some of them may neglect their wives and families, it seems to be a point of honour with all to treat their donkeys with kindness. For the kindness bestowed the animal invariably shows its gratitude by perfect docility and willingness to bear the yoke imposed by its master. The donkeys fare like their owners; a prosperous day will secure for them some dainty, or at least a feed without stint, of oats, beans, and hay, at a cost of eightpence or ninepence.

"I always feed my beast," said a coster to me, "to make sure he gets his grub regular. I look after him too, as I would a brother. He's worth all the trouble I can take about him. If he could only speak, I'm blest if he wouldn't lick all the scholards at the Board School. I bought him for five pounds at Smithfield Market, Caledonian Road. Some ten years ago he would have fetched only half that money. Everything's gone up, and donkeys to about double the price they used to was. Nothing in that line with legs to be had now under two pounds, and nothing good under a fiver. I've seen me get five shillings out of the sovereign in buying a beast some ten years ago. There's ever so many more costers now in London than there wor at that time. That's how it comes, I think; greater demand, and everything dearer. The carts we use may be bought second-hand, from a pound to five pounds, and the harness, wot's been used, from five shillings to a sovereign, according to its condition.

" During winter I deal in coke, which I get at the gas works at five shillings a load of six sacks. Wholesale, a sack fetches me one and six; but it pays best to sell it to poor folks, my chief customers, in small lots at a penny and twopence a lot. I carry no weights, a basket is my measure, it goes much further that way. Coke measures better than it weighs. But if one be fairly honest—some ain't by half so honest as they should be—it makes not such mighty odds in the end which way the coke is sold. I don't know as it's fair, but the poorer folks be, the more 'ave they to fork out for everything. Costers, most on 'em, could not live if they did everything on the square. Many buy dear, and sell dearer. My customers are poor, wonderful poor, living round Battersea and thereabouts. I don't believe some of 'em women and children 'ave clothes to cover 'em, so they use coal or coke in winter to get up some heat. Many of my best customers I never see, though they deal ' reglar.' I see no more of 'em than a dirty 'and, or lean arm, stuck out with the coppers through half-closed doors. Summer's the time for such like folks, when the sun's out and warm. They take 'art then and come out with some cheap rags on. Most of the men are labourers when they can get work, and loafers when they can't. The women, many of 'em, work in the dust-yards, picking rubbish. That is in fine weather. They make about two shillings a day, and they tell me they gets the bones and rags that turns up. The best men can make four shillings or four and six a day labouring at the gas works. When I set up, as I said, part of my traps was borrowed. Everything in our line can be 'ad on hire, from a basket or weights to a donkey, and stock can be got by going shares in the profits. But it don't pay to borrow or hire. You 'ave to pay as much for the hire of a basket or a pot in a fortnight as would buy the article."

Jack trades in summer with silver sand, which may be bought from a dealer in sand, hearth-stone, bath-brick, and pipeclay, in Old Kent Road. The silver sand costs the coster about eleven shillings a ton. Red sand about the same. When ordered in large quantities, the coster will undertake to lay it down in any part of London at about thirty shillings per ton. The red sand is chiefly used in livery stables, and the white for tap-room floors, the polishing of pewter pots, horse-harness, &c. Half-a-crown a bushel, measured in a basket, is paid for silver sand; one shilling and sixpence a peck; the price increasing in proportion as the quantity supplied decreases. Half a ton sold in this way returns a profit of at least twenty-five shillings. The average profits of the costermonger, with care and economy, not only enable him to live well, but to save a portion of his earnings, which he not unfrequently lends at enormous rates of interest to his less provident neighbours. The loans contracted by persons of his class are speedily repaid, as security is neither sought by the lender nor tendered by the borrower. It is customary in some instances to lend barrow and stock day by day. If the stock is worth twenty shillings, about thirty shillings must be returned to the lender at the close of the day, when the barrow has been cleared. There are, nevertheless, many members of this modest fraternity who, like Black Jack, started life by borrowing, and who at length filled the position of independent master costermongers.

———◆———

THE CHEAP FISH OF ST. GILES'S.

IT has often been remarked that but for our cheap fish supply the poor of London would undoubtedly be reduced to the most acute stages of starvation. Notwithstanding, therefore, the obnoxious smell and dirt created by a street fish-stall, this method of selling fish, if it insures cheapness, and brings the fish to the doors of the poor, is undoubtedly useful. The costermonger is certainly in a position to supply fish at a low price. He need not rent a shop, or consume expensive gas, or pay enormous rates; the chief anxiety of his life is to procure a barrow, and that is a trivial matter, when compared to the responsibilities of the ordinary tradesman and fishmonger. Then there are barrow clubs that dispel even this difficulty. They are constituted after the model of building societies. Members pay sixpence per week, and when sufficient money has been accumulated to buy a barrow, lots are drawn, and the barrow given to the winner, who must henceforth pay a shilling a week till the cost has been refunded. Awaiting the moment when the costermonger is able to procure a barrow of his own he must pay eighteen pence per week for the cost of hiring. Then he must beware of the police, who have a knack of confiscating these barrows, on the pretext that they obstruct the thoroughfare and of placing them in what is termed the Green Yard,

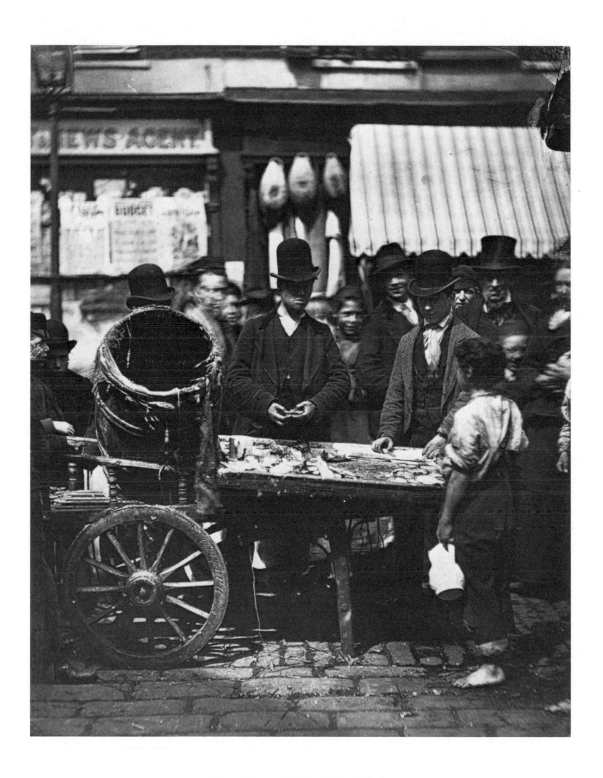

The Cheap Fish of St. Giles's

where no less than a shilling per day is charged for the room the barrow is supposed to occupy. At the same time, its owner will probably be fined from half-a-crown to ten shillings ; so that altogether it is much safer to secure a good place in a crowded street market. In this respect, Joseph Carney, the costermonger, whose portrait is before the reader, has been most fortunate. He stands regularly in the street market that stretches between Seven Dials and what is called Five Dials, making his pitch by a well-known newsagent's, whose shop serves as a landmark. Like the majority of his class, he does not always sell fish, but only when the wind is propitious and it can be bought cheaply. On the day when the photograph was taken, he had succeeded in buying a barrel of five hundred fresh herrings for twenty-five shillings. Out of these he selected about two hundred of the largest fish, which he sold at a penny each, while he disposed of the smaller herrings at a halfpenny. Trade was brisk at that moment, though the fish is sometimes much cheaper. Indeed, I have seen fresh herrings sold at five a penny ; and this is all the more fortunate, as notwithstanding the small cost, they are, with the exception of good salmon, about the most nutritious fish in the market. Herrings contain far more fat than either soles or whiting, and are therefore much more useful. Cod would be as good if we were able to eat the liver ; but, in default of this, eels and herrings give the most strength and nutriment.

When there is a great demand for fish, or an exceptional bargain can be offered, it is possible to sell a whole barrel of five hundred herrings in two hours and a half, but at other times it may take more than a day to get rid of the same quantity. These fluctuations in the sale often compel the costermongers to avail themselves of the help proffered by persons hanging about the market. Thus, on Carney's left hand may be noticed a German " pal," who has volunteered to help him to clean and scrape the fish, though his real calling in life is that of rolling cigars ! It is questionable whether the detritus of herrings is calculated to add to the agreeable flavour of the fragrant weed which this youth would be subsequently called upon to manipulate, but the frequenters of Seven Dials are not very particular over such trifles. On the other side of the herring-barrel, and with his back to the lamp-post, is a poor orphan boy, generally known by the frank if uncomplimentary cognomen of " Ugly." He is the adopted child of the market. He has no relations, no friends, but the whole market supports him. He spends his time wandering about from barrow to barrow, from stall to stall, eagerly watching for an opportunity of rendering himself useful, so as better to merit the pence which, in their sympathy for his forlorn condition, the costermongers never fail to give him. The unostentatious manner in which this was related to me by one of the costermongers was very characteristic of the freedom with which the poor help each other. In the foreground, a boy with a pitcher was about to fetch some spring water, to bathe a woman's sprained ankle, an impression prevail ing that spring water would produce a more rapid cure than the ordinary water supplied to the houses of the district ; while, in the background, the sole personage who can boast of so respectable an appendage as a silk hat, stands the proud owner of two houses situated within the immediate vicinity, and who, consequently, disapproves of street markets. They have a tendency to reduce the value of house property.

" Little Mic-Mac Gosling," as the boy with the pitcher is familiarly called by all in his extended circle of friends and acquaintances, is seventeen years old, though he only reaches the height of three feet ten inches. He is, in fact, so small, and, at the same time, so intelligent for his size, that he once held an excellent situation as a lady's page ; but I presume he is now getting too old for such an office. His bare feet, I

should add, are not necessarily symptoms of poverty; for, as a sailor, and during a long voyage to South Africa, he learnt to dispense with boots and shoes while on deck.

The best customers for the fish sold in the streets are, according to Joseph Carney's experience, the Jews, for they not only buy the greatest quantity of fish, but give the highest price—a peculiarity not often attributed to the children of Israel. The fish sold in the neighbourhood of the Dials is, I am assured, especially renowned, and the Jews who frequent this market are far more wealthy and liberal than their co-religionists of the East End. On the other hand, they will not buy skate, eels, or shell-fish; but they are particularly partial to haddocks, which they fry with eggs in salad oil, and eat with slices of lemon. The Irish will not give half the money the Jews freely pay for fish, so that, perhaps, the French are the next best customers. They come in large numbers from Soho, and being such good cooks, can utilize fish in a number of dishes totally ignored by the English poor. Strange to say, Lent is a bad time for this business; the winds are often unfavourable during this period of the year, and the fishing-smacks are unable to come up the Thames. The costers have often to wait at Billingsgate market from seven in the morning till late in the afternoon before they can get any cheap fish. This loss of time is disastrous, particularly as it makes them miss the dinner-hour, when some of their stock might have been sold. When the fish has been finally bought, the market porters convey the barrels, hampers, or casks of fish to the coster's barrow, for which they receive fourpence per parcel, the coster preferring to reserve his strength to drag his stock to his customers. Should he suspect that the fish is not good, he must, to obtain reimbursement, take it to the authorities, at what is termed the stone-yard. Here the case or hamper is opened before the inspector and other witnesses, and if the fish are not good they are taken away and mixed with lime. This practice opens out the broad question of the utilization of this refuse. It should be converted into an innocuous though fertilizing manure; but the problem is altogether beyond the scope of this chapter.

As a rule, most money is realized on the sale of fish from November to January, and in that season sometimes as much as £1 net profit may be gained in a day. This is, of course, quite exceptional, and such irregularities render it especially difficult to estimate a costermonger's income. The average varies, I am assured by some of the class, from 30s. to £2 per week, so that the costermongers can, if they choose, live in a comfortable and respectable manner. They are certainly honest and trustworthy, and pay their debts. We must also credit them with considerable industry and perseverance. At seven o'clock they must reach Billingsgate, yet they may be found selling their fish as late as ten in the evening on ordinary days, and they are still at work at midnight on Saturdays. But, unlike the Italian ice-men, they have no care for their old age; nor have they any dread of accidents or sickness. They look to the hospitals to cure their physical ailments, and as for old age, they deny that it will prevent them working. They may not earn so much when the energy of youth is spent, but they will always be strong enough to sit on a stone or a stool by a barrow or tray containing a few fish to be sold. They, therefore, repudiate the necessity of saving more money than what is required for the purchase of a barrow and some stock; and in this they show that singular lack of ambition which is peculiar to some sections of the English poor. A. S.

CAST-IRON BILLY.

ORTY-THREE years on the road, and more," said Cast-iron Billy; "and, but for my 'rheumatics,' I feel almost as 'ale and 'earty as any gentleman could wish. But I'm lost, I've been put off my perch. I don't mind telling of you I'm not so 'andy wi' the ribbons as in my younger days I was. Twice in my life I've been put off, and this finishes me. I'll never hold the whip again that's been in my hand these three and forty year, never! I can't sit at 'ome, my perch up there was more 'ome to me than 'anythink.' Havin' lost that I'm no no good to nobody; a fish out o' water I be."

William Parragreen, known as "Cast-iron Billy," may be said to have commenced life with the whip in his hand. With an inborn aptitude for the profession he took to the road early. Whip in hand he mounted his father's cab, and continued for some years to pilot the vehicle through the busy streets of London.

In the days when the Royal Mails ran from the Post Office, with their armed guards and passengers, prepared for long weary journeys, William was fired with the ambition to drive some more imposing conveyance than the old four-wheeler. At last his hopes were realized, and he commenced his career as omnibus driver on the London roads. This event was indelibly fixed in his memory as it happened in 1834, when the old Houses of Parliament were destroyed by fire.

The first locomotive was running successfully between Manchester and Liverpool, although it was regarded by many as a fool-hardy experiment that would speedily come to an end. The first accident on the rails led our hero to believe that the new mode of travelling would not answer. "There was safety and comfort in the old mail, but to be smashed up into minced meat by steam is the sort o' thing folks wouldn't stand." But he has advanced with the times, and now regards the railroad as the great feeder of his own and every other sort of labour in the metropolis.

Two or three years later William engaged himself to the London Conveyance Company. After fourteen years' faithful service the stock was sold off, and he was discharged. "Don't know if they was broke, or wot. They sold off." He next found employment with a job-master for about twelve months, but in the end was turned adrift, and two years elapsed before he again obtained regular employment. This, he assured me, was the only time in his life in which he came to grief.

Fortune smiled once more, and he entered as driver to the London General Omnibus Company, in whose service he has ended his career on the road. "Now," he pathetically remarked, "I'm too old to look ahead. There's the 'workus' on one side; it's not pleasant, and who knows? on t'other, perhaps, some sporting gent wanting me to keep his gate. I might do that; you see I could sit in front fourteen hour out o' the twenty-four, always 'andy." This then is the poor man's paradise, to have some settled spot where he could sit out his days, in imagination perched on his old seat above his steady-going "cattle." He confessed that the post would have its drawbacks. He would miss the scenes of city life, the traffic of the streets, the excitement of

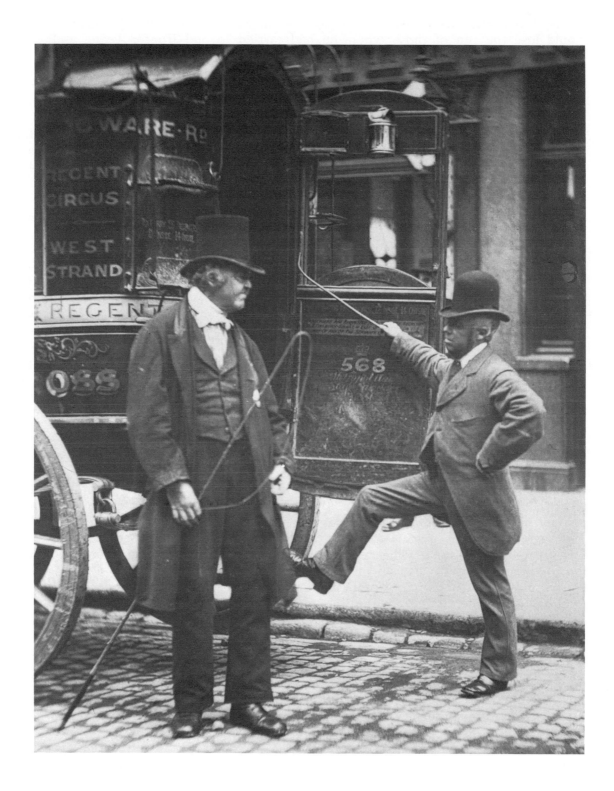

Cast-Iron Billy

racing against opposition. He would miss, too, the greeting of his old patrons, whose front seats were held sacred for the morning and evening journeys. He would lose the run of those whom he had carried to and fro for years, and who, owing to the punctuality of his omnibus at the corner, had risen to fame and fortune. Unlike a well-known aged driver on another metropolitan route, who has amassed two thousand pounds, William was never able to do more than keep things going at home. His first wife was for many years an invalid, and a drain on his resources. His children, who were sickly, needed constant tending. Nor is his poverty to be attributed to intemperance, although he owned to taking "a drop o' liquor to keep the frost out in winter, and stave off the heat in summer;" he also defied any man to say that he had seen him drunk when he should have been sober.

"Nothin' like old Skyler, one o' the best whips on the road; he's over seventy, and rides 'jobbin' post,' or drives to the Derby four-in-hand. But he never goes to bed sober, not if he knows it! He'll swallow more 'dog-noses' * in a journey than most men livin'."

The subject of the photograph lost his position as driver, owing to his inability to cope with younger men driving opposition omnibuses along the same route. In this instance the omnibuses crossed each other, the younger and more active man so taking the lead as to pick up all the passengers. This was not all, our veteran had become so enfeebled as to require help to mount his perch, while the reins had to be secured to his coat, as he has partially lost the use of his left hand.

The practice of racing, to the detriment of vehicles and discomfort of passengers, has been in vogue for half a century; but my informant remarked that in the "good old days" the struggle raged much more fiercely than it does now. Then there were many small proprietors running a neck-and-neck race for a living. The large companies which now monopolize the routes have in some measure tended to check the evil. At the same time the daily earnings of each conveyance depends so much on the joint efforts of driver and conductor, that they do not scruple to urge on their steeds when it suits their convenience. The demands thus made upon the strength of the horses soon renders them unfit for the road. I have been assured by more authorities than one that such horses as are employed will, on an average, stand omnibus work no longer than eight years. It is curious to observe that both horse and conveyance must be renewed at about the same time. I gather from the Police Report for 1875 that in six years 8180 public conveyances were condemned as unfit for use. In 1875, 9684 licences were granted for public conveyances in the metropolitan district. It will be seen, therefore, that the whole of the public conveyances of London are renewed about every eight years. The number of omnibuses running last year within the metropolitan area was 1448; horses, allowing ten to each omnibus, 14,480; drivers, conductors, and horse-keepers, 4344. The men employed in omnibus work are, as a class, fairly healthy, notwithstanding their exposure to all weathers, and that they labour fourteen hours out of every twenty-four. The supply of men flows from a great variety of sources; the majority of the drivers have been trained early in the management of horses. In some cases the education thus bestowed has been so purely professional as to leave the men ignorant of the most rudimentary branches of knowledge. For all that, some of them have filled better positions, they have owned their own studs, and driven their own coaches. One I may mention was at one time a man of property, and an authority on all matters relating to the "turf." Early in life he made up his mind, seemingly, to spend

* Ale, halfpenny-worth, Gin, penny-worth.

his money, and to live merrily while it lasted; and when his funds were gone he settled down, cheerfully enough, to driving an omnibus. Quite recently he has come in for a windfall, in the shape of a legacy of over a thousand pounds. Immediately on his receiving the money he descended from his perch, and was last seen lolling over the bar of a restaurant, smoking a fragrant cigar, and wearing a suit most horsey and juvenile; a white hat, tilted so as to partially shade the left eye, would have completed his attire, but for a narrow black band with which it was adorned. The band was possibly worn in grateful remembrance of the friend who left him the money, or of the money that had already gone in procuring some fleeting pleasure for its owner. Be that as it may, when the legacy has been squandered its owner will doubtless resume his seat on the box.

Omnibus conductors are drawn from the ranks of unfortunate clerks, mechanics, and tradesmen of all sorts. No special training being required for the duties of a conductor, the post is open to all comers who can read and write, and who can produce some satisfactory reference as to character. The pay is 4s. a day, but the "black mail" exacted from them in various ways renders it almost impossible for them to exist on their pay. There being, moreover, no proper check on their drawings, the men are exposed to the greatest temptations. It is in some instances tacitly understood by employers that the taxes imposed on conductors (for tips and treats to driver, horse-keeper, &c., &c.) shall be taken from the fares; were this not so, and the conductor strictly honest, his fourteen hours' work would go for next to nothing.

Would it not be possible, in the interest of masters and men, to let out the omnibuses by the day? To adopt indeed the system in force with hackney carriages. The masters would require to find time-keepers, and appoint inspectors to prevent racing, and to limit the number of journeys. Although the number of omnibuses running in the metropolis is perhaps not so great as before the introduction of city lines and tramways, they are again steadily increasing to meet the demand of a growing population.

A great reduction in fare followed the laying of railways and tram-lines; but there has been no diminution in the gross earnings of the omnibuses. This is accounted for in two ways, the abolition of mileage and tolls, and in short journeys. When Henry Mayhew wrote on this subject, the mileage tax on each conveyance was three halfpence for every mile traversed; seventy miles being the average distance per day, the charge for mileage was eight shillings and nine pence. In some of the routes the toll charged was tenpence per journey, or five shillings for the day's work of six journeys. The abolition of these imposts conferred a great boon on the public, as under the old system omnibuses could not run at the present low fares and yield a profit to their owners.

In conclusion I must thank Mr. Smith, of the City Mission—the pioneer missionary to omnibus men—for his introduction to "Cast-iron Billy."

WORKERS ON THE "SILENT HIGHWAY."

THOUGH so much has been said of late concerning our canal population, and the evils attendant on their mode of life, the men who have the more difficult task of conducting clumsy barges down the swift ebb and flow of the Thames, have been comparatively neglected. A long list of grievances may nevertheless be drawn up concerning this class. They have their faults and their hardships to expiate and to endure. Their former prestige has disappeared. The silent highway they navigate is no longer the main thoroughfare of London life and commerce. The smooth pavements of the streets have successfully competed with the placid current of the Thames; the "Merry Waterman's" mission is exhausted, he is superseded by the trains, cabs, omnibuses, and penny steamers of modern London. He is compelled to abandon the pleasant occupation of rowing passengers to and fro, and must now devote himself solely to manœuvring huge barges. Lightermen and bargemen have succeeded to the "Jolly Young Waterman," immortalized in Dibdin's ballad opera. Of course a few of the latter still find occupation, and notably below London Bridge, where they take passengers out to ships anchored in the stream ; but when comparisons are established between the present and past demand for watermen, it may well be said that this means of earning a living has almost died out. Nevertheless, the old institutions which formerly governed the London watermen still exist, and possess considerable power. Indeed, this is one of the many anomalies in our social system which does not fail to produce considerable mischief.

Under Queen Anne's reign it was probably both wise and proper to incorporate the watermen of the Thames in a company or guild, and grant them certain privileges. They alone were allowed to navigate the river ; but, on the other hand, they were compelled to man her Majesty's fleet in times of war. Now, by an Act passed by Parliament in 1859, these privileges and these obligations were abolished ; but the Watermen's Company still continued to exist, and to this day governs to some extent the navigation of the Thames, its jurisdiction extending from Teddington Lock to Lower Hope Point, near Gravesend. By the side of this old corporation a new authority, known as the Thames Conservancy, has sprung into existence, and also derives its powers from Acts of Parliament. Thus the Thames is governed by two distinct authorities, each entrusted with a similar task ; while, to further complicate matters, the lightermen have themselves created yet a third organization which is at times able to challenge both these bodies. I allude to the Trade Union formed by the lightermen. A bargeman generally obtains his licence from the Company, but if refused, from the Thames Conservancy, while at the same time he relies on his trade union to maintain the rate of his wages and procure him employment. The masters, however, experience considerable difficulty in managing their affairs and executing the orders they receive with due punctuality, as they are thus exposed to the conflicts which arise between these various organizations. The working men are able to play the one off against the other in their struggles to obtain exceptional terms from their employers.

Workers on the "Silent Highway"

The head of a city firm, owning a large number of barges, described all these difficulties to me, but was more particularly bitter in his complaints against the Watermen's Company. This Company is governed by a self-elected court, or managing committee, and any one who has once become a member is obliged to remain associated with the society all his life. He is compelled to continue paying his quarterage, however dissatisfied he may be ; and further to increase the income of the Company, the fines they have a right to inflict are generally heavier for the same offence than those imposed at a police court. Thus a master or a lighterman who has served his apprenticeship under the Watermen's Company, and received his licence from them, must, in case of misdemeanour or infringement of any of their regulations, be brought before the Court of the Company and there sentenced. If he refuse to pay the fine imposed, he is brought before an ordinary magistrate who is compelled to enforce the verdict pronounced by the Company, and this without investigating the case at issue. The bargemen, on the other hand, who are licensed but are themselves not members of the Watermen's Company, that is to say not " freemen," are, it is urged, in a more fortunate position. They are summoned before an ordinary magistrate, when any accident or infringement of the regulations has taken place, and the magistrate often imposes a fine of one shilling in cases where the Watermen's Company, anxious to increase their private funds, would inflict a penalty of £1. Though often excessively severe when a fine can be extorted, the Company is supposed to be less strict where money is not to be obtained. Thus, some months ago, an owner was fined £1 because his name was not distinctly inscribed on his barge ; at the same time one of the men was fined only ten shillings for sinking a craft worth £100. ·This disproportionate sentence evidently represented the paying capacity of the offenders rather than the gravity of their respective offences.

With regard to the character of the men who work on the barges, a graver accusation might be brought against the Watermen's Company. Licences are sometimes granted to the most unworthy persons, and the safety of property on the river gravely compromised. I have a list before me of Freemen of the Watermen's Company who have been sentenced to different terms of imprisonment for felony, for plundering barges, &c., and who have nevertheless again obtained the Company's licence on their release from prison. One man, for instance, was tried in December, 1868, and sentenced to eighteen months' imprisonment—Detective Howard convicted him of stealing wheat from a barge—yet this man is now working on the Thames with the Company's licence. In October, 1869, another bargeman, denounced by Inspector Reid, was sentenced to fourteen years' penal servitude, and I shall be curious to know, when this sentence is expired, whether the Watermen's Company will renew his licence. The Company did not object to another man who had completed five years' imprisonment, but gave him a licence, so that he was able to commit further depredations, for which he is now undergoing another term of seven years' imprisonment. We also owe the capture of this thief to the same inspector of police. Then there is a man who was sentenced to six months' imprisonment in May, 1870, who had previously been convicted on two occasions, and who is still working with the Company's licence. In December, 1871, and in June, 1872, two men, also captured by Inspector Reid, were each sentenced to six months' imprisonment, and are now both navigating the Thames with the Company's licence. In December, 1873, three more bargemen were sentenced to twelve months' imprisonment each for felony, and in January, 1873, there was another similar conviction ; yet all these men have been again armed with the Company's licence, and can resume tranquilly their evil practices. Further, it is not always easy to refuse their services. For instance, my attention was directed

to a case of an apprentice, who was condemned to ten days' imprisonment for stealing locust beans. When he was released from prison, the Company, through whom he had been apprenticed, insisted that he should continue to serve his time, and fined the employer for refusing to entrust his goods and barges to a convicted felon. Nor has the employer any redress against this injustice. He must submit to the jurisdiction of the Company to which both the apprentice and himself belong. But if dishonest men are maintained in places of trust, one of our most important channels for the conveyance of goods, will become insecure and discredited. There have been, unfortunately, some other convictions besides those which I have mentioned, and it really would seem as if the Company gave licences to work in a most blameworthy and indiscriminate manner, so long as the licence-holder pays his quarterage. The police state that these men go about armed with these licences and board crafts in the dead of the night. When arrested they allege that they were only anxious to ascertain whether any men not free of the Company were working on board the crafts in question. But if they are not detected, they seize such opportunities to plunder the barges, or to plan an attack, or to persuade the men in charge to help them.

At the same time, while the lack of uniform control, and perhaps the eagerness of the Company to secure quarterage fees, &c., have tended to corrupt the men employed in the navigation of the Thames, and facilitated the introduction of thieves within their ranks, I should be very sorry to cast a slur over the whole class. There are, undoubtedly, many most honest, hard-working, and in every sense worthy men, who hold licences from the Watermen's Company, or from the Thames Conservancy. That these men are rough and but poorly educated is a natural consequence of their calling. Never stationary in any one place, it is difficult for them to secure education for their children, and regular attendance at school would be impossible unless the child left its parents altogether. Thus there is an enormous percentage of men who cannot read at all. Their domestic arrangements are, however, better than the canal bargemen. Cramped up in little cabins, the scenes of over-crowding enacted on board canal barges, equal and even exceed in their horrors what occurs in the worse rookeries of London. Fortunately, the very nature of their occupation compels the men to enjoy plenty of fresh air and invigorating exercise, and this naturally counteracts the evil effects resulting from their occasional confinement in cabins unfit for human habitation. It has also been justly remarked that these floating homes are the probable medium for conveyance of epidemics from bank to bank of the canals. But these remarks apply almost exclusively to our canal and not to our Thames population. As the barges on the Thames do not travel so far, it is easier for the men to live on shore, where of course they can obtain better accommodation, particularly if they are married and have families. Nevertheless, there is urgent need of reform to ameliorate the condition of bargemen, both from a sanitary and educational point of view. It is most revolting to think that in the narrow and dark cabins of a barge, children are sometimes born. The sun cannot shine within these cabin homes and purify the atmosphere ; the germs of disease may therefore linger here for an indefinite time and be conveyed from place to place. Fortunately, this question has of late attracted considerable public attention ; several ardent reformers have taken the matter in hand, and sooner or later these good endeavours must bear fruit. We may, therefore, look forward to the time with some feeling of confidence, when the lightermen of London will be more worthy of the noble river on which they earn their living.

A. S.

THE STREET FRUIT TRADE.

HE season for strawberries, the most delicious of English fruits, has ended. This delicacy was brought in numberless barrow-loads to the doors of the poorest inhabitants of London. The familiar cry, " Fine strawberries. All ripe! all ripe!" is silenced for a season by sounds less welcome. The fragrance of the ripe fruit wafted by the summer breeze from the coster's cart as it passed through the alleys, is replaced by less grateful odours—by the normal atmosphere of overcrowded neighbourhoods, by the autumn taint of animal and vegetable decay, which invests the low-lying districts of London.

One of the most agreeable phases of our modern civilization, is the supply of luxuries brought to the doors of the poorest inhabitants of this vast city, and offered at such prices as to place them within the reach of all. The illustration will convey some idea of the manner in which one luxury at least is distributed among the lower orders of the community.

The strawberry season began late this year, owing to cold winds in spring retarding the growth of the plant. The fruit was nevertheless so plentiful as to prove unremunerative to many of the growers. West of England strawberries should appear in the London markets about the end of May, and continue until about the 10th of June, after which the fruit grown around the metropolis takes the lead. The crop, when brought from the western counties, had to compete with supplies from other sources. The prices offered in Covent Garden were so low as to induce some of the growers to dispose of their entire crop at home to manufacturers of preserved fruits.

Foreign strawberries during the height of the season are sold at prices ranging from ninepence to one shilling and sixpence per six-pound box. One of the wholesale merchants in Covent Garden, informed me that he thought about eighty pounds sterling would be the monthly value of the trade in strawberries in this market alone, while the fruit lasted. About one-half of the monthly supply of this fruit is bought by costermongers. But, as a rule, the costers do not venture to buy until the price falls so as to enable them to retail the fruit at fourpence or sixpence a punnet-basket. The rough native and foreign sorts fall to their share. They not unfrequently club, two or three together, and purchase cheap lots at the morning auctions held in the Garden. Three partners, with a joint capital of £4, may invest in a lot that will turn out thirty-five or forty dozen "punnets." These they will readily dispose of the same day at an average price of fourpence a basket, or a trifle less. Each partner expects to realize a profit of about three halfpence on each basket. At that rate one gross of baskets would yield eighteen shillings. This sum represents more than the average day's earnings of a prosperous costermonger. From this amount working expenses have to be deducted. He may probably have to pay two shillings interest on borrowed capital, food for himself and his donkey two shillings, and porterage fourpence.

A coster, from whom I obtained some information relating to this branch of

The Street Fruit Trade

street industry, set down his private expenditure and other matters thus,—" I should think a good clean day's work with strawberries will turn in about ten 'bob '— shillings—perhaps not so much, and at times sum'at below that 'figar.' Strawberries ain't like marbles that stand chuckin' about. They are wot you may call fancy goods. On a 'ot night I'd rather sell 'em than eat 'em! You should never let 'em know you've got fingers, leastwise fingers like mine—all thumbs. They don't like it. They must be worked without touching, and kep'—them on top—as fresh as they was pulled. They won't hardly bear to be looked at. When I've got to my last dozen baskets they must be worked off for wot they'll fetch. They gets soft, and only want mixin' with sugar to make jam. They won't stand a coster's lodgin', not a single night. They like it so bad you'd find 'em all muck and mildew in the morning. There's no trouble in sellin', folks will buy anythink if its cheap and can be swallered. I can tell you in these times my profit goes like winkin'. I have a missus and four young uns, all lookin' hungry and naked, for they never seem better off, though they gets wittles, and wot not, reg'lar. My missus 'as four 'bob' a day, and six on Sundays, the two extra for a good dinner, and such like, when I'm at 'ome. Besides that I pays four 'bob' a week rent for two rooms in a very 'aristocratic street not far off." My informant, although he could neither read nor write, had a simple mode of keeping his accounts. He had acquired the use of numerals, and was in the habit of jotting down his daily expenditure in detail. His memoranda consisted of numerals only, so arranged on a piece of paper as to represent to this simple accountant £ s. d. The articles he bought at the morning sale were set down in the order in which they were purchased. Thus in his day book 2 8 4 were placed so as to denote two sacks of potatoes, price eight shillings, porterage fourpence. In the same way, 2 6 2 stood for two bushels of peas, price six shillings, money left on baskets two shillings, and so on. He assured me that by this system, supplemented by the use of the ten digits, he was enabled to keep his accounts with unerring accuracy. I found that by following his own plan he could solve simple problems in arithmetic with marvellous facility. He himself thought that the method was somewhat involved, and that it would be greatly simplified by education. After he had acquired the use of figures from a learned friend, who could read the best newspapers, the difficulty presented itself how to employ them. He could count the number of strawberries in a basket, or of potatoes in a sack, but that led to no good, as the articles in question varied in size, and the operation involved was complicated. The notion was then suggested of indicating gold, silver, copper, and wares, by their relative positions on paper, and by the aid of memory.

Like many other petty traders in London, equally ignorant of the science of numbers, he conferred new properties on numbers only understood by himself, but which at once facilitated his trading operations. I have found that an independent system of notation is made use of by individual costers, some of whom employ marks which they themselves alone can decipher.

Touching the subject of the borrowed capital used by costermongers, space will only permit me to say, in conclusion, that were offices instituted where small sums of money could be borrowed, on such security as might be forthcoming, they would prove a great boon to the poor traders of the London streets, while the profit accruing from the loans might satisfy even a Shylock.

THE LONDON BOARDMEN.

EW men who earn their living in the streets are better abused and more persistently jeered at than the unfortunate individuals who let themselves out for hire as walking advertisements. The work is so hopelessly simple, that any one who can put one foot before the other can undertake it, and the carrying of boards has therefore become a means of subsistence open to the most stupid and forlorn of individuals. These facts are so self-evident that the smallest street urchin is sensible of the absurd picture presented by a full-grown man carrying an advertisement " back and front " all day long. The boardmen have therefore become a general butt, and it is considered fair play to tease them in every conceivable manner. The old joke, the query as to the whereabouts of the mustard, has now died out, and it is considered better sport to bespatter the " sandwich " men with mud, or to tickle their faces with a straw when the paraphernalia on their backs prevents all attempt at self-defence. While the street boys indulge in these and various other practical jokes, omnibus conductors also relieve their feelings as they pass by kicking at the boards. These can be conveniently reached from the steps behind an omnibus, and give a jovial clattering sound in answer to a kick well administered with a hob-nail boot. The poor boardman, groaning under this insult, staggers forward, ploughing with his sorry boots the mire of the gutter, and is unable to recover his balance before the omnibus has driven far away. Pursuit is impossible, redress unattainable ; the boardman must remain true to his boards, and patiently endure the trials inflicted upon him. But few have escaped receiving ugly cuts from the whips of irate coachmen. If they walk on the pavement the policemen indignantly thrust them off into the gutter, where they become entangled in the wheels of carriages, and where cabs and omnibuses are ruthlessly driven against them. If to these discomforts we add that the mud thrown up by the wheels must bespatter them from head to foot, and that they have no other shelter but the boards themselves to save them from the rain, we may safely conclude that their existence is not fraught with many comforts. Nor is the remuneration they earn sufficient to afford ample consolation for the hardships they undergo.

As a rule, the services of boardmen are secured through the intermediary of contractors. A business firm, advertising on a large scale, could not incur the trouble of enlisting the band of boardmen. The organization, the superintendence, and payment, &c., of these men is a business in itself, and the intermediary is, therefore, almost indispensable. Boards have to be purchased, the correct advertisements pasted on them, the men must be enrolled, started at a fixed hour, and above all carefully watched, or they would simply deposit the boards in a corner and spend the day quietly reclining in the cosy nook of a favourite public-house. For all this work and organization the more respectable contractors generally charge two shillings per day per man to the advertiser, and reserve twenty-five per cent. as compensation for their trouble and responsibility. Thus a boardman will generally receive eighteen-pence per day, but there are some contractors who only give one shilling and four-pence, and others, I believe, even less. Their hours, it is true, are short, that is to say from ten to five in winter, and ten to six in summer ; but they must be constantly

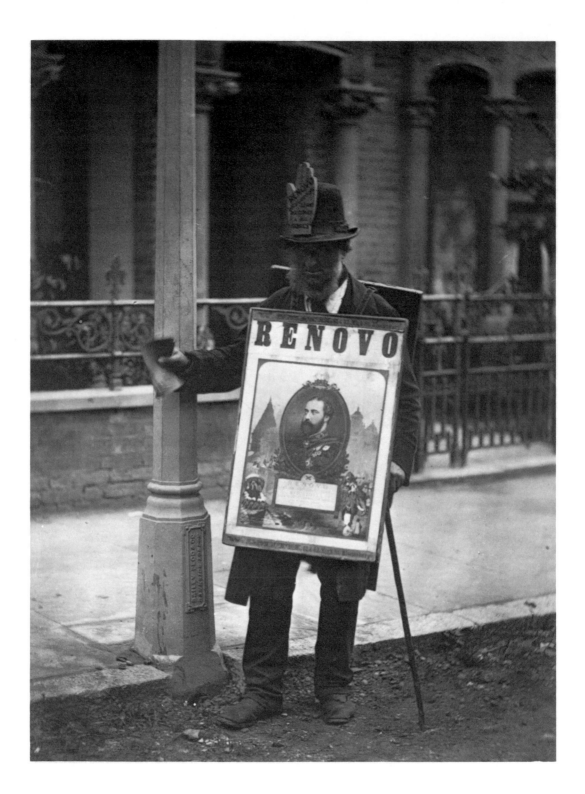

The London Boardmen

on the move during the whole of this time, and their employment is far from regular. For instance, during the cattle-market there is a great demand for boardmen. The pantomines are also largely advertised by their medium; but after Christmas there ensues a lull which is distressing in its effects on these men. Fortunately, even during the dullest seasons, new inventions constantly require new publicity, and thus, though the demand varies, it never entirely ceases. This year, for instance, an enterprising trunk-maker conceived the ingenious idea of placing a number of men inside some of his trunks, so that their heads and feet only appeared. Huge portmanteaus and boxes were thus seen slowly progressing along the streets in single file. Of course every one looked to ascertain from whence this eccentric procession came, and did not fail to find the name of the trunk-maker on each of the trunks. The accompanying photograph is another good specimen of this eccentric method of publicity, and does not fail to attract attention to the popular patent advertised, not only " back and front," but also on the head of the boardman.

There is perhaps no more heterogeneous set in existence than the London boardmen. Unlike many other street trades, this business is not followed by a special tribe. Costermongers, for instance, are almost a race apart, and differ both in their habits and even physically from the rest of the population, but boardmen are of all sizes, ages, shape, and complexion. Some are hopelessly vulgar and ignorant, others have received the education of gentlemen. They represent, to use a consecrated expression, all who have " gone to the wall." Any one who is temporarily in difficulties may offer to carry boards. Others, who are permanently incapable of helping themselves, live on, year after year, contentedly bearing this simple burden. Old men, grown grey in crime and drunkenness, may by a little dissimulation obtain employment as boardmen. There is not much chance of their stealing the boards; and a bout of drunkenness is the worst catastrophe that generally happens.

By the side of these unreliable and disreputable characters, there are many boardmen whose case is more deserving of sympathy. I had, for instance, an occasion of discussing with two boardmen who seemed worthy of a better position. The first had been trained as a smith, and engaged in the making of iron bedsteads. Now, however, smiths are no longer employed for this sort of work. It has been found more expedient and economical to make bedsteads with cast iron, and this change in the mode of manufacture threw many men out of employment, and notably my informant, who gradually sank to that state of misery when street life becomes the only means of existence. The other boardman with whom I conversed was an old soldier, and had served nine years in the East Indies. He had shared in many glorious engagements, and was proud to relate that he had fought in Major-General Havelock's division at the relief of Lucknow. Probably his position in life would have been secured had he only received a good education; but he was not well enough read to occupy the post or undertake the business his friends were willing to offer him. He consequently dwindled down till he reached that point in life when anything that brings a few pence is heartily welcome. But the old soldier has still retained considerable energy. He is not content with carrying the boards during the day, but also seeks to make use of his evenings. He has, fortunately, often obtained a shilling a night at the Globe Theatre where he appeared as a supernumerary.

Several attempts have been made to better the condition of London boardmen, and on one occasion a Co-operative Boardmen's Society was established. A missionary had opened a room where the poor and destitute might come and warm themselves gratuitously. The only condition exacted in exchange for this shelter was that the people should remain tolerably quiet, while the missionary engaged in

extemporaneous prayers and exhortations. The poor people cared but little for preaching that apparently brought no result, and appreciated the heat of the stove more than the eloquence of the sermons. Some practical gentlemen who became acquainted with this little institution, at once suggested action, and that if any sermons at all were given they should be preached from the maxim that God helps those who help themselves. As an easy means of giving employment to all who came to the missionary's stove, it was proposed that they should be sent out as boardmen, for, whatever the nature of their previous occupation, none could pretend that they were incapable of carrying boards. This movement was the origin of the co-operative society, and at first some sixty members were enrolled. The idea that they were not only to be paid for their day's work, but would share once a year the profits that generally accrue to the contractor, was certainly very enticing, and the society was at first greeted with much applause and approbation. Unfortunately there is generally a wide difference between theory and practice. Skilled and educated artisans have not always succeeded in making co-operative enterprises succeed. Many institutions of this character have collapsed, though they have been managed by far more able persons than the motley crew gathered in the missionary's hall. In a very short time half the committee, in obedience to its own rules, had to be dismissed for drunkenness. The management fell into chaotic confusion, and an enterprising contractor gathered together the wrecks of this business, united them to his own, and thus disappeared the Co-operative Boardmen's Society.

Taken as a body, it would be difficult to help these men to a better condition, and the only practical service that can be rendered is by the selection of individual and more worthy cases. In one instance, however, this system failed egregiously. A contractor discovered among the boardmen in his employ an individual who was not only a good grammarian, and wrote well, but was thoroughly conversant with three foreign languages. That so superior a person should, in the very prime of his life, waste his existence carrying boards about, seemed too great a loss of human ability. The contractor invited this boardman to enter his office, and at once gave him the position, the work, and emoluments of a clerk. He further, I believe, gave him a suit of clothes, so that the new clerk might not betray by his appearance the humble position from which he had been promoted. For a week or so the contractor had reason to congratulate himself several times on the wise selection he had made. No clerk had ever displayed so much business aptitude. No secretary could write a better letter, and he seemed with intuitive facility to understand all he was required to accomplish. The boardman's future was now insured. He had only to continue working with the same steadiness and aptitude, and every phase of prosperity was accessible—the most brilliant business career lay stretched before him. Never had so complete a transformation been accomplished in so short a time. The contractor was lost in admiration for the elegant, able, and gentlemanly clerk he had extracted from between the boards and raised to his office. But in one day all these illusions were dispelled. The model clerk made his appearance late one morning, his eyes were bloodshot, his new clothes all torn and dirty, and he was screaming and wildly gesti-culating. Drink had brought him to the verge of madness. A strait-waistcoat alone could overcome the violence of his antics. No subsequent lecturing and kindly advice could persuade him to break off from the fatal vice. His promises were never observed ; when sober he was as industrious, as grateful, as it was possible to expect, but about once a week he yielded to his passion for drink, and finally became so unmanageable that he had to be dismissed. This individual, if still alive, is probably wandering about the streets in a state of the most abject misery.

<div align="right">A. S.</div>

THE WATER-CART.

HE old wooden water-cart will be rapidly superseded by a perfectly-constructed iron tank fixed on the framework of a specially-fitted cart. The tank, besides containing a larger supply of water, is not liable to leakage, while the span of its perforated tube behind, and the force of the water discharged, are all admirably adapted for the efficient watering of roads.

Independently of the rain which frequently cleanses the metropolis, and the gentle showers that lay the dust, the enormous quantity of water annually poured on the roads of London constitutes an important drain upon the water supplied to the metropolis.

The men employed on the water-carts work according to the state of the weather. Thus, in summer under a hot dry wind, they emerge at early morning from the vestry yards and radiate over the parishes. During wet weather some are employed in cleansing the roads, others in carting materials for the contractors who supply the building trade. These are the hands who find constant employment under one master at weekly wages ranging from eighteen to twenty-three shillings. In justice to the contractors, I must express my admiration of the carts, men, and horses used in this branch of road labour.

The accompanying illustration is a fair specimen of the modern water-cart and its accessories. The cart is, I believe, protected by a patent, and is assuredly of the most novel construction. The horse is typical of the class of animal used for the work—large and powerful, so as to stand the strain of incessant journeyings two and fro, and of the weight of water in the tank. The man is a fair type of his class, being attired in a manner peculiar to watering-men. Beyond the ability to groom and manage a well-fed docile horse, nothing approaching skilled labour is required. He sits on his perch all day long, only descending when it is necessary to refill his cart at the hydrants.

I was fortunate in making the acquaintance of a young water-carman, who commenced life as a butcher, but disliking the trade, he left and took to cart-driving. He was a singularly-handsome young fellow, attired in a manner at once simple, careful, and betokening the cleanness of his occupation. I found him when he had nearly finished his day's work, whistling gaily while his cart was filling at a hydrant. He informed me that his hours of labour were from five o'clock in the morning to seven at night. First of all his custom was to tend his horse and prepare for the day's journey. At an early hour he received instructions regarding his day's work. If his services were required on the roads, he started out with his water-cart, taking first the main roads along his beat, and gradually making his way round into less-frequented streets, until the dust had been effectually laid through the length and breadth of his ward. The work is constant and monotonous while it lasts, and one hour and a half only for meals is allowed. As soon as his cart had gone the rounds, and discharged on an average forty-three fills of the tank, he returned to the yard, and had again to start off with another load—it might be of bricks or sand. For this final load he received extra pay, his weekly wages being twenty-three shillings. He gave me the following account of his mode of life :—

"I may say, sir, I have no proper home. My father and mother are both living. But mother for many years has done all the work." He modestly confessed, a blush

The Water-Cart

mantling his cheek, to helping his mother. He indeed gave her regularly the extra three shillings of his weekly earnings. "As to my father," he continued, "I had to leave home on his account. I quarrelled with him, and never could have saved a penny while I lived under his roof. I had a small cash-box containing my savings—some three pounds odd ; my father one morning broke open the box and helped himself to one pound. I never could feel the same to him after that, I felt savage and sorry too. So I left the old people, and took a lodging not far off. My mate, in the same employ, and me, pay half-a-crown a week each for one room, washing, and cooking. It must pay the landlady, because we are no trouble. She cooks, we buy the meat just as we feel inclined. My washing is not heavy—two shirts, two pairs of stockings, one slop jacket, and the 'kerchief I have about my neck. It costs me, all told, about twelve shillings a week for my living, the rest I mostly save. I have laid by about eight pounds this last twelve months ; I mean to put it in the bank, that, please God, when I am old, I may need no man's help."

It is refreshing to come across a man of this stamp, kind-hearted, independent, and steady. "If I have ever done any good," he said, "it's my mother I have to thank for that. She managed to keep us straight when we could do nothing for ourselves, and when things looked black enough."

Another weather-beaten waterman told me he had been off and on twenty years with the cart. In his young days he served a corn-chandler. "But the hours was killing ; and my gov'nor would ha' took more if he could. Seventeen hour a day sometimes, what do ye think of that ? I left when I got this job, waterin' in summer, and cartin' in winter." I remarked on the fine condition of his horse. "Bless ye, yes," he said ; "you see, sir, my family is all grow'd up like and away, and I takes to this beast uncommon." I said that he was uncomplimentary to his family. "Not a bit, not a bit ! Some on 'em 'ad not the manners o' that beast, but they was mainly good. That 'os knows my 'and as well as if he war a dog ; he knows my foot too, and w'en I wakes 'im he pricks up 'is ears, and a'most smiles he do w'en I says a cheery word. I believe that 'os understands all I say, and if he could speak would give me as good a character as my master. But I don't want no new place, I am comfor'able, 'e and I gets on like brothers. That is the 'os for me."

"MUSH-FAKERS" AND GINGER-BEER MAKERS.

ACCORDING to a rough estimate there must be about 300,000 gallons of ginger-beer sold per annum in the streets and immediate neighbourhood of London. This summer beverage, therefore, represents an important trade, and it has the further advantage of giving employment to a number of indigent persons who would otherwise, probably, fall on the rates. The trade requires but little capital, no skill, and scarcely any knowledge. A pound or thirty shillings would suffice to start a man or woman in this business, and a recipe for the brewing of ginger-beer is easily obtained. The difficulty, if any, consists of boiling the ginger in the large volume of water employed. For instance, three pounds of ginger are generally used for nine gallons of water, and will make altogether a gross of ginger-beer. The poor who make ginger-beer do not, however,

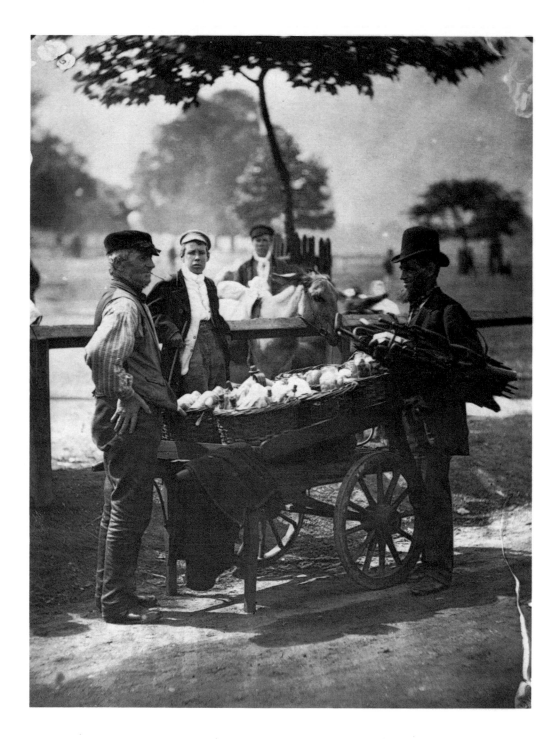

"Mush-Fakers" and Ginger-Beer Makers

possess stew-pans that will hold nine gallons; and, therefore, do not scruple to resort to the copper. This disgusting habit of boiling ginger in the same vessel which serves for washing the dirty linen of several families is, I fear, extensively practised, nor is it thought in any way derogatory to the value and popularity of the drink. The ginger-beer seller who initiated me into this mystery acknowledged that he used the copper in his house, after the other lodgers had finished washing and boiling their clothes, and did not for a moment anticipate that I should take exception to such a practice. When the strength of the ginger has been extracted by boiling, a little lemon acid, some essence of cloves, loaf sugar, and yeast have to be added. The mixture can then be bottled, and should be left to stand twenty-four hours. If, however, the stock has suddenly fallen short, either through excessive demand, resulting from the sudden advent of hot weather, or in consequence of the small supply of bottles possessed by dealers whose capital is very limited, a larger quantity of yeast will produce effervescence much sooner. Further, to add to the sharpness which should result from the essence of lemon, some makers do not hesitate to employ a little oil of vitriol; so that, after all, it is problematical whether the strict temperance advocate who remains faithful, even during the dog-days, to ginger-beer and lemonade, does not run as much risk of poisoning himself as the frequenters of public-houses. The various forms of lemonade, which are so often preferred to ginger-beer, present the same dangers, and may at times be productive of considerable mischief.

The present generation of street vendors have had, however, to compete against the great wholesale manufacturers, who employ the powerful aid of steam. The soda-water, lemonade, &c., produced in these large factories has at least the advantage of being clean, though often impregnated with lead.

A most experienced ginger-beer maker, a man who had served in the Indian army, and was accustomed to brew for his entire regiment, explained to me how he lost one of his best customers. He sold to a public-house keeper near London Bridge, about half-a-gross per week. On one occasion, while delivering his usual supply to the publican, there happened to be four gentlemen drinking ginger-beer at the bar, who noticed him. On leaving the public-house, these gentlemen passed by the barrow, on which his glasses and bottles were laid out to attract pedestrians. They had just paid fourpence a glass for the ginger-beer they had seen this man deliver over to the publican; and on tasting what he sold in the street for a penny, discovered it was precisely the same brew. Every one knows, who reflects on the subject, that the ginger-beer publicans sell for fourpence is not worth a halfpenny a bottle; but when these extortionate charges are rendered so apparent to the victims, they are apt to produce an irritating effect. Hence the gentlemen in question returned to the public-house, expressed their discontent in terms more forcible than elegant, and the publican was not a little disconcerted when it was conclusively proved before his assembled customers, that he realized more than three hundred per cent. on the sale of ginger-beer—selling bottles at fourpence which he had bought from a poor man for three farthings! This demonstration produced, however, a disastrous effect, so far as the ginger-beer seller was concerned. The publican, in a fury, not only refused to buy any more beer from him, but would not even return his empty bottles. The ginger-beer man was therefore compelled to take out a summons to recover his empty bottles, but I am pleased to add that the magistrate expressed his sentiments in strong terms, and compelled the publican to pay compensation for the time the ginger-beer seller had lost. Thus this publican ceased to patronize the street vendor, and, like the other members of his trade, ordered his supplies from the wholesale manufacturers, where he obtains the beer at the same price,

if not cheaper, and does not run so much risk of being discovered in the extortions he practises.

The most fruitful ground for the sale of ginger-beer, lemonade, and the other summer drinks which can be conveyed on a barrow, is, undoubtedly, the open-air resorts, where on holidays crowds of people seek health and amusement. At Clapham Common—where the accompanying photograph was taken—Hampstead, Greenwich, Battersea Park, &c., &c., on a broiling summer's day, there is a great demand for light, refreshing drinks, and more than £1 may be taken during one day by those who have a sufficient supply of ginger-beer with them, or some friend who can bring a fresh stock in the course of the afternoon. In ordinary times, however, twenty shillings a week net profit is considered a very fair reward for selling ginger-beer in the streets. Apart from the very hot days, and the pleasure-grounds around the metropolis, the best time and place for the sale is near the closed public-houses on a Sunday morning. The enormous number of persons who have spent their Saturday evening and wages in getting lamentably drunk, come out in the morning with their throats parched, and are glad of anything that will relieve the retributive thirst from which they suffer. Ginger-beer, under these circumstances, is particularly effective in restoring tone and mitigating the consequences of intemperance; and these are facts which readily account for the large sales effected on Sunday mornings.

Even this phase of the business is, however, barely to be relied upon in the winter months; but, as it is an ill wind that blows nobody good, what the itinerary ginger-beer dealer loses, the street vendor of umbrellas gains. Thus we have before us two men who interpret the weather in a diametrically opposed sense. Every shower clouds the brow of the man whose income depends on the consumption of the summer drinks, while rain brings business and money to the seller of umbrellas. These latter are divided into various classes, and work according to the degree of capital they possess. The real "mush-fakers" are men who not only sell, but can mend and make umbrellas. Wandering from street to street, with a bundle of old umbrellas and a few necessary tools under their arm, they inquire for umbrellas to mend from house to house. When their services are accepted, they have two objects in view. First, having obtained an umbrella to mend, they prefer sitting out doing the work in the street, in front of the house. This attracts the attention of the neighbours, and the fact that they have been entrusted with work by the inhabitants of one house generally brings more custom from those who live next door. When the job is terminated, the "mush-faker" looks about him, as he enters the house, in quest of an umbrella which has passed the mending stage; and, in exchange for the same, offers to make a slight reduction in his charge. Thus he gradually obtains a stock of very old umbrellas, and by taking the good bits from one old "mushroom" and adding it to another, he is able to make, out of two broken and torn umbrellas, a tolerably stout and serviceable gingham.

If he should fail to obtain sufficient stock in this manner, lots varying from a dozen to a gross of old broken umbrellas are sold in Petticoat Lane. These are brought to the Lane by the men who go about offering china in exchange for old coats, hats, umbrellas, &c., and are then sold wholesale in Petticoat Lane to the "mush-fakers," who have purchased the "commodity of the market" by paying the customary sixpence per week for the privilege of admission. In the evening, after the "mush-faker" has wandered through the suburbs in the manner I have described, he takes his stand on some special spot, probably near or in the midst of a street market, and attempts to sell the second-hand umbrellas which he has resuscitated with the aid of considerable ingenuity and skill. Altogether, he is able to clear from

eighteenpence to five shillings a day. But the "city men," as they are called, make far more. These latter frequent the City, may generally be found near the Royal Exchange, and can be distinguished by the green baize with which they envelope about two dozen umbrellas. They must possess some capital, at least £2, to buy so extensive a stock, and are consequently looked upon with some degree of envy by the ordinary "mush-faker." It is urged that they often known nothing of the trade; their success depends on their more elegant stock, and on the fact that their dress is sufficiently respectable for them to venture to stop a gentleman in the street and offer him an umbrella. On a very showery day these men have realized as much as £2 in a few hours; and though their umbrellas are not often worth the money paid for them, they are useful in cases of emergency.

Another set of men, who pursue a different branch of the same business, are known as "stool men," and they are more particularly distasteful to the real "mush-fakers." The "stool men" have a still larger capital, and, what is more, possess "the gift of the gab." Selecting a corner or a by-street running into a crowded thorough-fare, they take their stand on a stool, and from that eminence commence an eloquent harangue, which culminates in the presentation of a number of umbrellas to the crowd which has gathered around. These men do not always admit that their umbrellas are second-hand. With new handles and fittings they make an old umbrella appear as if it had never been used. If the silk is very old and limp, it may be dipped in a weak solution of gum, and this will make it both stiff and glossy; so long, at least, as the umbrella is kept dry. But as the purport of an umbrella is precisely that of receiving the wet, it generally happens that this mode of deception is soon detected, and purchasers from "stool men" do not often renew their custom. The "stool men's" umbrellas, in fact, are made more for show than for wear; polished brass, nickel, or silver "fixings" are relied upon more than the quality of the silk or alpaca—show, as opposed to utility, carrying the day. The "stool men" themselves, even, very rarely know anything about umbrellas. They buy them wholesale from firms established in the neighbourhood of Bishopsgate or Petticoat Lane, and, when by accident any of them break, the "stool men" are often obliged to ask a "mush-faker" to help them to mend their stock. This is a moment of triumph for the latter, for such incidents demonstrate that the trade should, if justice were done, be in their hands, instead of being shared by individuals whose only recommendation is due to the fact that they possess a little more money and a great deal more impudence. But, on the other hand, the "stool men," and also the "city men," are frequently obliged to change quarters; for when once they become known, custom leaves them, as neighbours relate to each other the deceptions they have experienced. The genuine "mush-faker," however—the man who is familiar with the nature of every "rib" and "stretcher" that expands and sustains his "mushrooms," and can make, or "fake," any part of an umbrella—is able to hold his ground, and re-appears, night after night, at the same market, gathers around him the support of regular customers, who can testify that they have never been deceived. Thus, I know of a "mush-faker" who has frequented the corner of Tottenham Court Road, near Oxford Street, for many years, and who always appears on this spot when he has anything to sell; but scores of "stool men" and "city men" have come and gone during the course of these years, and were never able to outlive the contumely which rewarded the impositions they practised on the poor who placed too much confidence in them.

<div style="text-align: right">A. S.</div>

NOVEMBER EFFIGIES.

ORMERLY the 5th of November was simply a day of national rejoicing, principally celebrated by boys. The poor have, however, contrived to turn this anniversary to some account, and many bad debts, arrears in rent, huckster's bills, &c., have been finally settled with the profits derived from exhibiting Guy Fawkes. About thirty or forty years ago only boys carried guys about. These were of a diminutive size, and uniformly represented Guy Fawkes. The sole object of the boys who made these demonstrations was that of enjoyment; and they only looked forward to a bonfire, and a brilliant display of fireworks in the evening. Now, however, the parading of a Guy Fawkes may be considered in the light of a commercial undertaking, and the organizer of the show may undoubtedly be ranked among the street *impresarii* who prepare open-air entertainments. This comparatively novel state of affairs originated at the time of the "No Popery" agitation that ensued after the division of England into papal bishoprics. Lay figures representing Cardinal Wiseman, the Pope, and Guy Fawkes fraternizing together over a powder barrel, were dragged about the streets and greeted with cries of "No Popery," followed by showers of pence. Costermongers, and other persons who earn their living in the streets, did not fail to profit by such opportunities. They saved money for weeks previously, and expended considerable sums in dressing and preparing gigantic guys, it having been ascertained by experience, that the more elaborate the show, the greater the receipts. Gradually, however, the excitement with regard to the spread of Roman Catholicism in England subsided, and at the same time, the number of Irish poor who live in our large towns greatly increased. These latter did not fail at times to express their resentment against the Guy Fawkes demonstration. Fights often ensued, and the Irish frequently succeeded in tearing expensive guys to pieces, thus wrecking the show, and destroying all hope of gain. Evidently, this form of speculative enterprise was losing ground, and would have died out altogether but for the modifications introduced.

It was discovered that lay figures, representing unpopular persons other than Guy Fawkes, proved equally amusing to the public, and were not so likely to be attacked by the Irish. Thus, during the Crimean War, effigies of the Emperor Nicholas were far more applauded than the stale representation of the Gunpowder Plot. Nor have the figures always been of political significance. Of late years, Madame Rachel and Mrs. Prodgers were burnt in effigy amidst cries of undivided enthusiasm. The Irish, as well as the general public, enjoyed the skit at Mrs. Prodgers, particularly as there are several Hibernian cab-drivers, and this is an important consideration. In the wealthy quarters, but little interest is manifested in these tawdry and clumsily-built figures. The rowdies and rough horse-play that follows a guy is naturally distasteful to the West End, and greater receipts, therefore, are made in the poorer quarters, and here the Irish abound.

The preparation of a Guy Fawkes, or his modern substitute, whatever that may

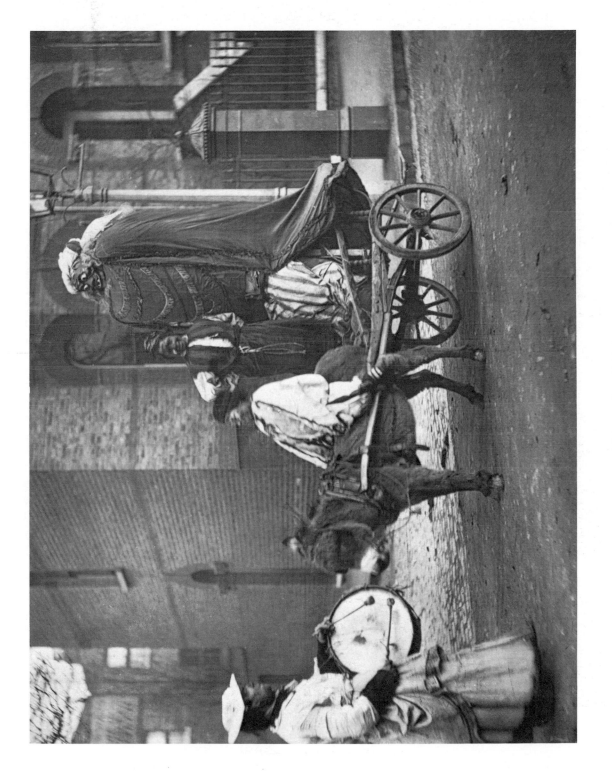

November Effigies

be, is a matter of considerable difficulty to the persons who undertake such ventures, for they are generally very restricted in their means. Spangles and paper play a prominent part in the apparel of a guy. But now it is also the fashion to dress the men and boys who attend, and sometimes clowns are engaged to follow and amuse all who deign to look at the show. The accompanying photograph is that of a nondescript guy, somewhat clumsily built up by a costermonger who lives in the south-east of London. This meaningless monstrosity, together with the absurd appearance of the man in woman's clothes, amuses some persons, and the conductor of such an exhibition can hope to realize about thirty shillings the first day, a pound on the 6th of November, and ten or fifteen shillings on the 7th. With this money the cost of getting up the guy must be refunded, and a shilling or eighteenpence per day given to the boys who help to swell the cortége. The boys' share of the proceeds is consequently somewhat out of proportion with the time and cheers they devote to promoting the success of the enterprise ; but it is argued that they enjoy the fun, while to their seniors the venture is attended with some risk, and is only considered as another form of labour for daily bread. Hence the absence of the joviality and real lightness of feeling which characterize the masquerades of the continent, where pleasure is the sole object in view. It has often been remarked by foreign critics, that Englishmen do not know how to enjoy themselves, and certainly nothing can be more melancholy than some of these Guy Fawkes exhibitions. In spite of assumed gaiety and continual cheering, the men who lead the guys about have often care-worn faces, which betoken an anxious and hard struggle for bread, and show that they have not in the least degree abandoned themselves to the pleasures of a holiday, but have on the contrary converted what might be a holiday into a period of special exertion, speculation, anxiety, and fatigue.

Sometimes, it is true, when the labour is all over, and the money has been shared, there is some feeble attempt at rejoicing. But even then the guy must not be burnt ; its clothes are too precious, the spangles might be used again next year. At most the straw, saw-dust, and wood shavings are extracted, and a bonfire lighted with these combustibles. Finally, what might have been an English carnival degenerates into a bout of unwholesome drinking in low public-houses. Here the Guy Fawkes men, like the English poor generally, show how devoid they are of ingenuity when there is a question of amusing themselves, and spend their hard-earned money in a form of drink which only increases their natural dulness. How different are the great historical processions which enliven the streets of the antiquated towns of Belgium, recalling the great struggles for religion and political liberty, inspiring every spectator with a due sense of reverence and gratitude for the deeds accomplished by their ancestors, diffusing some knowledge of history, and spreading the taste for what is truly artistic and picturesque ! How different also in its liveliness, and in its real and for the most part innocent enjoyment, is the carnival at Rome ! But we in England must apparently rest content with barbaric and uncouth exhibitions, some not even as good as that which is before the reader. In these hideous guys, we find evidence to corroborate the lack of artistic sense which is one of the greatest failings of the English race. At the same time, they occasionally testify to a certain rough sense of humour, and further serve as a public pillory, enabling the people to vent their anger on the effigy of some unpopular character.

A. S.

"HOOKEY ALF," OF WHITECHAPEL.

ON the 25th of October, 1693, Lady Wentworth sold a waste piece of ground, situated out in the fields to the east of London, on which a tavern or inn was forthwith built, and there it stands to this day, obtruding itself in a most remarkable manner in the very centre of the Whitechapel Road. Like an island in that great stream of human activity, the artery which stretches from east to west through the metropolis, this old inn has withstood all alterations, and remained unmoved by the huge suburb which has sprung into existence around. The road, the broadest road in London, had perforce to be narrowed here ; for the sacred rights of property could not be menaced, and the inn was allowed to remain blocking the very middle of the thoroughfare. Nor has age and the conversion of the neighbouring fields into a crowded portion of the metropolis entirely deprived the inn of its former rural aspect. There are still tables and benches placed outside, as if to entice Londoners to sit and enjoy the country air, though they are no longer planted on the green sward, but stand on the hard and smooth pavement stone. Even new paint and a new roof have failed to destroy the quaint look of this inn, while the groups generally seated outside contemplating the broad, busy road before them, add to the interest of this resort. No public-house could have a better claim to be included within the scope of this book. It is essentially a street public-house, for it stands in the middle and not on the side of the street. Here the customers are allowed to drink in the open air, and a large proportion of the persons who profit by this opportunity are themselves dependent on the streets for their livelihood. The groups, however, that may thus be observed seated outside the inn are not always picturesque or pleasing, though generally interesting. There is a metropolitan mixture of good and evil in the countenances that may here be studied, which will supply food for thought, if the thought be not always cheerful. Thus in the photograph before us we have the calm undisturbed face of the skilled artisan, who has spent a life of tranquil, useful labour, and can enjoy his pipe in peace, while under him sits a woman whose painful expression seems to indicate a troubled existence, and a past which even drink cannot obliterate. By her side, a brawny, healthy "woman of the people," is not to be disturbed from her enjoyment of a "drop of beer" by domestic cares ; and early acclimatizes her infant to the fumes of tobacco and alcohol. But in the fore-ground the camera has chronicled the most touching episode. A little girl, not too young, however, to ignore the fatal consequences of drink, has penetrated boldly into the group, as if about to reclaim some relation in danger, and drag him away from evil companionship. There is no sight to be seen in the streets of London more pathetic than this oft-repeated story—the little child leading home a drunken parent. Well may those little faces early bear the stamp of the anxiety that destroys their youthfulness, and saddens all who have the heart to study such scenes. Inured to a life crowded with episodes of this description, the pot-boy stands in the back-ground with immoveable countenance, while at his side a well-to-do tradesman has an expression of sleek contentment, which renders him superior to the misery around.

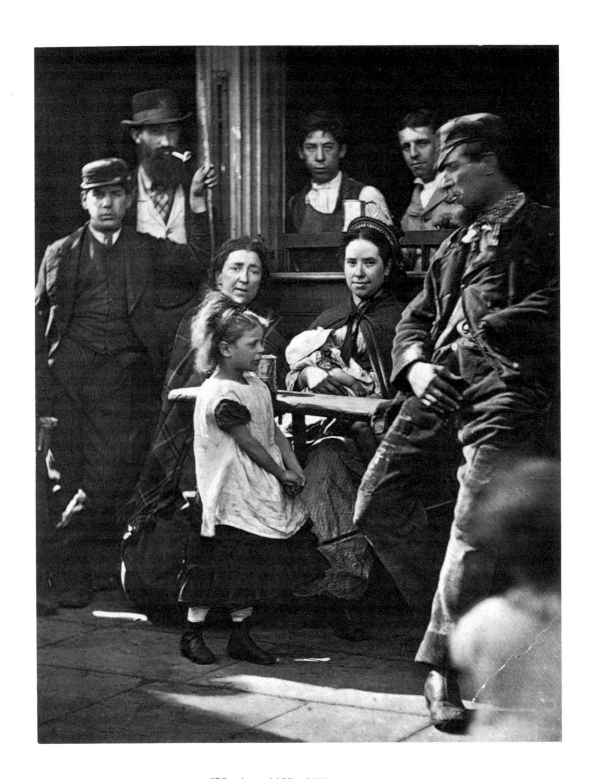

"Hookey Alf," of Whitechapel

The most remarkable figure in this group is that of "Ted Coally," or "Hookey Alf," as he is called according to circumstances. His story is a simple illustration of the accidents that may bring a man into the streets, though born of respectable parents, well trained and of steady disposition. This man's father worked in a brewery, earned large wages, married, kept a comfortable home, and apprenticed his son to the trunk-making and packing trade. The boy frequently helped to affix heavy cases to a crane, so that they might be lowered from the upper story of a warehouse into the street. As the boxes were lined with tin it required considerable strength to push them out of the loop-hole over into the street, and, the young apprentice having inherited his father's stalwart form, was selected for this work. On one occasion, however, he threw the whole of his weight against a huge case which, through some mistake, had not been lined with tin; of course the case yielded at once to so tremendous a shock, it swung out into the street, and the lad, carried away by his own unresisted impetus, fell head foremost to the pavement below. This accident at once put an end to his career in the trunk and packing trade, and rendered all the expense of his apprenticeship useless. He recovered, it is true, from the fall, but has ever since been subject to epileptic fits. Finding that under these circumstances he could no longer attempt complicated and difficult work, he thought he would seek to make his living in one of those occupations where mere muscular strength is the chief qualification required. Thus he was able for some time to earn his living as a coal porter, and most fortunately made himself very popular among the "coal-whippers," &c., with whom he associated. But even in this more humble calling fate still seemed to conspire against him. While high up on an iron ladder near the canal, at the Whitechapel coal wharfs, he twisted himself round to speak to some one below, lost his balance and fell heavily to the ground. Hastily conveyed to the London Hospital, it was discovered that he had broken his right wrist and his left arm. The latter limb was so seriously injured that amputation was unavoidable, and when Ted Coally reappeared in Whitechapel society, a hook had replaced his lost arm. Thus crippled, he was no longer fit for regular work of any description, and having by that time lost his father, the family soon found themselves reduced to want. "Hookey Alf," as he was now called, did not, however, lose heart; and, pocketing his pride, he wandered from street to street in search of any sort of work he could find. Hovering in the vicinity of the coal-yards he often met his old fellow-workers, and whenever a little extra help was required they gladly offered him a few pence for what feeble assistance he could render. Gradually he became accustomed to the use of his hook, and proved himself of more service than might have been anticipated; but, nevertheless, he has never been able to secure anything like regular employment. He may often be found waiting about the brewery in the Whitechapel Road, where ten or twelve tons of coal are frequently taken in during the course of the day. "Hookey" stands here on guard, in the hope that when the coal arrives there will be some need of his services to unload. On these occasions he will earn a meal and a few pence, and with this he returns home rejoicing. But, if after a long day's patient endeavour he fails to make anything, the worry and disappointment will probably cause an attack of epilepsy, and thus add ill-health to poverty. The tender concern of his mother cannot soothe the wounded feelings of the strong man. The energy and will are still there, it is the power of action alone that is wanting; and this good-natured, honest man, feels that he ought to be supporting his mother and sister, while in reality he is often living on their meagre earnings. The position is certainly trying, and it is difficult to make poor "Hookey" understand that an epileptic cripple cannot be expected to fulfil the same duties as a man in sound health. It is some consolation

to this worthy family to know that reliance may be placed on the daughter, whose earnings as a machinist keep the wolf from the door; but the spectacle of this once fine boy, the pride of his native street, now helpless in his spoilt manhood, must be a source of constant grief and disappointment. Perhaps the lowest depths of misery were reached when "Hookey," in despair, slung a little string round his neck to hold in front of him a box or tray containing vesuvians, and presented himself at the entrance of a neighbouring railway station, and sought to sell a few matches. For a man still young in years, if not in suffering, this must have been a galling trial, and from my knowledge of the family I feel convinced that they keenly realized all its bitterness. "Hookey's" misfortunes will, however, serve for one good purpose. They demonstrate that even those who resort to the humblest methods of making money in the streets are not always unworthy of respect and sympathy.

Many cases of this description might be found "Whitechapel way," by those who have the time, energy, and desire to seek them out; and personal investigation is at once the truest and most useful form of charity. It will always be found that those who have the best claim to help and succour are the last to seek out for themselves the assistance they should receive. It is only by accident that such cases are discovered, and hence my belief that time spent among the poor themselves is far more productive of good and permanent results, than liberal subscriptions given to institutions of which the donor knows no more than can be gleaned from the hurried perusal of an abbreviated prospectus. In this manner Dickens acquired his marvellous stores of material and knowledge of the people. Exaggerated as some of his characters may seem, their prototypes are constantly coming on the scene, and as I talked to "Hookey" it seemed as if the shade of Captain Cuttle had penetrated the wilds of Whitechapel. A. S.

THE "CRAWLERS."

HUDDLED together on the workhouse steps in Short's Gardens, those wrecks of humanity, the Crawlers of St. Giles's, may be seen both day and night seeking mutual warmth and mutual consolation in their extreme misery. As a rule, they are old women reduced by vice and poverty to that degree of wretchedness which destroys even the energy to beg. They have not the strength to struggle for bread, and prefer starvation to the activity which an ordinary mendicant must display. As a natural consequence, they cannot obtain money for a lodging or for food. What little charity they receive is more frequently derived from the lowest orders. They beg from beggars, and the energetic, prosperous mendicant is in his turn called upon to give to those who are his inferiors in the "profession." Stale bread, half-used tea-leaves, and on gala days, the fly-blown bone of a joint, are their principal items of diet. A broken jug, or a tea-pot without spout or handle, constitutes the domestic crockery. In this the stale tea-leaves, or, perhaps, if one of the company has succeeded in begging a penny, a halfpenny-worth of new tea is carefully placed; then one of the women rises and

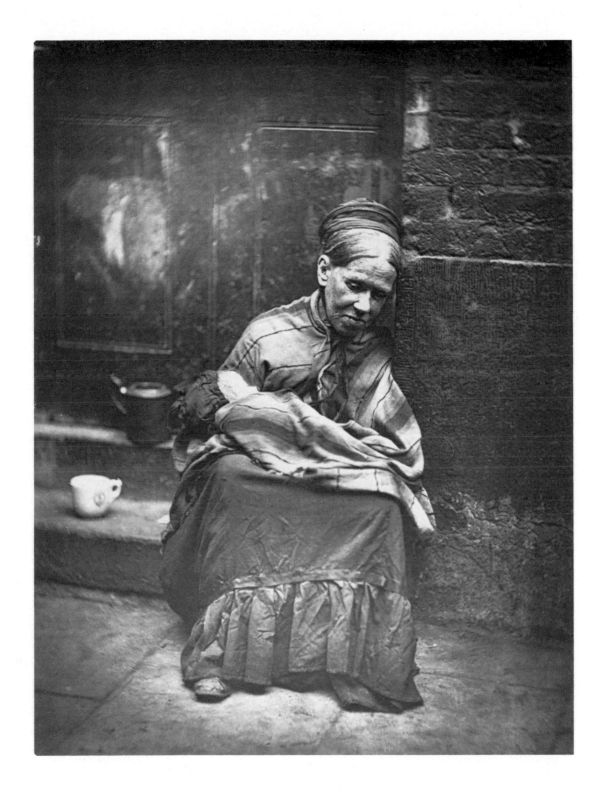

The "Crawlers"

crawls slowly towards Drury Lane, where there is a coffee-shop keeper and also a publican who take compassion on these women, and supply them gratuitously with boiling water. Warm tea is thus procured at a minimum cost, and the poor women's lives prolonged. But old age, and want of proper food and rest, reduces them to a lethargic condition which can scarcely be preferable to death itself. It will be noticed that they are constantly dozing, and yet are never really asleep. Some of them are unable to lie down for days. They sit on the hard stone step of the workhouse, their heads reclining on the door, and here by old custom they are left undisturbed. Indeed, the policeman of this beat displays, I am told, much commiseration for these poor refugees, and in no way molests them. When it rains, the door offers a little shelter if the wind is in a favourable direction, but as a rule the women are soon drenched, and consequently experience all the tortures of ague and rheumatism in addition to their other ailments. Under such circumstances sound sleep is an unknown luxury, hence that drowsiness from which they are never thoroughly exempt. This peculiarity has earned them the nick-name of "dosses," derived from the verb to doze, by which they are sometimes recognized. The crawlers may truly be described as persons who sleep with one eye open. Those who seem in the soundest sleep will look up languidly on the approach of a stranger, as if they were always anticipating interference of some sort.

Some of these crawlers are not, however, so devoid of energy as we might at first be led to infer. A few days' good lodging and good food might operate a marvellous transformation. The abject misery into which they are plunged is not always self-sought and merited; but is, as often, the result of unfortunate circumstances and accident. The crawler, for instance, whose portrait is now before the reader, is the widow of a tailor who died some ten years ago. She had been living with her son-in-law, a marble stone-polisher by trade, who is now in difficulties through ill-health. It appears, however, that, at best, "he never cared much for his work," and innumerable quarrels ensued between him, his wife, his mother-in-law, and his brother-in-law, a youth of fifteen. At last, after many years of wrangling, the mother, finding that her presence aggravated her daughter's troubles, left this uncomfortable home, and with her young son descended penniless into the street. From that day she fell lower and lower, and now takes her seat among the crawlers of the district. Her young son is not only helpless, but troubled with unjustifiable pride. He has pawned his clothes, is covered with rags, but still scorns to sell matches in the street, and is accused of giving himself airs above his station! The woman, though once able to earn money as a tailoress, was obliged to abandon that style of work in consequence of her weak eyesight, and now her great ambition is to "go out scrubbing." But who will employ even for this menial purpose, a woman who has no home, no address to give, and sleeps on the workhouse steps when she cannot gain admittance into the casual ward? Her son, equally homeless and ragged, cannot, for the same reasons, hope to obtain work; but, on the other hand, I convinced myself after a long conversation, that this woman thoroughly realized her position, and had a very clear idea as to what she should do to redeem herself. She would move heaven and earth to obtain a few shillings, and with these would proceed to the hop-fields, where she would earn enough to save about a pound, and one pound, she urged, would be sufficient to start in life once more. Her son might get his clothes out of pawn, and then obtain work. She would, on her side, rent a little room so as to have an address, and then it would be possible for her to apply for work. Nor was this castle in the air beyond realization. A fellow crawler, who used to doze on the same step leading to St. Giles's workhouse, had actually obtained employment in a coffee-shop, and, while

awaiting an opportunity to follow this example, my informant was taking care of her friend's child. This infant appears in the photograph, and is entrusted by its mother to the tender mercies of the crawler at about ten o'clock every morning. The mother returns from her work at four in the afternoon, but resumes her occupation at the coffee-shop from eight to ten in the evening, when the infant is once more handed over to the crawler, and kept out in the streets through all weathers with no extra protection against the rain and sleet than the dirty and worn shawl which covers the poor woman's shoulders; but, as she explained, "it pushes its little head under my chin when it is very cold, and cuddles up to me, so that it keeps me warm as well as itself." The child, however, cried, and wheezed, and coughed in a manner that did not testify to the success of this expedient; but it was a wonder that, under the conditions, the woman took care of the child at all. The only reward she receives for the eight hours' nursing per day devoted to this little urchin, is a cup of tea and a little bread. Even this modest remuneration is not always forthcoming, and the crawler has often been compelled to content herself with bread without tea, or tea without bread, so that even this, her principal and often her only meal per day, is not always to be had.

Another well-known crawler had consented to have her portrait taken in company with that of the woman whose circumstances I have already described, but on the previous evening a gentleman gave her sixpence while she was strolling down Albemarle Street. This enabled her to indulge in a night's lodging, and she was so unaccustomed to the luxury of a bed, that she overslept herself and thus missed the appointment! She is a tall, bony, grey-haired Scotchwoman, and wears a hideous grey waterproof, fastened as tightly round her as is safe, considering the feeble and worn nature of its texture. It is not known that she has any under-clothing. There is only a muddy nondescript substance hanging loosely round the lower part of her legs, which may be freely seen peering from under the skirt of the waterproof, while the upper portion of her feet are covered by soleless goloshes, on the purchase of which she actually laid out the sum of twopence. There was no certain evidence as to her possessing anything else. "Scotty," as she is called, had recently been condemned to pick oakum for three days in the Marylebone workhouse, as a punishment for having sought refuge in the casual ward three times in the course of one month. To risk what is equivalent to three days' imprisonment with hard labour, for the sake of spending one night in a casual ward, testifies to a degree of misery and want that beggars all description. But the horror of this picture is intensified when we consider that it is often undeservedly endured. Scotty, for instance, is no criminal, nor is she even a drunkard. No amount of pressure on my part could persuade her to drink even a single glass of beer with the dinner which, of course, I found an early opportunity of giving her. Further, she is neither stupid nor ignorant. She can read and write well, and her language is at times even polished and refined. How, under these circumstances, she could have become a crawler was at first an inexplicable mystery; but gradually I discovered, one by one, the chief incidents in her career, and it all seemed so natural that it was difficult to doubt her word.

"Scotty's" husband had been employed in a bank at Edinburgh, and, at one time, possessed property to the value of £2000; but this was sold, and the proceeds placed in the hands of some lawyers. I do not know whether Scotty's husband was also born north of the Tweed, but, in any case, he was not gifted with that spirit of economy, which, when it does not lead to the vice of meanness, is one of the chief characteristic virtues of Scotchmen. At every moment, whenever he experienced the least want of money, he applied to his lawyers, till at last they one day informed him

that there was none remaining. His first impression was that he had been egregiously robbed, but he had not kept any account of the sums received, and was therefore quite helpless. The poverty-stricken couple came up to London, and Scotty soon found herself a widow. Alone and friendless, she nevertheless bravely struggled against adversity, and obtained work as a tailoress, but an illness almost deprived her of her eyesight. So long as her eyes remained inflamed she was unable to work, and consequently fell into debt, till at last she was turned out of her room and her things seized and sold. This harshness on the part of her landlord did not, however, crush the poor woman. She had no money to pay a week's rent in advance so as to obtain a private room, and was therefore compelled to go to a common lodging-house; but she determined to spend the whole of the next day searching for work, and for some more respectable abode. During the night, however, a final catastrophe destroyed all these hopes. A fellow-lodger stole all her clothes. Protestations and complaints were all in vain, it was impossible to detect the thief, and poor Scotty, like Cardinal Wolsey, but in a more literal sense, found herself left naked to her enemies. Her petticoats, underlinen, skirt, apron, boots, all were gone, nothing but her waterproof, which fortunately she had put over her bed, remained. In this plight it was impossible to apply for work; no one was at hand to help or to suggest a remedy, and shivering with cold and almost naked, Scotty went out into the streets which were henceforth to become her only home. Hunger and cold soon reduced her to still deeper gloom and helplessness, till, at last, she gladly availed herself of the meagre shelter available on the workhouse steps. At times the stupor that this intense suffering begets, obtains such complete sway over her mind and body that she is unable to stand or walk, and she has often fallen from sheer exhaustion. "But," added Scotty, "I am becoming more accustomed to it now; I have not fallen once the whole of this week. What, however, I cannot endure, is the awful lazy, idle life I am forced to lead; it is a thousand times worse than the hardest labour, and I would much rather my hands were cut, blistered, and sore with toil, than, as you see them, swollen, and red, and smarting from the exposure to the sun, the rain, and the cold."

Gradually she seemed to recover her old energy. If she could only obtain a decent set of clothes, she would seek employment at the army stores in Pimlico, where she had worked in her more prosperous days. Here she could earn seven shillings a week. An old woman whom she had met in a mission hall had offered to share her room, a back kitchen, with her for eighteenpence a week. Scotty had been obliged to refuse this offer, as she had no earthly prospect of being able to pay even the eighteenpence; but, if ever she got to work again, this was the style of arrangement she would make. Then she would spend four shillings a week on her food, which she declared would be ample, particularly as she knew where to get excellent porridge! There would, therefore, remain out of seven shillings per week about eighteenpence for clothes, &c. Such was the ambition of this poor woman, and yet, for want of the slight assistance necessary to attain this modest end, she had been compelled to live the life of a crawler for nearly two months. Imbued with a pride that does honour to her nationality, Scotty has stubbornly rejected all suggestions as to her entering the workhouse, and does not, I believe, condescend to beg. Sometimes persons take compassion on her, and seeing her forlorn appearance, give her a few pence; but, had it been her practice to beg, she would never have endured all the misery I have but feebly described. Perhaps, however, with the help that will now be forthcoming, Scotty may once more resume work and leave the "dossing door."

<div style="text-align: right">A.S.</div>

ITALIAN STREET MUSICIANS.

ITALIAN boys and Savoyard children have always excited the interest and sympathy of northern peoples. It is perhaps difficult to attribute any sound reason to this fact, and we may question whether it is altogether just, that a comparatively speaking well-to-do foreigner should elicit more commiseration than the squalid and degraded fellow-countrymen who swarm in our streets. But there is an element of romance about the swarthy Italian youth to which the English poor cannot aspire. Then there is something irresistible in the bright glitter of his eyes, in his cheerful gait, and his fascinating manners ; while the English mendicant is coarse, ungainly, dirty, rude of speech, unartist-like in his appearance, out of tune when he sings, vulgar in all his deeds, and often bears the stamp of a hopeless drunkard. This perhaps explains how it is that Italians, sons of peasants, agricultural labourers, and others who might lead respectable lives in their own country, prefer to come over to England where they are sometimes treated as mere beggars. They find that a beggar in England is richer than a labourer in Italy ; and if he be not equally prosperous it is because he is not equally abstemious and economical. The Italian, therefore, migrates with the knowledge that he may rely on the generosity of the English, and that, if he only receives as much as many of the English poor, he may hope to save enough to buy himself a farm in his own country. They arrive, therefore, in shoals, and seeing how their presence is appreciated, do not realize the somewhat humiliating character of their avocation. Many, on the contrary, proudly claim a right to be ranked above the mendicant class. They urge, and to a certain extent justly, that they are of use to the community ; that, as a rule, their performance, whether with the barrel-organ, the piano-organ, the harp, fiddle, or other instrument, gratifies the majority of their hearers, and propagates the love for music among the poor. The only difference, so far as the political economy of the case is concerned, between them and actors and professional singers is the fact that they impose themselves on the public by performing in the street, and have to solicit, cap in hand, their reward. Otherwise, they argue, that they simply cater for the public amusement ; that if their performance is of a very inferior character to what may be heard in concert-rooms or theatres, they consequently receive very inferior pay. This is in fact but a mere question of supply and demand. The wealthy prefer to hear Italian singers instead of English vocalists at the great opera houses ; why should not the poor display a similar unpatriotic predilection for the merry Southener who plays the harp or grinds an organ in the street ? Just as in the higher class of art the Italians excel, so also in the more modest street performances do they attract more applause.

In this, however, as in many other circumstances which at first sight seem simple and innocent, abuses have gradually been engendered. A traffic in children has grown into a regular business which, like most trades, has entailed intense suffering on its weakest members. On this subject the Charity Organization Society published a special report, which, though certainly accurate in its main facts, insisted perhaps too

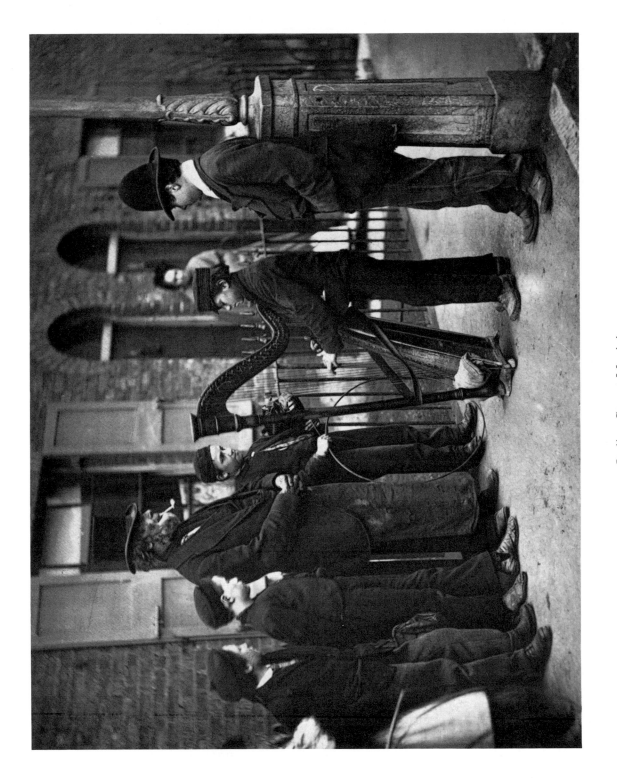

Italian Street Musicians

exclusively on one side of the question. We are told that a band of villains, an association of modern slave-traders, purchase helpless children in the neighbourhood of Naples, promising to teach them a *virtù*—that is to say, how to play or sing—and to return them to their parents at the end of two years, together with a sum of money. We are left to infer, however, that these conditions are never accomplished; but, considering that this traffic has been carried on for several generations, it is curious if the Neapolitan parents have learnt nothing from experience. Probably they do not care to have the children back, in which case the children may be better off away from such parents. In any case, one-half of the contract is strictly carried out; the children are undoubtedly taught a *virtù*, and consequently ultimately manage to make a good position. But we are informed that in the meanwhile they are most cruelly treated. Packed in rooms, hired for the purpose by the *padroni*, they live in an unhealthy atmosphere, and are contaminated by vicious associations; nevertheless, I venture to doubt if they are worse off than in their own country, where they so often fall victims to a vice utterly unknown in England. From a sanitary point of view, this condition certainly requires immediate reformation, but the need of good sanitation is even more urgent in southern Italy than in England.

The *padroni*, men of consummate experience in these matters, know precisely where the children are most likely to make money, and send them out in various districts, taking care that their efforts should not clash, but that each should separately cultivate good ground. In exchange, however, for this careful training and organization, they expect the child to give up all he has received; thus are the children made to pay the premium of their apprenticeship. If, at the same time, they were well fed, well clothed, well housed, and carefully trained, I fail to see that there would be any grave ground remaining for complaint. The Italian *padroni* should be treated in the same manner as other employers of labour; and, though undoubtedly he has at times proved himself cruel, tyrannical, exacting, and has not shrunk from the responsibility of inflicting starvation and misery on those who work for him, he has only followed the example set by innumerable manufacturers and other employers of labour both in England and abroad. We have often been compelled to legislate to protect the poor worker against the exactions of the capitalist; and, doubtless, there are still among us many manufacturers, coal-mine owners, &c., who, in their heart of hearts, complain that Acts regulating the work of women and children in mines, factories, and fields, have reduced their profits—men in fact who, but for our labour laws, would show scarcely more consideration for their dependents than that displayed by the *padroni*. For my part, I would welcome any measure that would protect the Italian children against the exactions of their *padroni*, however inquisitional and stringent such a law might be; but it is equally urgent to protect our native street arabs—to redeem from the starvation, drunkenness, degradation, and immorality of their homes those poor English children, whose care-worn, haggard faces, peering from our back courts and alleys, testify that their lot is not to be compared with that of the bright, laughing, healthy foreign children, who, for some inscrutable reason, seem to have momentarily monopolized what little human sympathy can survive the business of charity organization.

Among the Italian colony of Saffron Hill, where I made inquiries from Italians who are totally disinterested in the matter, I found a general impression prevailing that the children were not always ill-treated. Of course there have been a great number of complaints, and measures should be taken to prevent the repetition of cruelties; but still there are some persons who do not believe that the children are especially to be pitied. They sleep, it is urged, several in a room, and are thus able

to afford each other mutual protection. Living always in the centre of the Italian colony, the force of public opinion should tend to prevent cruelty. The Italians are notoriously fond of children, and nurture them with the tenderest care, and a tale of cruelty would produce far more effect among the Italian than among the English poor. It is stated that, as the children cannot speak English, they must endure tortures in silence; but this is altogether a fallacy, for they are surrounded by hundreds of fellow-countrymen, ice-sellers, organ-grinders, artisans, asphalte men, &c., who are not only Italians, but who, for the most part, come from precisely the same province, are constantly communicating and sending money over to their native homes, and would rapidly spread throughout the Calabrian mountains the news of any evil afflicting the Italian colonies in the great towns of England. The boys are for the most part intelligent and quick, would probably complain of any gross ill-treatment, and often show their sense of independence by running away altogether from their *padroni* when they are not comfortable, or think they have gained sufficient knowledge to carry on business alone. Nor are they likely to starve when hungry. Their pockets full of pence, what system of control can prevent them from buying food in the streets where they play? It is notorious that, apart from the food supplied by the *padroni*, the boys subtract a few pence from the money they obtain to buy some extras. The receipts made by the boys varies from 1*s*. 8*d*. to 4*s*. per day, and their healthy, hearty appearance and merry faces, testify that a portion of this is spent on food. I know at least of one *padroni*, living at Saffron Hill, who has the reputation of giving his boys plenty of food. Maccaroni is of course the chief dish, but it would be fortunate if our English poor knew how to enjoy so simple, nutritious, and wholesome a dinner. The *padroni* in question sends his own son out with the other boys. He has taught him to play the violin, and to good purpose. A harper boy, who also, I believe, came under his care, was taught how to speak English, French, and good Italian, and will probably go half round the world with his harp, and finally retire on his savings.

Other children come over to England to join their families, or the more enterprising members of their families, who have found out how to make money in our midst. The Italian harper, whose photograph accompanies this chapter, belongs to the latter class. His parents have long been established in England, and have a regular home at Deptford. From this centre various members of the family radiate in different directions, frequenting the sea-side in summer, and the cities and large towns in winter. One of the daughters plays the fiddle admirably, and the young son is equally skilful with the harp. He has only been in England about two years, and can already speak English fluently. He is described throughout the neighbourhood, where he is known to every one, as a charming boy, whose amiable disposition, modest bearing, and musical talents ensure him success wherever he may present himself. It would be absurd to treat this youth in the light of a mendicant. His clothes are ample, neat, and clean, his purse well-filled, for his earnings almost equal those of a skilled artisan, though he is but a boy, and he has far more right to public support and sympathy, in exchange for the good and simple melodies he brings to the doors of the poor, than, for instance, the great majority of singers who lower the taste and degrade the morals of the audiences at our Music Halls. Indeed, these street minstrels have sometimes attempted to gain a hearing in Music Halls, but their songs lacked the improper inuendo which, in such places, is the secret of success; and,

> " Io ti voglio ben assai
> Ma tu non pensi a me,"

is at once too simple and sweet a melody to satisfy the vitiated taste engendered in these establishments. But, in the streets, many a moment of quiet enjoyment has been afforded to the tired artisan by these modest minstrels. They have repeated to the uncouth English labourer the warm melodies of the Italian opera, they have helped to spread among the poor the love for the most humanizing and innocent of enjoyments, and have nurtured in our courts and alleys echoes of purer music than could otherwise have reached these dismal abodes. In this, the piano-organs have been of special service. As a rule, their selections are excellent, and the execution far surpasses that of a number of ladies who do not hesitate to play before company. Even classical music is sometimes executed with remarkable accuracy by these instruments, and the Italian organ-man has actually ventured to render extracts from *Tannhäusser* and *Lohengrin* to the startled inhabitants of our crowded thoroughfares, thus familiarizing all classes of the community with the mysteries of the "music of the future."

Little children are, however, less useful in this respect. Their performances are as a rule very crude, and it certainly would be no loss to the community, and much gain to themselves, if they were sent to school. This, on the other hand, would not be the case if they remained in Italy, nor would they be likely to gain as much money in the long run. The traffic in very young children should be checked; the older children will continue to come over here of their own accord. The well-founded hope of gain, and the love of travel and change will suffice to attract a constant supply of street musicians. These will be obtained readily enough without any resort to kidnapping, or the creation of a white slave trade. The present evils, whether exaggerated or not, would soon disappear if the operations of the Elementary Education Act could be made to extend to foreign children, and if the *padroni* were brought under the Factory and Sanitary Acts which govern other employers of labour. In the meanwhile it is to be hoped that the English public will continue to welcome with their pence all who cheer with good music our dull streets.

<div align="right">A. S.</div>

THE STREET LOCKSMITH.

THE trade in old iron, old tools, locks, and keys, gives employment to a great number of persons who are gifted with a little ingenuity. It is first necessary to recognize what are good and useful articles, then, by an observant study of human nature, to learn which is the best means of selling. There are, for instance, several stalls devoted to this business in the Whitechapel Road, and each possesses a sufficient number of keys to open almost every lock in London. Old keys constitute a staple article in the trade. A chatty, merry-faced, energetic, little woman, her hands red with the rust of a thousand keys she had been assorting with evident pride, once observed to me that the number of keys people lose was altogether beyond conception. "We buy the lost keys," she added, "and we sometimes sell them back to the very persons who lose them! We have a

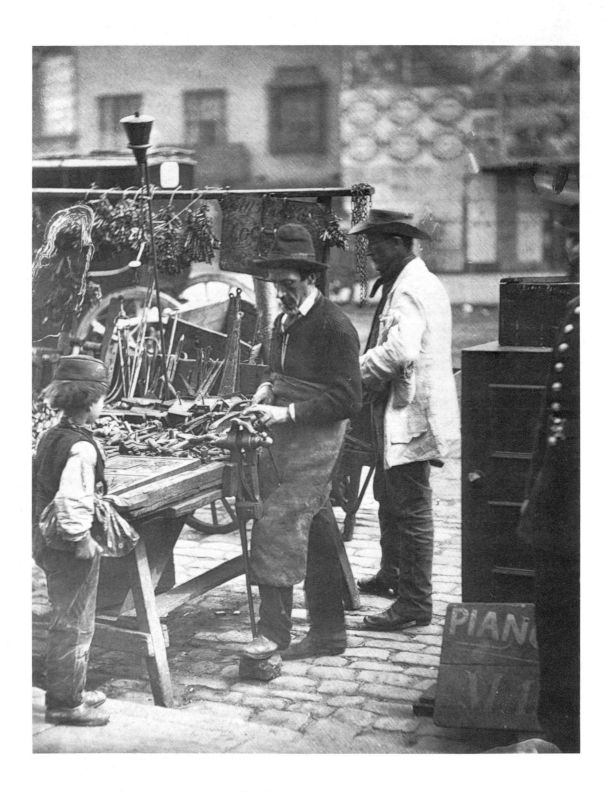

The Street Locksmith

uniform price, and will give you a key for anything for a shilling; and if out of this lot none fit, we just take one about the size, and my husband there with his file will soon make it open any lock you may choose to bring us." After much persuasion, I finally extracted a confession that she often sold many dozens of keys in a day. When the stock ran out, it was renewed at the dust-sifters' yard. Here innumerable articles may be bought, and notably tools, long lost, and finally carried away by the dustmen, amid the house refuse.

The owner of the stall in the accompanying photograph had, however, a different story to tell concerning keys. He possessed some keys which he would gladly sell for twopence, and he reminded me that this branch of his business was subject to certain restrictions which made him at times "lose a job or two." If keys were sold and made indiscriminately, burglars, and in fact all thieves would find easy access to other people's property. Hence certain laws were enacted with the object of preventing any one buying keys save the rightful owners of the locks they were intended to fit. A locksmith is, therefore, not allowed to make a key from an impression. Either the lock itself must be brought to him, or the locksmith must be allowed to enter the premises and fit his key into the door. Otherwise it would suffice to obtain an impression of a key on a piece of soap or wax for a thief to procure himself a similar one, and thus open the lock protecting the coveted treasure. Further, it is illegal for a locksmith to lend a bunch of his keys; and, in a word, before exercising his art to open locks he must assure himself that his services are not required for any dishonest purpose.

Many persons not only lose their keys, but contrive to break their locks, so that there is some trade done in both locks and keys. These can be bought in the Whitechapel Road for 1s. 6d. to 1s. 9d. each; while the same article in a shop would cost 3s. 6d. It is not surprising, under these circumstances, that the poor prefer the open-air street market, even for purchases of this description. Indeed they are so convinced that second-hand ironware is cheaper and as good as what is new, that in many cases they will not buy an object which does not appear to have been used. If a tool is stained with rust they imagine a low price will be asked; but if the dealer have the imprudence to clean it, then he is less likely to find a purchaser. Some of the tools thus sold nevertheless often possess considerable value, and the dealer, who as a rule may be numbered among the skilled street artisans, is always able to repair any little imperfection. Altogether this is, therefore, a very superior phase of street life, and the street locksmith is as a rule considered to be a respectable, and, to a certain extent, a prosperous member of the industrial classes. The accompanying portrait is that, for instance, of a man of exemplary rectitude. He has abstained from drink since the age of sixteen, and is the father of no less than sixteen children. His life has been spent in the pursuit of monotonous but honest work, and the regularity of his habits, the skill he displays in his handicraft, are all qualities which afford a pleasing and forcible contrast to the characteristics of the great majority of persons who earn their living in the streets.

A considerable export trade has been developed of late years in the old iron accumulated by dealers of this description. While in 1857, only 36,500 tons of old and broken iron were shipped from this country, no less than 139,812 tons were exported in 1871. This is generally sent out as ballast in ships bound for the Continent or the United States, and comprises such articles as frying-pans, gridirons, saucepans, candlesticks, broken pieces of chain, old boilers, tea-trays, fire-irons, and scrap iron, bolts, wire, hoop iron, old files, axes, saws, etc. All this iron, as a rule carelessly collected and sometimes carelessly sold, has a distinct market value accord-

ing to its nature and quality. The most fibrous iron, such as that employed for horse-shoes and horse-shoe nails, is in much demand among gunmakers, as also the scrap iron from needle-making, and other manufactures where finely-tempered steel is employed. These scraps, if ably treated, can be welded together and form the toughest gun-barrels. Old iron is also convenient in shape for piling, it is more easily manipulated, and, when worked with new iron, requires less labour. As each style of iron has, however, a different welding point, the one might be burnt and the other scarcely melted if they were all placed in the furnace together. Skilled judges must, therefore, be employed to sort this old iron, and but few persons are really able to judge the fibrous qualities of a piece of metal. Connoisseurs have, therefore, many opportunities of making excellent bargains through the ignorance of the persons with whom they deal. In this trade, therefore, as in so many other occupations, knowledge, and especially scientific knowledge, is the true means of success. Not that this knowledge should be employed for extorting at a vile price what is of considerable value, but it would enable dealers to protect themselves against the possibility of being imposed upon by the brilliant aspect of those shoddy wares which now invade every branch of commerce. So just and great is the fear entertained by artisans of shoddy tools, that those who cannot afford to buy good new implements, frequently prefer purchasing the first-class, but second-hand articles often sold at street stalls ; and, if they were always certain of not being imposed upon, this would undoubtedly be the wisest course to follow.

A. S.

THE SELLER OF SHELL-FISH.

THE street purveyors of shell-fish find their principal customers among the poor in such quarters as Whitechapel, Drury Lane, the New Cut, Lambeth ; and in the immediate neighbourhood of theatres and places of amusement. One of the chief elements of success in this, as in other branches of street industry, lies in selecting a suitable " pitch " for the stall. In answer to my inquiries on this subject, an old hand in the trade said, " If a friend should ask my advice about starting, I should say, Cruise round the likeliest neighbourhoods, and find out a prime thirsty spot, which you'll know by the number of public-'ouses it supports. Oysters, whelks, and liquor go together inwariable ; consequence where there's fewest stalls and most publics is the choicest spot for a pitch. See you choose the right side of the street. There's al'ays two sides of a street if it's any good, one's the right side for custom. Don't know 'ow it comes, whether it's the sunny side or what, but it's so, and it's so much so that it makes all the differ in trade. Your pitch should be close again some cab-stand or omnibus-yard, or about

The Seller of Shell-Fish

a market-place. Cabmen and men on the road are uncommon partial to our goods. Next to getting a proper pitch is making the barrow look as tempting as the fish is good. But a man should serve a sort of apprenticeship before he can hope to please the public with his barrow and his cooking. It's not enough to be able to tell a hoyster from a whelk, it's to know a good un when he sees it, and tell its wally in the market. Hoysters wants no cooking, but whelks, eels, and herrings should be kep' in stock cooked to a turn."

Although my informant was of opinion that a professional reputation could only be achieved by a course of regular training, there are many well-known whelk and oyster men in London who have served no apprenticeship to the trade. The owner of the barrow photographed is one of this class of untutored whelk men, who recounted his experience of street life in the following words :—

"Whelk selling is not my choice as a trade, I'd cut it to-morrow if I could do anything better. It don't pay more than a poor living, although me and my missus are at this here corner with the barrow in all weathers, 'specially the missus, as I takes odd jobs beating carpets, cleaning windows, and working round the public-'ouses with my goods. So the old gal has the most of the weather to herself. I have to start every morning about five for Billingsgate, to lay in stock for the day. I require about ten shillings in money with me. When they're in I usually get about a hundred oysters. This morning I had only twenty-five. Sometimes they are six shillings a hundred; to-day they cost eleven shillings. I also got half a measure of whelks, cost half-a-crown. I sometimes can work off a measure a day, on Saturday. The oysters on the barrow, with pepper, salt, and vinegar, fetch from a penny to three halfpence : I tries it on twopence for big uns. The whelks are not so easily managed. They must be bought alive, and boiled alive, till they comes out of the shell, and then served up with vinegar-sauce, same as oysters. I laid in twenty fine herrings this morning. There they are, cooked, or soused, as they call it, same as usual. They fetch a penny and three halfpence apiece. The whelks come into Billingsgate very irregular. Some mornings there will be about a couple hundred sacks, other mornings there's none to be bought for money. This makes our business uncertain and unprofitable, as they vary in price, and we always have to sell 'em about the same figure; that is, five or six a penny small, with sauce; four a penny large. I've been told they are difficult to catch. They are nice about their bait, and prefer it salted to fresh. Perhaps they might like fish sauce with it; can't say. Crabs and lobsters is what they likes best, and you'd hardly believe they can suck a lobster clean out of its shell, leaving it whole in every claw and joint. When whelks can't be got, I take more oysters and some Dutch eels. The regular shop men come first to the market. It's after they are done buying we gets what's left at a cheaper rate. The eels and other fish we gets ain't perhaps the best, but they're tidy goods for all that. Hot eel selling is a trade by itself; it's only took up by turns by whelk sellers. The eels wants good cooking and making into a kind of soup that goes down well with our class of customers in cold weather. The fish must be cut up, cleaned, and dressed, and after that's done boiled in flour and water. The soup has then to be made tasty with spices, parsley, vinegar, and pepper. You see that youngster coming with his news-papers. He's one of my best eel customers. He and another works the corner where the 'busses stop with ' Echos.' Whenever a gentleman gives him a penny, and takes no change, he comes here for a halfpenny-worth of eels." The little news-vendor came briskly forward, eager for his favourite delicacy. "Spoon 'em up big, gov'nor," he said; "this is the third go this arternoon!" He had sold four shillings' worth of newspapers, and earned a profit of eightpence on his afternoon's work. This sum was

sacredly set aside for his widowed mother, while the extra halfpennies he might chance to get from good-hearted customers were spent in food for himself.

After this characteristic episode the whelk man proceeded with the following biographical sketch :—" That boy has a hard life, sir, out in all weathers, but so is the lot of most on us in the street. It's perhaps harder to the likes of me, as I was not used to this sort of business. Not many years ago me and my missus had a green-grocery shop. It was a good going concern, and might have made money for us. But one year, when small-pox was bad, my two boys and the other children was all took with it. The hospital was full, and anyhow we thought we could pay doctoring, and nurse 'em at home. It was a mistake for 'em and for us. The two boys, as fine fellows as ever stepped on English ground, died. We had had two months of it then, and all that time, and for a while after, never saw nobody save the doctor. Our customers every one left. The whole trouble was so hard on me that my boys had to be buried at the expense of the parish. More than that, I had to sell my horse and cart, and everything we could well spare to get food. I tried on business again, when the beds and house had been cleaned; but it was no go, nobody would buy any more, as if every blessed cabbage had carried plague in its blades. Some of my friends, 'bus-men, seeing my plight, advised me to go fish selling, and made me a gift of a basket. That was the first of my street life. These men bought all they could from me, and I worked round the public-houses with the rest. By degrees I made my way until the master of the " Greyhound," over there, gave me leave to pitch my barrow opposite his door, where it have been ever since. The barrow was part of my old stock, rigged with a canvas cover, to keep the sun from spoiling the goods. I lose a good deal by spoiling, sometimes as much as a shilling a day. When the things won't sell, and we can't eat 'em all at home, they won't keep fresh till morning. At least the profit from the barrow is never over five shillings a day, often not so much. I have always, from pride partly, kep' a good home over our heads. We live in a sort of mews, and pay seven shillings a week rent for four small rooms and kitchen. The owner has stuck to us all through, although, at times, we have not been able to raise the rent. He has took it out in carpet-beating, and odd shillings as we could pay 'em. We have to be out all day, and leave the children at home. Me and missus runs down now and again to have a look at 'em. The oldest is in service, and the others mind one another. Three of 'em goes to school. At night one of us sees them abed, as it's late, sometimes half past twelve, before we gets home ourselves. I have still some debts to pay off, and I've the heart to live square and pay all I owe. But it's hard to pick up money on the streets; there is so many at the same game now, that it's about all we can do to get food. Fridays and Saturdays we stands a better chance of extra custom. Fish on Fridays goes down with the Irish, and on Saturday nights we get often a better class of customers than on other days. The workmen and their wives and sweethearts are about then, and hardly know how to spend their money fast enough. After visiting the public-houses they finish up with a fish supper of the very finest sort. Although I say it, no finer can be got, not at Greenwich or anywhere else. I've got to know exactly what I am about, and always to keep things going on the barrow in a style that brings folks back again. It's no use for a man always on the same pitch going in for the cheap and nasty; he couldn't stand a day against the competition of his neighbours. I never pick out anything that looks the least thing gone, for fear of losing the run of trade. When it's possible to work off some doubtful goods is at night, at the bar of a public-house, when the men drinking are too far gone to be nice about smell or taste, so long as they gets something strong. But even that is a dangerous game to be tried on too often, so I for my part leaves it alone."

FLYING DUSTMEN.

HE removal of dust and refuse from the houses of the metropolis is a task which devolves on the officers of the various parishes. Although the duty of collecting dust is not always discharged to the satisfaction of householders, it must be admitted, when the gigantic nature of the work is taken into account, that there is very little ground for complaint. In the parish of Lambeth alone there are about 40,000 rateable houses. Each house is calculated to contribute on an average three loads of dust in the course of the year, so that the accumulated annual refuse of this section of London would form a mound of no mean proportions. In this parish matters are so arranged that a dust-cart is supposed to pass each door twice a week. The faithful observance of this and other rules depends jointly on the men themselves, and on the efficient supervision of foremen set over them. These foremen are in the pay of the vestry, while the men and carts are hired by the day from a contractor. The rubbish thus collected is carted away in part to "shoots" found by the vestry within the area of the parish, and in part to the Thames, where it is deposited in boats hired for its removal at one pound sterling per load.

Formerly, contractors were employed to remove the dust in their own way, and held responsible for the proper fulfilment of their contracts. As the system proved costly and unsatisfactory, it was resolved that the parish should collect its own dust, and so dispose of it as to effect a reduction in the rates. Part of the scheme has been successfully carried out, but as yet no profit has accrued from the contents of the dust-carts. It is treated as waste material. Under the old system, householders were incessantly lodging complaints against the dustman, who was seldom to be found when his services were in demand. Not only had ratepayers to solicit the aid of that useful functionary, but he had his own way of letting it be understood that his services were not gratuitous. The dry dust would get into his throat, causing an abnormal thirst and choking sensation which could only be allayed by a copious draught of beer, or by a few pence to purchase the needful stimulant. This sort of "black mail" is still levied, although the authorities of the parish are making the most strenuous efforts to have it abolished, having inscribed on each cart a caution against the bestowal of gratuities.

For all that, the crafty dustman expects, and frequently receives, his accustomed "tip." When it is not forthcoming his visits become both dangerous and disagreeable. Rough at all times and heavy-booted, he calls on a wet day, and brings a trail of mud with him from the outer world. At other times he discovers that the passage from the dust-bin to the door is too contracted to admit of his exit without leaving some trace of his visit on the wall-paper or floor; or he pleads that his cart is too full and that he must call again.

Not many years ago dust had a high value; it yielded the following among other marketable products:—Fine dust, used in making bricks and as manure; coarse dust or "breeze," used in burning bricks; rags, bones, fragments of tin and other metals,

Flying Dustmen

old boots and shoes, paper, &c. That the refuse of the metropolis continues to be of some value, may be gathered from a visit to the establishment at Belvedere Wharf, where there is every appliance for sifting the dust of one of the city parishes, and turning it to profitable account. In some yards the fine dust is mixed with road-sweepings, and forms an excellent manure for poor land. "Breeze" is also employed by some builders to mix with mortar. It is cheaper than sand, and is supposed to answer the same purpose. I myself have seen in a single day, the contents of half-a-dozen dust-carts discharged on the road close to a suburban building plot. This heap remained for weeks in the same spot, until indeed it had assumed vast pro-portions and was emitting the foulest odours. It was then sifted into another heap, beneath which a fire of coal had been kindled for the purpose of burning out soft perishable foreign matter. There could be no fault found with the breeze thus produced, provided the entire heap could have been raised to a red heat, or that the subsequent admixture of lime it received was sufficient to destroy all animal and vegetable matter. In some instances sufficient mortar is not added to make this muddy compound cohere as it ought. The result is a new danger to the individuals who invest in new abodes and inhabit them before the walls are dry. They may possibly breathe noxious and infectious gasses, given off by the damp decomposing matter of the transformed dust-heap. They will also find to their dismay, difficulty in persuading walls thus plastered to hold a nail, while the ceilings will in time manifest signs of decomposition by dissolving partnership with their elaborate stucco ornaments and thin coating of white plaster. On the other hand, if the dust is properly sifted, burned, and strengthened by a suitable proportion of lime, the resulting mortar will prove of excellent quality. Rags, bones, and fragments of old metal found in dust-yards, realize prices that leave a handsome profit after paying the expense of sifting. There are, indeed, establishments in London where such miscellaneous refuse is received, sifted anew, and bought up by merchants and manufacturers. The collecting and sorting of waste-paper alone, forms a special industry. Many young women find daily employment in sorting paper picked out of refuse. In the houses where such labour is employed, tons of sweepings may be seen piled up in huge sacks. These are duly emptied and examined by the nimble fingers of the women, who assort the contents into lots according to quality. These lots are ultimately utilized in a variety of ways. The enormous quantities of old iron utensils, empty meat and biscuit tins, are sold to the makers of small tin boxes and to trunk makers for clamping the corners of their trunks. It will be seen, therefore, that the filthy refuse collected from houses can still be transmuted into coin, although the coin may be bronze in place of silver as in former days. When the trade of dust-collecting was more lucrative, Flying Dustmen appeared and pursued their craft in defiance of law, if not of order.

The men photographed are types of this class of "Street Labourers," who obtained their cognomen from their habit of flying from one district to another. When in danger of collision with an inspector of nuisances, they adroitly change the scene of their labours. Flying dustmen are, however, neither totally unacquainted with the interior of police courts, nor have they invariably escaped being fined for their raids upon the parish. The cart pictured is the regulation shape, and might be mistaken for a parish conveyance, were it not for the horse, whose flying days may be fairly said to be over. The old dustman, in spite of misfortune, has followed his itinerant calling for a long term of years, and has met with a sort of *quasi* recognition in the parish as a civil and obliging dustman.

Flying dustmen are unreliable in their movements, while at night, like flying

comets, some of them may be traced in their course by the tail they throw out behind. Having no fixed "shoot," after the day's labour is done and the load denuded of its saleable contents, the tail of the conveyance is partially opened. The owner then seeking some by-way, proceeds to distribute the dust in a thin layer over the road, and thus lightens his burden at every step. On more occasions than one, inspectors of nuisances have traced the erratic course of these men, and at last caught them shooting the contents of their cart into some quiet field, or beneath the deep shadow of a railway arch. The industry is on the whole managed in such a way as to make it pay. Old bottles, tins, rags, and bones, are disposed of for about three shillings per hundredweight. The flying dustmen also study the routes of "regulars," and follow in their wake. In this way they pick up customers who have been over-looked, or who have failed to catch the husky croak of "dust ho!" In their plight housewives accept the proffered aid, and agree to have their bins emptied for a consi-deration. It is, of course, necessary to point out to those in pressing need, that the regular dustmen have just gone, and cannot appear again for at least a week. Diffi-culties are also raised as to the quality and quantity of dust to be removed. At last all is adjusted to the satisfaction of employer and contractor, and the flying dustman proceeds upon his rounds.

It is a question worthy of the serious consideration of chemists, and of some at least of the vestries of London, whether some advance could not be made in the utilization of the ever-increasing quantity of refuse discharged from the houses of the metropolis? It can hardly be conducive to the health of the community to cast away all sorts of garbage, and to deposit the filthy contents of the carts in a shoot within a densely-populous suburb. In summer, the proximity of a dust-cart even may be ascertained by the mouldy taint it distributes through the air. In times of epidemic disease, the air may not only be charged with disagreeable odours, but with the germs of infection existing in the dust and litter conveyed from fever-stricken abodes. If the germs of zymotic disease remain active for even a short period, it is manifest that shooting household refuse into suburban gravel pits is attended with danger to the community. It seems to me that under efficient supervision, in the hands of experienced contractors for road-cleansing, the bulk of road-sweepings and domestic refuse might be mingled and used as manure. This has already been done, but on too limited a scale. Again, it has been shown that the filthiest rags prove an excellent manure in the hands of hop-growers, who transform what is positively dangerous and offensive if allowed to rot on a dust heap, into the material used in preparing one of our chief beverages.

The Chinese, who are eminently an agricultural people, turn the dust and refuse collected within their abodes to better account than we do in London. Animal and vegetable matter, rags and dust are consigned to manure pits, and there mingled with ordinary sewage. When ripe, the liquid compound is transferred to fields required to yield two or three crops a year. If a body of Chinese emigrants had to deal with the garbage of a city so vast as London, we should find many of the poorest lands around the metropolis transformed into gardens and markets stocked with even a more abundant supply than we already possess of the choicest fruits and vegetables.

OLD FURNITURE.

T the corner of Church Lane, Holborn, there was a second-hand furniture dealer, whose business was a cross between that of a shop and a street stall. The dealer was never satisfied unless the weather allowed him to disgorge nearly the whole of his stock into the middle of the street, a method which alone secured the approval and custom of his neighbours. As a matter of fact, the inhabitants of Church Lane were nearly all what I may term "street folks"—living, buying, selling, transacting all their business in the open street. It was a celebrated resort for tramps and costers of every description, men and women who hawk during the day and evening the flowers, fruits, and vegetables they buy in the morning at Covent Garden. When, however, the question of improving this district was first broached, Church Lane stood condemned as an unwholesome, overcrowded thoroughfare, and the houses on either side are now almost entirely destroyed, and the inhabitants have been compelled to migrate to other more distant and less convenient parts of the metropolis. This lane was not certainly one of the worst streets in the neighbourhood, but it stood in disagreeable proximity to New Oxford Street, and the tax-payers of that important thoroughfare had to be conciliated. When the furniture dealer found that his customers were thus one by one leaving the quarter, and that the most elaborate street display of his goods failed to attract any buyers, he was ultimately obliged to join the general exodus. The accompanying photograph will, therefore, recall the entrance of Church Lane as it used to be in the olden time, and yet remained till the beginning of the year 1877. It will also afford a striking contrast to the improvements which are now about to be realized.

Furniture dealers of this class, that is to say, the men who cater for the poor, generally obtain their stock from brokers and bailiffs. They will buy up the entire furniture of a poor household for a given sum, without discussing in detail the separate value of each article. Of course, the greater portion of the goods thus obtained are more or less old, damaged, and some even broken into fragments; but, to the second-hand dealer, no article of furniture can be so entirely destroyed as to be totally useless. He will contrive, with two broken chairs, to make one sound one. The boards taken from one chest of drawers will serve to repair another which may be in a less dilapidated condition; and when once old furniture, particularly a chair, has been repainted, repaired, varnished, or polished, it is impossible to distinguish any difference between an old and a new article, if both are made after the same model. Unless pieces are hacked out of the framework, an old chair may always be made to look new. Even if the wood is damaged, four sound legs may generally be selected from two old and battered chairs, so that one sound piece of furniture is thus produced. But in this business considerable skill and ingenuity must be exercised, and an extensive knowledge of cabinet-making and upholstery is indispensable. For this purpose, the second-hand furniture dealers generally secure the services of a sort of nondescript artisan, who is usually called the "handy man." He is, in a word, the very opposite to the specialist. He can do a little—perhaps very little—but still a little of every

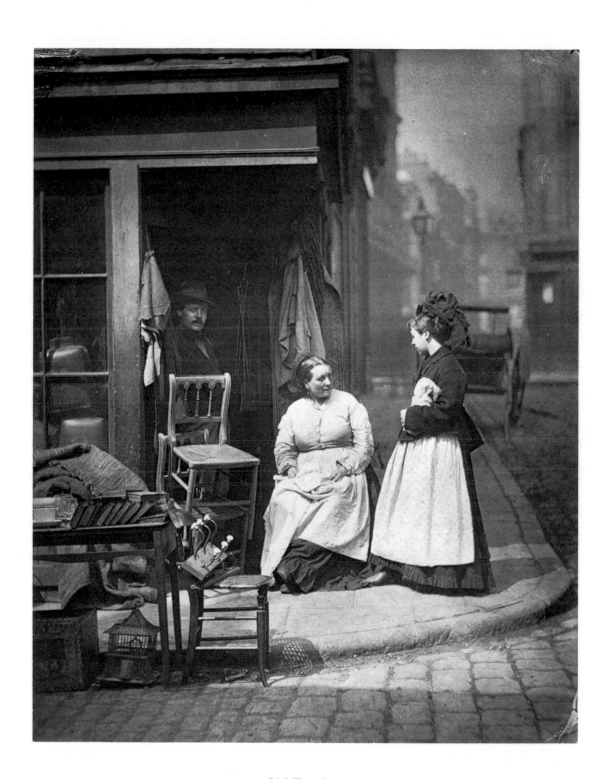

Old Furniture

style of work, so that he can always patch up, improve, mend, or adapt to some new purpose, whatever second-hand furniture and lumber his employer may buy. The handy men are, therefore, the genii of this trade; and yet they are often recruited from the street. Some have never been apprenticed as cabinet-makers or upholsterers, but have led a wild, errant life, learning from necessity how to exercise whatever latent power they possess of invention or contrivance. Sometimes the men who wander about the streets seeking chairs to mend develop into "handy men." They begin by offering to put new cane into the chairs they may notice in shops requiring repair of this description. Then, while on the premises, they look about for some other and different kind of work, and sometimes succeed in obtaining permission to attempt work of a higher description. After many failures, a man of ingenuity may pick up sufficient knowledge, if he has a natural taste for this craft, to be regularly employed as a handy man; and, having once acquired that position, he may so improve upon it as to render himself quite indispensable to his master. Thus these second-hand furniture shops are in some cases the stepping-stones which enable men of capacity and good will, to quit street life and join the great artisan class.

Apart from the stock obtained from brokers, a certain number of articles are bought from the poor themselves. But it is curious to note all the circumspection that must be displayed in this phase of the trade. The proverbial pride of the poor has to be conciliated with elaborate care. In this respect the pawnbroker has a decided advantage. A small parcel can be taken in and out of his pledge shop without necessarily attracting the notice of the neighbours; but a chair, a table, a large, heavy article of furniture, cannot be so easily removed. It is, therefore, only as a last resort that the furniture is sold; and even then the dealer is told to observe innumerable precautions. He must come and fetch the things away himself, and that only after dark. He receives special injunctions not to make any noise on the stairs, and if he should be so unfortunate as to meet any other tenant of the house, he must pretend that he is only taking the things away to be repaired, re-varnished, or otherwise improved. Unfortunately, these artifices are not often rewarded by success. When a poor man begins to sell his household furniture he is not far from the last steps in the downward direction. He may disguise his misery at first, but it soon becomes apparent to all, and the furniture dealers have but little faith in the utility of the precautions they are so often required to practise. As a rule, second-hand furniture men take a hard and uncharitable view of mankind. They are accustomed to scenes of misery, and the drunkenness and vice that has led up to the seizure of the furniture that becomes their stock. Then they have also to be thoroughly acquainted with the various forms of swindling practised in auction rooms; while, on the other hand, the customers who buy from them are not often very creditable people. The surroundings of the trade are, therefore, calculated to engender suspicion, harshness, and perhaps dishonesty. In all cases there is a tendency to sacrifice principles for the sake of securing a good bargain. At the same time, it is only fair to add that these shops afford facilities to persons whose means are very restricted, and enable them to furnish a home and thus obtain an established position. The furniture sold by the " tally-man " is far dearer, and often not so good, though advertised as new. A good second-hand article is generally preferable to the new shoddy ware sold at a higher price, and hence the popularity enjoyed by furniture dealers whose shops may be found in our back streets. A. S.

THE INDEPENDENT SHOE-BLACK.

LONG and uneven war has been waged for many years between the various members of the shoe-blacking fraternity. The factions that divide those who look to our boots for a mode of livelihood are wonderfully numerous. There are boys who maintain that no able-bodied man should seek to clean boots, that this work should be monopolized by children. Others, on the contrary, urge that the street should be free to all, and that if an able-bodied man chooses to devote himself to the art of blacking boots, as a free British subject, he has a right to follow this or any other calling, however humble it may be. Probably he is not fitted for anything better; and if so, it is to the interest of the community that he should be allowed to do, at least, that which he feels disposed to attempt. A third party will rejoin that this is altogether a false theory, that men who are capable of more worthy work should not be allowed to degrade themselves by menial offices,—a principle which, however, if universally applied, would soon revolutionize the whole face of society. So far as the London boot-blacks are concerned, this principle has, nevertheless, been carried out to a very great extent. The police authorities have taken upon themselves to interfere, indeed to destroy, the freedom of trade in the matter of cleaning gentlemen's boots, and the independent boot-black is consequently treated by the authorities as if he was little better than a smuggler.

Useful, though perhaps unfair, patronage is accorded to the members of the Boot-black Brigades. These are the orthodox or legitimate boot-blacks, and they consequently find favour in the eyes of the police. The policeman, who is essentially a lover of order, an admirer of discipline, cannot understand why, if a boy wants to manipulate brush and blacking for a living, he should not join one of the brigades. He is likely to forget that the real attraction of street life, the one advantage it offers in exchange for all the hardships and poverty to be endured, is precisely that sense of independence and absence from discipline which no member of the brigade can enjoy. The shoe-black brigades, though excellent institutions, have decidedly trespassed on the freedom of street industries. Their organized and disciplined boys have the monopoly of various "beats" and "pitches" given them, and their exclusive right to clean boots in the streets or at the corners in question is rigorously enforced by the police. Yet, notwithstanding such privileges, the brigades are unpopular among the classes they are supposed to serve, and this opinion I find confirmed by the last Annual Report of the Ragged School Union.

The author of this Report qualifies results achieved in the year 1876 as a success, because the number of boys employed in the nine societies has been augmented to the extent of twelve recruits! In this huge metropolis, with its rapidly-increasing population—in a year, too, of commercial depression, when the poor are naturally driven to such expedients—only twelve new boys were found willing to join the nine different societies. An augmentation of one and one-quarter of a boy per society during twelve months cannot be qualified as a success.

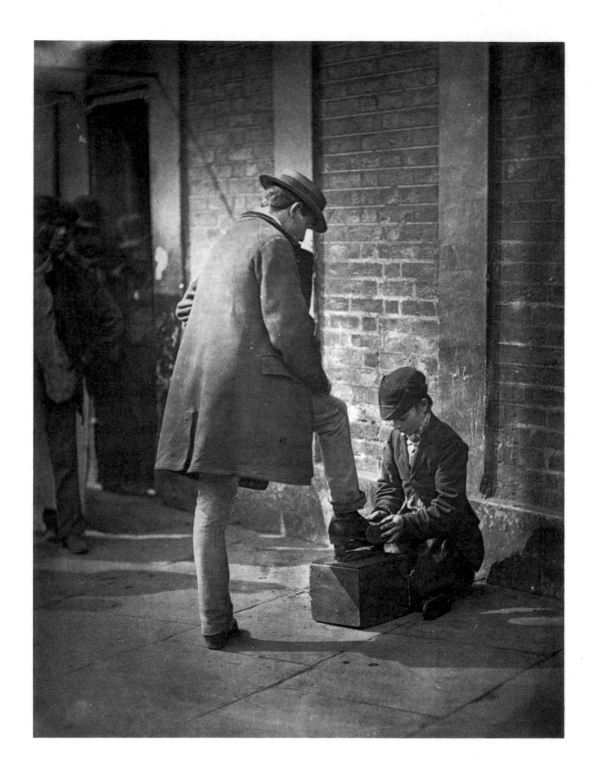

The Independent Shoe-Black

The Boot-blacking Brigade movement was started in 1851, when 36 boys were enrolled, and they earned during the year £650. After labour extending over the whole metropolis, and unceasingly pursued during a quarter of a century, the number of boys has been increased to 385, and their annual earnings to £12,062. During the twenty-five years the boys have earned altogether £170,324; and the average benefits per week accruing to each boy, last year, amounted to twelve shillings. Considering the enormous influence brought to bear, the subscriptions, the patronage of the public, who generally prefer employing a boy wearing the brigade uniform, and, finally, the protection these boys receive from the police, I do not think that the above statistics are satisfactory. That independent boot-blacks should still be able and willing to wage war against the brigade boys, though the latter have every advantage, demonstrates how unpopular the movement is among the poor themselves. There is also the feeling that, if a boy is willing and sufficiently steady to submit to the discipline enforced by the managers of the brigades, he is worthy of some better employment than that of cleaning boots in the streets. This should be left to those who are less fortunate by reason of the bad education they have received, the bad instincts they have, through no fault of their own, inherited from vicious parents, and the disorderly disposition engendered by the bad company with which they have been surrounded from their youth upwards. In great towns, at least, there are always a large number of persons whom strict moralists—men who judge a fellow-man by his deeds, instead of taking into account his disposition and his surroundings—would condemn as altogether hopeless. Yet these persons, who are unfit for any good or steady work, must nevertheless live; if not in the streets, then, probably, in prison, or in the workhouse. But assuredly, instead of being supported by the rates or the taxes, it would be preferable that these unreliable and almost useless members of society should earn their living by cleaning boots, or carrying boards, or by any other similar catch-penny menial work. The police, however, are determined to debar this class from the free exercise of boot-cleaning in the streets.

An independent boot-black who has not secured a licence—for which, by the way, he must pay five shillings a year when, if ever, he does obtain it—is severely handled by the police. They will not allow him to stand in one place. If he deposits his box on the pavement, the policeman will kick it out in the street, among the carriages, where it will probably be broken, and the blacking spilt. The independent boot-black must be always on the move, carrying his box on his shoulders, and only putting it down when he has secured a customer. Even then, I have known cases of policemen who have interfered, and one actually kicked the box away from a gentleman's foot, while he was in the act of having his boots cleaned. This excess of authority was, I believe, illegal; and, I am glad to say, justly resented by the gentleman in question, who insisted that the independent boot-black should continue his work, and defied the police to arrest him. The policeman had evidently exceeded his orders, and this was proved by the fact that he did not dare accept the gentleman's challenge. Of course, if the shoe-black, though not belonging to a brigade, possesses a licence, he may do as he chooses, and need fear no interference, but the difficulty is to procure a licence. The police do not, I believe, absolutely refuse to give a licence to an able-bodied man, but they contrive to keep him waiting so long, probably twelve months, that he generally gives up the attempt, and turns his attention to some other sort of work, or else goes out with brush and blacking, but without the licence, and submits to the ill-treatment that results. On the other hand, an old man, a cripple, an infirm man, or youth who can draw up a petition and obtain the signature of four householders, will receive immediate attention at Scotland Yard, and have a licence

given him gratuitously and without any delay. This clearly proves that the police seek, as far as they can, to make the cleaning of boots in the streets a matter of privilege, and to reserve that privilege for the exclusive use of members of the brigades, or for old men and cripples.

Such a policy, which has certainly many reasons in its favour, has not, however, been brought into force without considerable opposition. The independent boot-black, whose photograph is before the reader, found by experience that the system instituted was not altogether pleasant. He has served in two brigades, the "blues" and the "reds," and found them both equally objectionable ; so, at last, he gave up the uniform, and became an independent boot-black. In this capacity, though free, he experienced all the persecutions to which I have alluded, and as he grew older and more tired of this life, he finally resolved to leave the narrow streets for the broader thoroughfares of the ocean. As a sailor, he promises to become a useful help to his captain and ship. His mother has to nurse an invalid husband, and must also provide for a large family. Under these circumstances, it was not always easy for her to spare the services of her son. But when he became an independent boot-black, he could go out at his own hours, and thus was of greater use to his mother in her trouble ; and it was a great help to the family to know that whenever the boy had a few moments to spare, he might run out and hope to gain some pence by cleaning gentlemen's boots.

The police have not been uniformly successful in stamping out unlicensed shoe-blacks. In some cases the tradesmen came out of their shops and spoke in their favour ; they objected that the shoe-black had been standing outside their doors for many years, was well known to the neighbourhood, had proved himself useful in running errands, or lent his aid to put up the shutters in the evening, and that, consequently, the policeman would oblige them by leaving him alone. There are, therefore, a few independent boot-blacks who lead an easy life, and whom the police refrain from molesting, but these are the exception. Taking a broad view of the question, I may safely repeat that the freedom of trade has, in this respect, been destroyed. Only boys of the brigades and old men and cripples are welcome to practise the art of cleaning boots in the streets of the metropolis.

<div align="right">A. S.</div>